DAVID BUSCH'S

DIGITAL PHOTOGRAPHY BUCKET LIST:

100 GREAT DIGITAL PHOTOS YOU MUST TAKE BEFORE YOU DIE

David D. Busch

Course Technology PTR

A part of Cengage Learning

COURSE TECHNOLOGY
CENGAGE Learning™

Australia, Brazil, Japan, Korea, Mexico, Singapore, Spain, United Kingdom, United States

COURSE TECHNOLOGY
CENGAGE Learning

David Busch's Digital Photography Bucket List: 100 Great Digital Photos You Must Take Before You Die
David D. Busch

Publisher and General Manager, Course Technology PTR:
Stacy L. Hiquet

Associate Director of Marketing:
Sarah Panella

Manager of Editorial Services:
Heather Talbot

Marketing Manager:
Jordan Casey

Executive Editor:
Kevin Harreld

Project Editor:
Jenny Davidson

Technical Reviewer:
Michael D. Sullivan

Editorial Services Coordinator:
Jen Blaney

Interior Layout Tech:
Bill Hartman

Cover Designer:
Mike Tanamachi

Indexer:
Katherine Stimson

Proofreader:
Sara Gullion

For product information and technology assistance, contact us at
Cengage Learning Customer & Sales Support, 1-800-354-9706

For permission to use material from this text or product, submit all requests online at **cengage.com/permissions**.
Further permissions questions can be e-mailed to
permissionrequest@cengage.com.

All trademarks are the property of their respective owners.

Library of Congress Control Number: 2009924533

ISBN-13: 978-1-59863-993-3

ISBN-10: 1-59863-993-5

Course Technology, a part of
Cengage Learning
20 Channel Center Street
Boston, MA 02210
USA

Cengage Learning is a leading provider of customized learning solutions with office locations around the globe, including Singapore, the United Kingdom, Australia, Mexico, Brazil, and Japan. Locate your local office at: **international.cengage.com/region**.

Cengage Learning products are represented in Canada by Nelson Education, Ltd.

For your lifelong learning solutions, visit **courseptr.com**.

Visit our corporate Web site at **cengage.com**.

Printed in the United States of America
1 2 3 4 5 6 7 11 10 09

Dedicated to the members of the Cleveland Photographic Society, whose inspiring photographs have given me ideas that I've added to my own personal photographic To-Do list.

Acknowledgments

Although my name is on the cover, this book is really a joint effort that involved the contributions of many people working behind the scenes at the publisher and within the Cleveland Photographic Society. One driving force who really made this book possible was Rob Erick, President of CPS during the period this book was compiled, and now esteemed Past President. Rob functioned as "CEO" for the project, drumming up support and participation, keeping it on track, and fine-tuning how the entries were collected and evaluated. Shannon Rice was the "COO" and "tech support" for the Bucket List, including designing the website used by CPS members to submit their photos, and compiling Excel spreadsheets with photographer and image data. Nancy Balluck and Barb Pennington served as co-chairs of the 14-person committee that established the rules and judged the entries.

And, once again I have to thank the folks at Course Technology, including executive editor Kevin Harreld, and my veteran production team, including project editor Jenny Davidson, and technical editor Mike Sullivan. Also thanks to Mike Tanamachi, cover designer; Bill Hartman, layout,; and my agent, Carole Jelen, who has the amazing ability to keep both publishers and authors happy.

Cover photos by: Varina Patel, Ed Rynes, Ron Wilson, Vincent Vartorella,
Todd Liebenauer, Blackwatch Studios, Joseph Polevoi.

About the Author

With more than a million books in print, **David D. Busch** is the world's #1 selling author of digital camera guides, and the originator of popular series like *David Busch's Pro Secrets* and *David Busch's Quick Snap Guides.* He has written nine hugely successful guidebooks for Nikon digital SLR models, and six additional user guides for other camera models, as well as many popular books devoted to dSLRs, including *Mastering Digital SLR Photography, Second Edition* and *Digital SLR Pro Secrets.* As a roving photojournalist for more than 20 years, he illustrated his books, magazine articles, and newspaper reports with award-winning images. He's operated his own commercial studio, suffocated in formal dress while shooting weddings-for-hire, and shot sports for a daily newspaper and upstate New York college. His photos and articles have been published in magazines as diverse as *Popular Photography & Imaging, The Rangefinder, The Professional Photographer*, and hundreds of other publications. He's also reviewed dozens of digital cameras for CNet and *Computer Shopper,* and his advice has been featured in National Public Radio's *All Tech Considered.*

When About.com named its top five books on Beginning Digital Photography, debuting at the #1 and #2 slots were Busch's *Digital Photography All-In-One Desk Reference for Dummies* and *Mastering Digital Photography.* During the past year, he's had as many as five of his books listed in the Top 20 of Amazon.com's Digital Photography Bestseller list—simultaneously! Busch's 100-plus other books published since 1983 include bestsellers like *David Busch's Quick Snap Guide to Lighting.*

Contents

CHAPTER 2
Special Moments

CHAPTER 3
Photojournalism

CHAPTER 4
The World of Nature

CHAPTER 5
Creatures Great and Small

CHAPTER 6
The Fine Arts

APPENDIX A

Preface

If you're looking for inspiration, the 100 rousing images in this book will get your creative juices flowing. Crafted by the master photographers who belong to the Cleveland Photographic Society, each of these photographic gems presents a definitive moment that you, as an avid photo buff, will want to include on your own personal "bucket list" of digital images that you can aspire to capture during your lifetime shooting career.

The intent here is not to present a "shot list" of pictures to imitate using your own camera and equipment. Instead, I hope you'll absorb the excitement and creativity that went into capturing each of these moments, and use them as a stimulus to nudge your own creative vision within each of the channels of imagery shown. Inspired by the photos you see here, you'll go out and shoot a deeply moving intimate portrait, portray the power of Nature's fury, or capture the exhilaration of a sports championship-winning score. You'll find some great photographs within this book and, I hope, the images here will help you find great photographs within yourself.

Introduction

Although "bucket list" entered the English vernacular only since 2007, following the success of the movie starring Jack Nicholson and Morgan Freeman, most of us, as photographers, have long maintained a mental list of great photographs that we aspire to shoot at some time in our amateur or professional "careers." Many of the shots that reside on our personal Bucket Lists are inspired by compelling photographs we've seen, whether they are well-known images from masters like Ansel Adams or Annie Liebovitz, or work we've seen in magazines, photo exhibits, or even the portfolios of friends. Most of the time, our goal is not to slavishly imitate the images we admire. Instead, we want to capture the energy and creativity that went into them and develop something new and personal with the same qualities.

Ideas and inspiration are the intent for this book, *David Busch's Digital Photography Bucket List: 100 Great Digital Photos You Must Take Before You Die.* I've collected a diverse set of images spanning dozens of categories, from deeply personal portraits through zany Photoshop composites, each of which should provide you with a rich trove of ideas you can use to arouse your creative instincts. The 100 photographs in this book are more than just a set of great images: they comprise a list of 100 potential projects you'll want to explore as you check off the challenges of your own Bucket List.

The Definitive Moment

I first got the idea for a Bucket List collection back when the film of the same name was still in theaters. I realized that, this late in my career, there were still many types of images that I had always hoped to take, but which had eluded me so far. M.I.T.'s Dr. Harold Edgerton's stop-motion work had captured my imagination, and I had always wanted to shoot one of those "bullet bursting a balloon" photos, even though the technology involved was daunting. I thought of Diane Arbus's *Identical Twins, Roselle, New Jersey, 1967* every time I found myself surrounded by more than 2,000 sets of "multiples" at the annual Twins Days Festival in Twinsburg, Ohio. And I didn't need to see a John Ford Western

to be motivated to shoot my own landscape of Monument Valley in Utah and Arizona. There were so many definitive moments to capture that I knew a Bucket List collection was a great idea. But I discovered that my "To-Do" list was a lot longer than my "Done" inventory.

Then, quite by accident, I discovered the Cleveland Photographic Society almost in my backyard. After attending a few meetings and seeing the work of the 275-plus photographers who belonged, I realized that a pretty good Bucket List of images could be compiled just from the photos of these shooters. Unlike many of the photography clubs I've visited, CPS had a mixture of experienced professional photographers, rank beginners just starting to learn how to use their cameras, and seasoned amateur photo enthusiasts who had both technical knowledge and a creative eye. This

genial gumbo of photo fanatics interacted freely and easily, without cliques and hierarchies. You really couldn't tell who the pros were and who the amateurs were from the animated discussions, informative presentations, and healthy competitions. The Society's membership is best illustrated by its official motto: "Photographers helping photographers."

Best of all, they had some great pictures to offer. I proposed this Bucket List book to the CPS board of directors, and, over a three-month period, several thousand entries were submitted, evaluated in "blind" judging, and winnowed down to the photographs you see in this book.

There were no "categories" as such. The goal was to collect 100 photographs that each captured a Bucket List-worthy definitive moment, regardless of subject matter. The final selections were made to provide as much

diversity and variety as possible. When I saw that, even with thousands of entries, there were several types of images not represented, I salted in a few of my own, as a dues-paying member of the group. I tried to keep those to a minimum, so most of the work you'll see in this book belongs to 43 other photographers.

Of course, the Cleveland Photographic Society has more than 43 great photographers. Some elected not to submit images, while others, who submitted some very, very good shots, were nudged out by other photographers' work that was similar or which provided some additional diversity in terms of theme or treatment. The "judging" process was as blind as we could make it. Neither I nor the other evaluators on the panel were provided information about who shot which picture, but, of course, some of us recognized a particular photographer's style (or *thought* we did; many times we were

fooled, and an image we'd pegged mentally turned out to be by someone else). Other photos we might have remembered from various competition nights at the club.

When all was said and done, the 100 images selected were chosen for their artistic value first, applicability to a theme that might make a good entry on anyone's Bucket List, and technical quality. As a result, the array of images you'll find in this book varies all over the photographic spectrum. Some photographers are represented by a single image in the book; others have several included. The themes are diverse, and some you might expect to find are not included, while others have a little overlap. (I grouped three of the "sports" photographs and two of the "dance" pictures in a single spread for that reason.)

Photoshop or Not?

The debate over whether photographs should be created solely in the camera didn't die out with the transition from the wet darkroom to the digital darkroom. Today, anyone can learn to use an image editor like Photoshop or Photoshop Elements to produce manipulations that, during the film era, required an impressive amount of technical skill, experience, and patience. It still takes a lot of work to become a Photoshop master, but many interesting tools are within the reach of anyone.

I didn't put any restrictions on the use of image editing for photographs submitted to this book, although I used a rough classification system to decide whether the photo manipulations deserved a special discussion. If the use of an image editor was obvious (for example, the Moon shown inside of a light bulb), the photo was probably a *composite* image, with elements taken from one or more pictures and combined. That sort of work definitely merited a mention and, in some cases,

inclusion in Chapter 8, which is devoted exclusively to images using special effects.

If it was difficult to tell that adjustments had been made, then the image was either *fine-tuned* (for example, brightness and/or contrast and tonal levels modified) or *retouched* (minor defects removed or minimized). I considered these as, more or less, straight photography, because the manipulations were things that could have been done in the camera or in a conventional darkroom. For instance, if a distracting background was blurred, it really didn't make much difference whether the photographer used a large f/stop and selective focus, or added some blurring in Photoshop. The impact of the image was the same. You'll find in this book a mixture of unadorned photographic techniques, Photoshop tweaking, and outrageous manipulations. (Check out the last chapter for the most blatant examples of the latter.)

What You'll See

This book contains 100 featured photographs and a smattering of other images used to illustrate a concept or how the featured photos were taken. Each highlighted photograph is displayed on a two-page spread, with the facing pages providing some information about how the picture was taken, and advice on how you can meet the challenge of shooting in similar situations. The images and text should help spark ideas that you can use to capture your own photographs of similar defining moments using your own creative initiative. Your own work may be influenced or inspired by what you see in this book, or you may end up shooting a very similar version (what we artistes call *un hommage*). In any case, each successful project means one more entry that can be crossed off your personal Bucket List.

Appendix A offers head shots and brief bios of each of the photographers and other contributors featured in this book. Most of them have web pages you can visit to see more of their work, or to order prints of their pictures. Some were brave enough to include e-mail addresses, so you can write to them with questions about their work.

About the Cleveland Photographic Society

In 1887, a group of dedicated enthusiasts formed an upstart organization and named it the Cleveland Photographic Society—dedicated to exploring this fledgling art form as it began to emerge as a hobby for the non-professional. As equipment became more technically refined, as tastes in preferred subject matter and technique ebbed and flowed, and as mass-marketed and more affordable cameras opened the hobby to the average person, CPS grew and changed with the times—always staying current and relevant, and always focused on the principles of education and fellowship.

During the 1940s the Society's School of Photography was formed, offering a course in Fundamentals of Good Photography that was designed to demystify the camera for the novice and to provide anyone the tools to become a better photographer. Eighty years later, a course with that same name is still being offered—and although the terminology has evolved over time and the focus has largely switched from film to digital, the basic concept of making photography fun and accessible to anyone interested remains very much the same. An accompanying course in Darkroom Technique has evolved into a Digital Imaging class, replacing the chemicals of the darkroom with the latest editing software—yet still allowing the opportunity for the photographer to apply an extra level of creativity to his/her work.

After meeting in various locations in and around downtown Cleveland since its inception, the Society relocated to its current home in Broadview Heights in 2005. Since that time, membership has more than doubled—and currently numbers more than 275 members, including couples and youths. During 2009, the group saw the expansion of its clubhouse, with renovations that included a new gathering area with complete kitchen, and a "roof-raising" in the main club room to provide more space and better sight lines for meetings that often attract nearly 100 members and visitors. The Society's website can be found at www.clevelandphoto.org.

Who Am I?

Although this book sees me riding on the coattails of a group of excellent photos by members of the Cleveland Photographic Society, I'm not entirely unknown (to resort to litotes) in the photographic field. Much of my notoriety is due to a horde of camera guidebooks and other photographically oriented tomes. You may have seen my photography articles in *Popular Photography & Imaging* magazine. I've also written about 2,000 articles for magazines like *PhotoGraphic*, plus *The Rangefinder*, *Professional Photographer*, and dozens of other photographic publications. I've blathered about digital photography on television and radio programs, and been featured on National Public Radio's *All Tech Considered*. But, first, and foremost, I'm a photojournalist and made my living in the field until I began devoting most of my time to writing books. Although I love writing, I'm happiest when I'm out taking pictures, which is why I took several weeks off this year for trips to

Major League Baseball Spring Training, the Sedona red rocks and Grand Canyon regions of Arizona, and to Prague, Czech Republic. By the time this book is published, I will be off for a week in Valencia, Spain. I go not as a tourist, but solely to take photographs of people, landscapes, and monuments that I've grown to love.

Over the years, I've worked as a sports photographer for an Ohio newspaper and for an upstate New York college. I've operated my own commercial studio and photo lab, cranking out product shots on demand and then printing a few hundred glossy 8×10s on a tight deadline for a press kit. I've served as a photo-posing instructor for a modeling agency. People have actually paid me to shoot their weddings and immortalize them with portraits. I even prepared press kits and articles on photography as a PR consultant for a large Rochester, N.Y., company, which shall remain nameless. My web page portal can be found at www.dbusch.com.

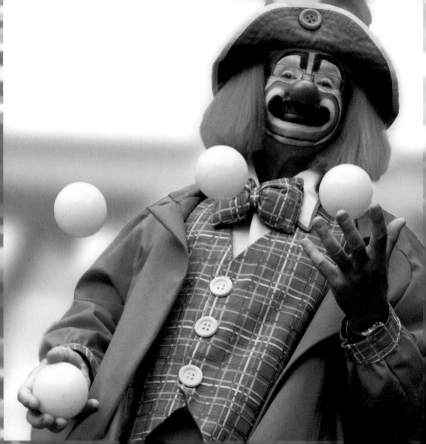

1 Capturing the Human Spirit

Some photographers specialize in one kind of picture or another, such as landscapes, sports, or close-ups. But everyone who uses a camera enjoys taking pictures of people, even if their main efforts are concentrated on other subjects. Unless you're a hermit, you love to photograph your friends, family, colleagues, and even perfect strangers. Human beings are the most fascinating subjects of all.

The person you photograph today may look completely different tomorrow, or might even adopt several different looks in a single afternoon with a quick change of clothing or hairstyle. Change the environment and surroundings, and you can transform the way you capture your subject's personality. Modify the lighting, and a person can be pictured as sinister, powerful, or glamorous. It's your choice.

Photographs such as the lively celebrity photography of Richard Avedon, or Yousuf Karsh's powerful portrait of Winston Churchill are some of the greatest images ever captured. The value we place on photographs we take of each other can be measured by the number of people who say the one object they'd grab on their way out of a burning home would be the family photo album. After all, photographs of our friends and family are a way of documenting our personal histories, and the best way we have of preserving memories. The fact that there are so many different categories of people-oriented pictures, from fashion photography to portraiture, demonstrates the depth of this particular photographic field. This chapter shows you some images that capture the human spirit and belong on your own personal Bucket List.

A Festive Moment

JUGGLING CLOWN—ED RYNES

Festivals, circuses, and major events of all types provide opportunities for capturing people at their light-hearted best. You can photograph family members enjoying the food, marveling at the sights, thrilling to amusement park rides, or watching the variety of entertainers who work hard to keep the festive mood alive. But don't limit yourself to the folks you came with! Other people in the crowd are worth a snapshot or two, and the entertainers themselves are likely to be colorfully dressed and engaged in interesting activities, like the juggling clown shown in photographer Ed Rynes' eye-catching photograph on the right-hand page. This image is particularly effective because the low shooting angle put the emphasis on the tumbling balls, and the rich saturation really made the colors pop.

Rynes says he grabbed this shot at a suburban street festival, wielding a 28-200mm lens on his Sony dSLR-A350 camera. The zoom lens gave him a choice of "normal" to long telephoto focal lengths, but he used the 28mm setting (equivalent to 42mm on a full-frame camera thanks to the Sony's 1.5X "crop" factor) to capture this well-coordinated performer. A shutter speed of 1/640th second at f/4 froze the balls in mid-flight, while throwing the background partially out of focus.

To give the clown's performance greater impact, Rynes further blurred and muted the background in an image editor, removed some distracting detail, and did some minor dodging and burning. Then, one finishing touch really made the photograph. The photographer added a cloned ball to the three the clown was juggling (see the

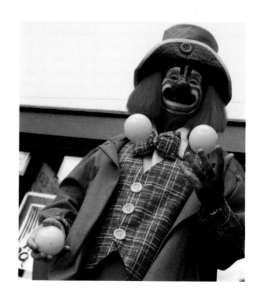

small version on this page) to better balance the composition. Even when a print of the final image is viewed up close, this Photoshop Elements manipulation is difficult to detect unless you know in advance that the work has been done.

Ed Rynes' technique is one you should keep in mind when trying to capture your own festive moment. These events frequently are crowded, and distracting backgrounds are the norm. Waist-level shooting can minimize the most obtrusive elements. When possible, use a large f/stop (f/5.6, f/4, or even f/2.8 if your lens has that aperture available) to throw the background out of focus. You'll reap an additional benefit of a higher shutter speed to freeze frenetic action. If you have room to back up a little, crank your zoom lens to a telephoto setting and allow the reduced depth-of-field to mute the background. When using selective focus, either focus manually or monitor the focus setting your camera's autofocus feature has chosen so that the subject you want to emphasize is sharp.

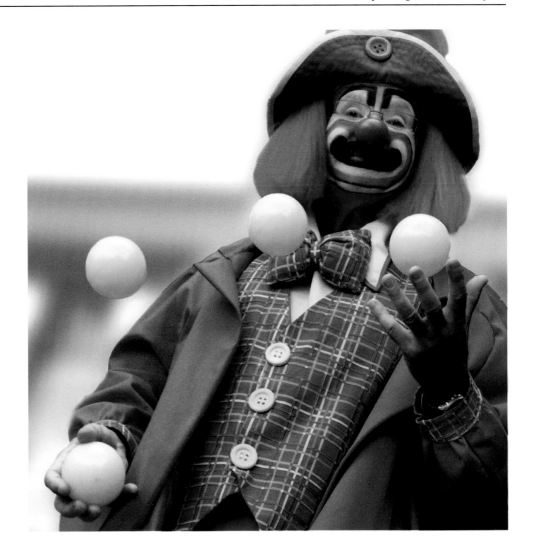

The Dignity of Age

AGED NAVAJO WOMAN—CHERYL DONOVAN

Beauty comes in many forms, and one of the gifts of a long life is the wonderful strength of character reflected in the features of someone who has lived a full life. Even though some of us may cringe at every new wrinkle and crease that appears in photographs taken of us during our middle years, the lines in the face of older people can be a badge of honor of a life well-lived. That's readily apparent in Cheryl Donovan's warm portrait of a woman who was 89 years old at the time. If you're at all interested in photographing the spirit of people, capturing the dignity of age should be high on your personal list of "must-take" photographs.

Donovan captured this image while attending one of the Friends of Arizona Highways field workshops in Canyon de Chelly, Arizona. The non-profit Friends (http://www. friendsofazhighways.com) conducts as many as 60 such workshops a year in Arizona and nearby States, from Monument Valley to the Grand Tetons (sites in Oregon, Colorado, and Utah are also visited). Limited to 8-15 participants, these workshops are a perfect opportunity to photograph interesting people and interesting locations.

Shot with a Nikon 70-200mm f/2.8 VR lens mounted on a Nikon D70, the photographer used an exposure of f/5.6 at 1/80th second. The image stabilization/vibration reduction built into this Nikon lens steadied the camera/lens so that the photograph was tack-sharp even at a relatively slow shutter speed for the telephoto lens. Donovan carefully focused on her subject's face, and the shallow depth-of-field allowed some features to drift out of focus. Reflected light produced a soft, non-directional illumination. She reports that an image editor was used to remove a distracting post in the doorway, as well as a turquoise necklace that took attention away from her subject's soulful face. "I didn't do much color correction, and the lines in her face were great! I didn't want to soften those," Donovan notes.

Image-stabilized lenses in the 70-200mm range are perfect for close-up portraiture of this sort. The 70mm focal length is ideal for three-quarters or head-and-shoulders portraits, and a bit of zooming lets you frame an exceptionally tight face shot. I typically use f/2.8 or f/4 to minimize depth-of-field and produce just the tiniest bit of softening in the corners.

Nikon and Canon both make prized 70-200mm zooms (Nikon has only an f/2.8 model, while Canon offers both an f/2.8 version and a more affordable f/4 IS lens). Third-party vendors like Sigma and Tamron also offer 70-200mm f/2.8 lenses for as little as half the price of the Nikon/Canon optics. They lack anti-shake properties, but, if you're using a Sony, Pentax/Samsung, or Olympus camera, that capability is built into the body.

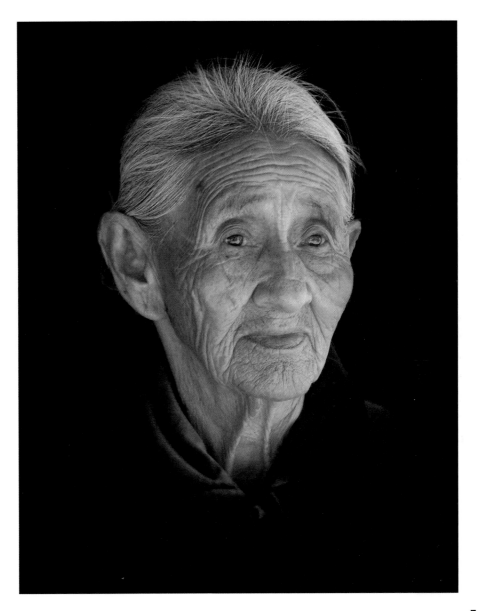

Other Lands, Other Cultures

VILLA DE LEYVA WOMAN IN WINDOW—CLARA AGUILAR

With a population of about 4,000, Villa de Leyva is a picturesque village that's been declared a National Monument by the government of Colombia. Located at an altitude of more than two kilometers, it's one of the best-preserved Spanish colonial towns, and serves as a stand-in for colonial Los Angeles in the Colombian television series, Zorro. It was the perfect setting, then, for Clara Aguilar's December stroll through the streets, where she discovered the woman pictured at right knitting in an open window.

Aguilar's Nikon camera had already been packed away, so she grabbed this shot with a small Olympus C-740 digital camera, a modest 3-megapixel model with a 38-380mm 10X zoom lens. "The colors looked perfect; her hat, her blouse, the bags hanging, even the construction of the house make this shot unique," she says. The only post-processing she needed to make was to adjust the tonal values slightly in Photoshop Elements.

Even though, in many ways, people are alike the world over, the cultural differences can provide some fascinating photographic opportunities. The joy of knitting is a universal pleasure enjoyed by both men and women, and, as shown in Aguilar's colorful image, those who knit tend to knit a great deal, with creative output like the woman's cap, the two purses, and pair of scarves that are all proudly on display.

That makes the differences stand out even more. The rough brick construction, studded with rocks and stones, the rustic window frame (unmarred by a screen or air-conditioner), and even the fact that the woman is knitting *al fresco* are ample clues that this scene was not captured in rural Iowa. When shooting an informal portrait like this one, you can certainly get in tight and capture the features of your subject—but don't ignore the surroundings. Additional shots of your subject in her natural environment can reveal much about culture, personality, and lifestyle, and add a great deal of interest.

Although Aguilar captured this image with a point-and-shoot camera, the exposure managed to accurately capture the high-contrast exterior of the building (only the white scarf at middle right is really "blown" out), while retaining a little detail in the room behind the woman. This type of scene is a good opportunity for bracketing (taking several exposures, one at the metered setting and one or more with over- and under-exposure). That will increase your chances of getting one where all the tones you want to capture are visible in your finished image.

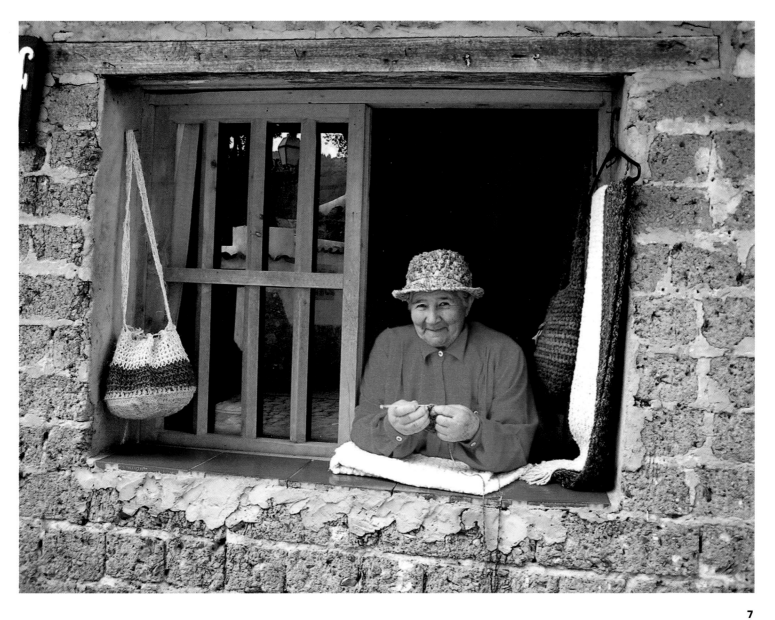

A Compelling Environmental Portrait

Ari—Nancy Balluck

One trick that portrait photographers will share willingly is that, above all, the eyes of your subject should be sharp and clear. The rest of the face can be slightly out of focus—indeed, you might *want* that to be the case—but the eyes, as the center of attention of any portrait, should be vividly sharp. That's certainly the case in this stunning environmental portrait of photographer Nancy Balluck's favorite model, Ari, shown at right.

Environmental portraits are shot in natural surroundings and not in a studio or indoor environment. They are the easiest type of people pictures to take from an equipment standpoint, because all you need is a camera, perhaps a reflector, and the great outdoors. But,

from a creative standpoint, they can be quite demanding, because you need to make the best of what you have in terms of lighting, background, and other environmental elements. Most of us shoot the majority of our subjects under these conditions, and yet a truly memorable environmental portrait is a challenge that is a fitting entry on our career Bucket List of pictures we really want to take before we adjourn to the great darkroom in the sky.

Nancy Balluck hasn't been content to rest on her environmental laurels, however, and specializes in this type of portraiture, quite often with her friend Ari as her model. She says that the woman's transformation in front of a camera is nothing short of incredible.

"She does all of the work and I just stand behind the camera, clicking the shutter. For the past five years, whenever we both need to bolster our egos, we go out for a fun shoot together," Balluck notes.

She says that this particular shot was taken inside a barn in mid-October. The warm autumn light and the rich weathered wood in the structure made a perfect backdrop for this particular shoot, which, Balluck says, lasted several hours. "I shot in RAW format with my Nikon D200 using an 18-200mm lens with a focal length of 95mm, using an exposure of f/6.3 and 1/90th second at ISO 400. Balluck took advantage of the wonderful light coming in from both sides of the open barn doors. As with most of her environmental shoots, she does not use a flash, and

prefers natural light. The photographer mounted her camera on a tripod to prevent camera shake at the relatively slow shutter speed.

Back at her computer, Balluck used Photoshop to convert the original RAW color photograph into a black and white image using the Channel Mixer (Image > Adjustments > Channel Mixer), which allows dialing in precise ratios of red, green, or blue tones. The most recent versions of Photoshop now have a Black and White command that also lets you directly specify combinations of the RGB primaries—yellow, magenta, and cyan. The Black and White command lets you change hue and saturation at the same time. Thanks to what Balluck calls "Ari's beautiful complexion, which seldom requires any touch-ups" the only additional work was a little dodging and burning of the skin, hair, and sweater, and a touch of a noise reduction filter. "I loved the luminous results!" Balluck says.

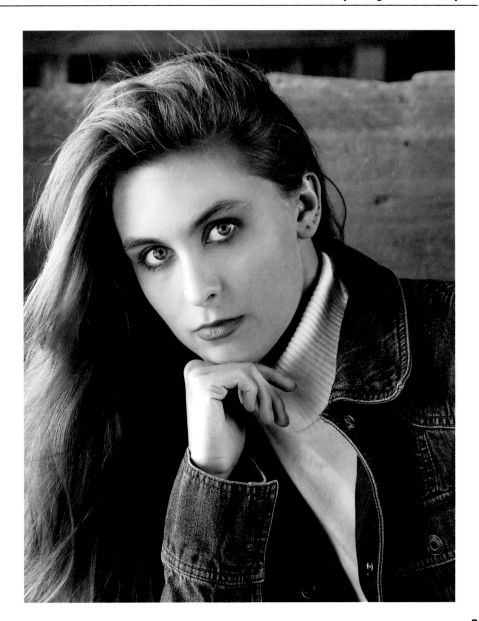

Capture Your Subject's Character

RICH—NANCY BALLUCK

The most difficult part about shooting a portrait is truly capturing a subject's character. Yousuf Karsh did it when he portrayed Winston Churchill in 1941, in what has been called the most repro-duced photographic portrait in history. *National Geographic* photographer Steve McCurry certainly succeeded with his compelling portrait of Sharbat Gula, more widely known as "Afghan woman" in 1985. Alberto Korda launched a thousand posters and tee shirts with his celebrated photo of Che Guevara at a memorial service in 1960, which the photographer says shows the revolutionary's "absolute implacability" as well as anger and pain. The fact that you know exactly which images I am referring to, without needing to show them to you, indicates just how iconic these portraits are.

While none of your own portrait efforts may make the cover of *National Geographic* magazine, there's no reason why your personal Bucket List of shots to aspire to shouldn't contain a picture that captures a subject's spirit and char-acter. That was the goal of environmen-tal portraitist Nancy Balluck when she took on the especially challenging task of photographing one of her photogra-phy teachers.

Balluck says that she had always thought that with his rugged good looks, Rich would make an excellent model. "He is at ease in front of the camera as he is behind the camera," she says. Rich met her at a barn, late on a summer afternoon, just as the light was near perfection. Prior to this shoot

she had discussed what she wanted him to wear and the edgy photographs she wanted to shoot. You'll find that when trying to image a subject's true character, it's best to have them wear something that reflects their personal style. This is not the time for "dress-up" clothes or formal attire. Casual is best.

"He could not have been more perfect for what I wanted to capture," Balluck recalls. She says this shot was taken at the entrance to the lower half of the barn. "His wild hair showed up nicely against the wooden door and I liked the way his jacket collar framed his face." The illumination in the barn cre-ated almost classical portrait lighting.

Balluck still uses her trusty Nikon D200 for most shoots, but for this one she wanted to try out a new Nikon D40 before leaving on vacation. She shot in RAW, using a Nikon AF-S DX Zoom-Nikkor 55-200mm f/4-5.6G lens. She prefers to shoot with natural light, and wanted to use an ISO of 200 to get optimum image quality, and so mounted the D40 on a tripod to counter camera shake. The exposure ended up being 1/4 second at f/13.

In Photoshop, Balluck converted the color image into a black and white photograph using the Channel Mixer to adjust tonal values. She then painted a Layer Mask that she used to lighten up the dark areas at the left of Rich's face, then used the Levels slider to correct the light balance for the rest of the image. "Just for fun, I decided to use a noise reduction filter and liked the slight softening in the final result."

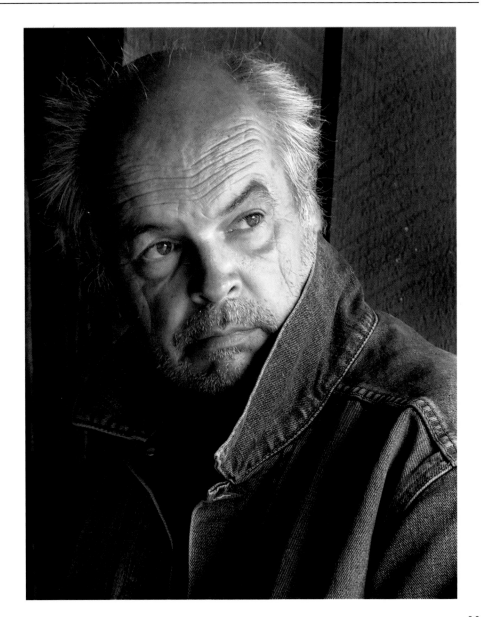

The Optimism of Youth

MISSY—ELISHA CERINO

What elevates a youth portrait or any portrait of someone under the age of 30 from the mundane to something special? It's not the sports paraphernalia or cheesy props that scream, "This photographer is with it!/Rad/Sick" (or whatever term was current nine or ten months ago). As it turns out, the real key to shooting an effective portrait of a younger person is timeless. Your goal should be to capture the optimism and enthusiasm you'll find in every subject who has an entire life of experiences ahead of them, as photographer Elisha Cerino did with this portrait of Missy.

In this picture, the vivacious expression and glow of Missy's face are the most important elements. It would have been a successful portrait even if the lighting weren't so flattering, and the background subdued but effective. But Cerino manages to bring all these aspects together in a classic portrait that has almost a three-dimensional effect.

Taken on a beautiful Fall day, Cerino seated Missy on a small boulder underneath a second story deck. She placed a white board on the ground in front of her subject and to the right of the camera, which illuminated her face well, creating the glowing look. The white board also added nice catch lights to her subject's eyes.

Cerino shot this picture with a Canon EOS 30D, using an exposure of 1/180th second at f/5.6 and ISO 250, using spot metering to determine the correct settings. With a focal length of 44mm on the Canon 17-85mm lens, the f/5.6 aperture allowed sufficient depth-of-field to image Cerino's young subject, but still threw the background slightly out of focus. (The photographer says she used a Gaussian blur filter in Photoshop to further blur the edges.) You'll find that for a waist-up portrait of this type, a 40-60mm focal length on a camera like the 30D (which has a 1.6X "crop" factor) is the equivalent, on Cerino's Canon camera, of a 64-96mm lens on a full-frame or film camera.

That range encompasses the perfect portrait focal lengths, providing the best combination of depth-of-field for selective focus, and accurate rendition of human subjects (without the flattening or distortion that longer or wider lens focal lengths can produce).

Of course, most portraits can benefit from a little digital retouching. Cerino used Photoshop to clone out some minor dark circles under Missy's eyes, and worked with the Curves command to brighten her eyes, teeth, and face in general, while darkening the background.

A Vibrant Philippe Halsman Moment

JUMPING JENNA—JAN DEBLAAY

Latvian photographer Philippe Halsman (1906-1979) had a profound effect on how portraits are captured, even among photographers who profess to be unfamiliar with his work. Surely, though, every image of a human leaping during an otherwise ordinary portrait session—like the exuberance shown by the young woman in Jan DeBlaay's Jumping Jenna, shown here—has to draw from Halsman's invention of what he called "jumpology." Many of his 101 covers for *Life* magazine used the technique for irreverant portraits of "leaping luminaries" like Salvador Dali, Marilyn Monroe, Richard Nixon, and Groucho Marx, all captured in midair.

There was method to Halsman's madness. He noted, "When you ask a person to jump, his attention is mostly directed toward the act of jumping and the mask falls so that the real person appears." That's certainly the case with Jumping Jenna, taken in DeBlaay's home studio using Alien Bees strobes bounced off umbrellas. She reports that several practice jumps were required to get the timing right for the straddle jump. She used a full-frame Canon EOS 5D camera with a focal length of 28mm (which, thanks to the full-frame sensor, is "magically" transformed into a wide-angle lens).

An exposure of f/8 captured the image. Although the camera shutter speed was set to 1/250th second, Jenna's leap was frozen by the brief duration of the Alien Bees flash unit, which is about 1/1000th second when the flash is set to full power.

You'll find that one of the advantages of using electronic flash for portraits is that their combination of high power and brief flash burst give you smaller f/stops and more action-stopping than incandescent lamps in the same environment. As a result, you can allow your subjects to move around freely without worrying about motion blur, and *you* can move around more freely, too, as you select your angles, because you can shoot without the camera mounted on a tripod. When shooting people in the studio, I almost always use strobe.

The Alien Bees that DeBlaay used, as well as most other studio flash units, allow "dialing down" the light output if, as is often the case, full power is too much for the effect you want. For example, if you've already set your camera to its lowest sensor sensitivity setting (typically ISO 100 to ISO 200), and still find yourself shooting at f/11 or f/16, you can reduce the studio flash's output until it becomes possible to shoot at f/8 or even f/5.6 if you're looking to use selective focus effects.

For Jumping Jenna, the photographer shot using Canon's RAW format, then fine-tuned white balance (you'll find that the color balance of some studio strobes varies as you dial down output), and boosted saturation. DeBlaay also applied the Curves command to tweak the brightness and contrast of this image, and applied some Unsharp Mask sharpening to the eyes (which are the focal point of any portrait—even a leaping image like this one).

Native American Culture

NAVAJO RIDER—BARB PENNINGTON

Native American culture is admired, studied, and imitated not just in North America, but worldwide. Indeed, while writing this book, I visited Prague where, I discovered, the Czech equivalent to the Boy Scouts and Girl Scouts involves youngsters at summer camps learning about Native American respect for nature, survival skills in the wilderness, and courage. In the U.S.A, we're fortunate that our own indigenous people (including several of my maternal grandfather's ancestors) are able and willing to share their culture in so many ways.

Many photographic workshops are organized around opportunities to learn about Native American culture. One of these sessions was the setting for Clevelander Barb Pennington's photograph of a Navajo named Anthony in

Chinle, Arizona, site of Canyon de Chelly National Monument. Unique among National Park areas, the canyon is owned by the Navajo Nation, but visitation is administered by the National Park Service.

Pennington recalls that Anthony arrived on a copper-colored stallion, galloping back and forth among the cluster of eager photographers, kicking up sand. When the dust and horse had settled down, the Navajo rider began to brush the horse's mane. "It was a tender moment of calm and trust. To witness the masculine beauty of man and beast at this moment was unforgettable," Pennington says. She wanted to capture Anthony's strong profile without the distraction of the other photographers in the background, so Pennington cranked the 70-200mm f/2.8 lens mounted on her Nikon

D300 out to 200mm and set the camera's Aperture Priority to f/4 to allow precise selective focus. At ISO 160, the D300's spot meter, centered on the subject's face, called for a shutter speed of 1/2000th second.

A little cropping in post processing to eliminate some background elements, a bit of shadow and highlight adjustment to make the image pop, and a touch of cloning to remove the last remaining portion of the horse's mane that was visible at lower left produced this interesting portrait.

A visit to a Native American cultural event, where the participants are sharing their customs, crafts, and traditional dress can yield a wealth of photo opportunities. Ornate jewelry and handicrafts make excellent fodder for close-up and macro photographs.

Dwellings and structures lend themselves to architectural studies. I've attended events where ceremonies and dances could be photographed, replete with colorful costumes. And the Native Americans themselves are excellent portrait subjects.

Your best bet for photographing Native American culture is to do as Pennington did, and wait for a special moment or unusual angle. Use a longer lens and a larger lens opening to allow selective focus to isolate your subject. While focal lengths of 60-125mm (depending on the focal length equivalent crop factor of your camera) are considered "best" for portraiture, I always shoot at least a few at 180-200mm to take advantage of the separation effect. Unless your subject has a very wide face, and is shot from the front, the flattening effect of a longer focal length lens used at a greater distance won't be objectionable. For a profile shot like Pennington's portrait, the distortion is minimal.

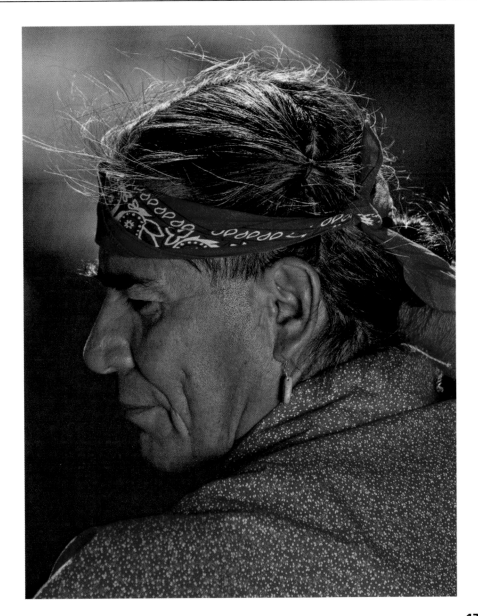

High Fashion Fantasy

SNOW PRINCESS—SHANNON RICE

If you want to move your personal photographic To-Do list out of your comfort zone, try tackling a high fashion photo shoot. A multitude of interesting challenges await you—all of them surprisingly surmountable once you get in the swing of things—and you'll definitely add some interesting and eye-catching shots to your portfolio. Once the high fashion fantasy bug has bit you, you may find that you've discovered a whole new realm of photography that, like landscape or macro photography, can become a passion.

Photographer Shannon Rice has a computer tech "day job," but has been spending more and more of her time shooting portraits, seniors, families, weddings, and other people pictures professionally. Her image of model Tina Grimm (a Cleveland Photographic Society favorite who appears in two

other pictures by other photographers in this book) demonstrates that you don't need to have a glitzy high fashion job to shoot compelling high fashion photos.

For this image, Rice had the services of a professional make-up artist and hair stylist, who gave Tina the full treatment in preparation for this shot. (I'll provide tips on how we mere mortals can gain access to these aides economically in the section "Sultry Glamour" elsewhere in this chapter.) The photographer got in close, using a focal length of 123mm to zero in on the model's face, being careful to focus on Tina's eyes. (Throughout this book, the photographers of people pictures will advise you that focus on the subject's eyes is one of the keys to a successful portrait.) With her Olympus E-500 set to ISO 100, Rice used an exposure of f/11 at

1/125th second with the Alien Bees studio flash units.

The lights were arranged in a setup called butterfly lighting, a basic glamour lighting effect that's easy to achieve, even by beginners. Just place the main light directly in front of the subject's face, and raise it high enough above eye-level to produce a shadow under, and in line with, the nose of the subject, as you can see in the figure. Don't raise the light so high the shadow extends down to obscure your model's lips. The exact position will vary from person to person. If a subject has a short nose, raise the light to lengthen the shadow and increase the apparent length of the nose. If your victim has a long nose, or is smiling broadly (which reduces the distance between the bottom of the nose and the upper lip), lower the light to shorten the shadow.

Position your lights like this:

- ▼ **Main light.** Place the main light directly in front of the subject's face, raised high above the camera. Rice used a large soft box elevated above head level, and positioned it in the direction the model was looking (in this case, almost above the camera itself).

- ▼ **Fill light.** A fill light was used in this case to illuminate the shadows on the face. Locate the fill somewhat lower than the main light (usually directly under it, at eye-level), but with a lower intensity.

- ▼ **Background light.** No background light was needed for this picture (no background is showing!), and in most cases, you'll find a lot of the light from the elevated main light may spill over onto the background, making a background light unnecessary.

- ▼ **Hair light.** If you want to use a hair light, it should be positioned behind the subject at the side opposite the main light.

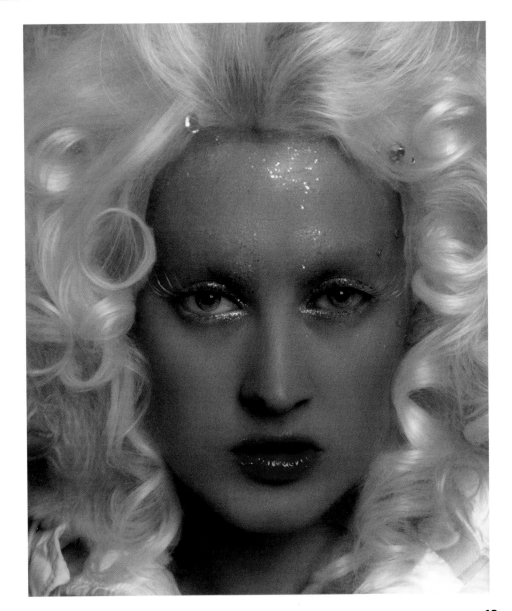

Eyes as Windows to the Soul

THE EYES—SHANNON RICE

If you want to test your photographic "eye," one of the best ways to do that is to zero in on one aspect of your subject matter, isolate it from everything else, and see what your creativity comes up with. If you can evoke the whole spirit of something from just one aspect, you've truly managed to capture your subject's essence.

I've already mentioned several times in this book the importance of imaging the eyes sharply and vividly in your pictures; indeed, the rest of the photo can almost be murky and blurry, and viewers will still remember captivating eyes. (See Nancy Balluck's "Ari" elsewhere in this chapter.) With human subjects, for certain, the eyes are the windows to the soul. Shakespeare said something to that effect in Richard III, but the Bard almost certainly stole the metaphor from some less memorable scribe, and, in turn, passed it down to luminaries

like William Blake and John Greenleaf Whittier. In modern times, we have Shannon Rice and other photographers concentrating on the eyes to the extent that, in this photo at least, we see almost nothing else of the subject.

Rice eschewed the soft fantasy lighting she used in her "Snow Princess" photo for more direct studio strobe illumination that used barn door "flaps" on the reflectors to carefully direct the light to produce bright, contrasty lighting that plays up the texture of the skin, lashes, jewels, and fabric while enhancing the sharpness of her subject's eyes. Her Olympus E-500 was set to ISO 100 at 1/125th second and f/8 with the studio flash, and her zoom was set to 150mm.

The telephoto focal length allowed Rice to get a close-up of the model's eyes from a few feet away, and the f/8 aperture was perfect for this shot. There's

sufficient depth-of-field that the eyes, lashes, and fabric around the nose and forehead are sharp, but the background fabric is out of focus. (See how this selective focus makes the lashes of the model's eye on the left side of the image stand out clearly from the blurred fabric covering her ear?)

Although the eye makeup and jewels applied to the model's face are interesting, the eyes—especially the whites, which are the brightest area of the photograph—are what capture your attention, framed as they are within an oval formed by the fabric. You can't help but notice the subject's gorgeous deep brown eyes, and the catchlights on each iris add a moist, life-like appearance. (Your portraits should always have well-illuminated eyes that include catchlights. Learn to add a realistic catchlight in Photoshop if you need to retouch an otherwise acceptable image.)

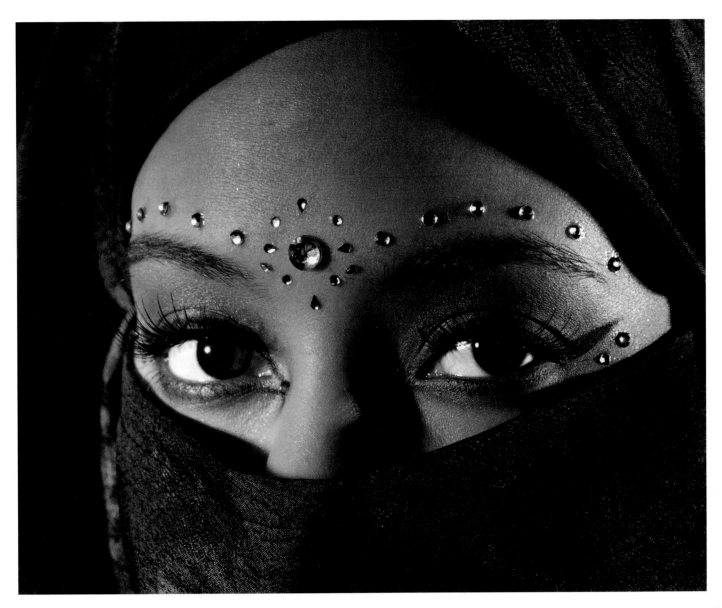

Alternative Lifestyles

Tattooed Entertainers—Ed Rynes

Down through the years, the term *alternative lifestyle* has come to mean many things, starting with the long hair that first seemed to sprout alongside the Beatles and, later, with the hippie movement, to vegetarianism, communes, up through today's punks and goths. Generally, any subculture with many enthusiastic adherents is considered an alternative lifestyle by those who prefer another, less adventurous, way of living.

And even when a particular life choice becomes exceedingly common and accepted—such as tattooing—there are those who take what has become commonplace to the very edge. Entertainers The Enigma and Katzen, both heavily tattooed (to put it mildly) are an eye-catching image just begging to be captured on film (or photons), as recognized by photographer Ed Rynes, who photographed the pair with his

Nikon Coolpix 8800 camera on a screened porch.

You may have seen The Enigma on "The Humbug" episode of the X-Files (I believe he is the only person featured in this book to have his own Palisade Toys action figure!), in other television shows and films, or on tour with Katzen. Rynes photographed the two by softly filtered ambient light on a screened porch. He placed a small strobe on the left and bounced some electronic flash off the ceiling of the porch to produce the basic image used for this portrait. Spot metering determined the exposure for the ambient light, 1/60th second at f/3.1 (almost the maximum aperture of this 8-megapixel camera's built-in 35mm-350mm [equivalent] zoom lens).

As you might guess, the background was added using Photoshop Elements,

specifically, the Gradient Tool, after the background was selected. In any other context, the yellow-orange gradient would have been garish and distracting, but with these particular subjects, it seems as normal and appropriate as posing an attorney in front of a shelf of law books. Rynes finished off the photo with some burning and cloning to fill out a few sections of the image that were a bit washed out.

No matter how staid and reserved your own lifestyle may be, if you have the opportunity to get to know some folks who seem a bit *unusual* (to you), you'll find that when treated with respect they may be eager to have you capture the image their life choices have produced for them. And, if you already hang with members in a particular subculture, you've already got an inside advantage. Remember, lifestyles may change, but photographs are forever.

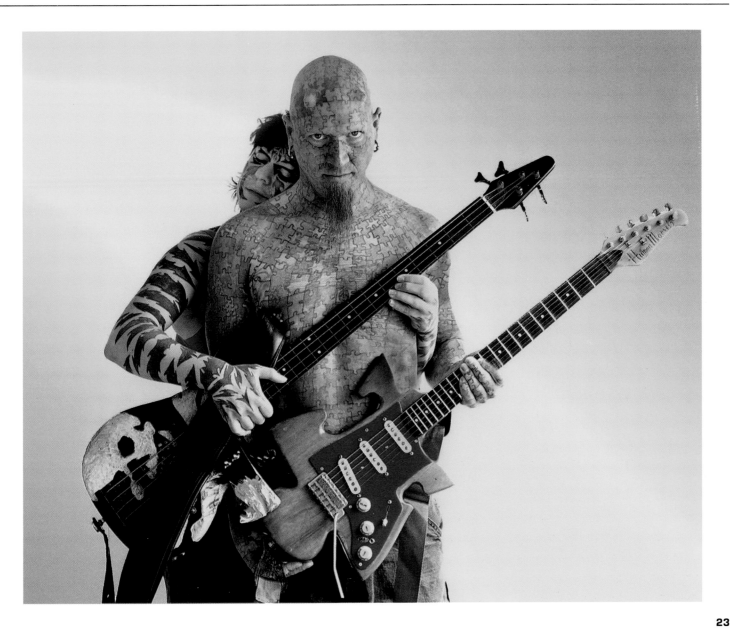

A Quirky Look

GOOFY GEISHA—DALE/JEN SIMMONS

Who needs Photoshop? One of the most remarkable things about this quirky photograph is that it's almost entirely a "straight" image. Photoshop was used to change a sedate background to a more garish (and color-appropriate) purple, but, other than that, this photo is, basically, entirely the non-computer-assisted work of Blackwatch Studios photography team Dale and Jen Simmons, and a supporting cast that included an adventurous model, and an inventive makeup artist who assisted with hair styling. The resulting shot perfectly matches the photo's official title, "Goofy Geisha," as well as the photo team's alternative label, "The One Who Makes Smiles." I hope you'll take this picture as inspiration for creating a "quirky" image of your own for your personal Bucket List.

Although model Rae Gentry (who also appears in two other shots in this book) looks like a somewhat unusual geisha in this photo, her "look" is more akin to the fashion seen in areas around the Harajuku Station in Tokyo, home to the Harajuku style of dress favored by Japanese young people who visit the area. I may be revealing my age, but I know that area chiefly from The Tubes' 1981 hit "Sushi Girl," rather than the Harajuku clothing style (which typically involves an amalgam of several different types of dress, none of which most of us in this country have ever heard of).

"We find the Harajuku style of clothing in Japan to be fascinating. It is so fun and quirky that we knew we wanted to incorporate it into a shoot," report Dale and Jen Simmons. "We began a series of photos depicting an odd Cinderella story, where a nerdy girl makes a dress for the ball with the assistance of her friends, a stuffed mouse, and several sock monkey puppets." The series depicts the process of preparation for the royal ball, culminating in this photo, where the girl finishes her dress, puts it on, and is transformed into a magical Harajuku version of Cinderella. If you research Harajuku style, you'll discover that its followers form a subculture that fits the "Alternative Lifestyle."

As you might guess, an elaborate image of this sort requires hours of effort, but exhaustive prep work is standard operating procedure at Blackwatch Studios. "It's funny, because occasionally we will invite another photographer to spend a day in the studio with us, and many times they are bored from all the waiting while we get ready for the shot!" Dale says. "Goofy Geisha" required a dress entirely made from

scratch by Jen, then hours of makeup work by the late artist Denise Pace, who collaborated with the Simmons on many projects before her passing. Denise and Jen both worked on model Rae Gentry's hair styling, with hours spent before the button on the camera was ever pressed.

Armed with a Canon EOS 40D and a set of Alien Bees studio flash, a series of exposures were made at ISO 100, 1/250th second, at f/13, with a relatively long focal length of 280mm. Rae Gentry worked through a whole catalog of facial expressions for the shooting session—which didn't last a fraction of the time the preparation had taken—and the photographers selected this bemused look as the one they wanted to highlight in the Cinderella series.

After spending so many hours taking the photo, post-processing was a breeze. The color of the backdrop was changed to purple, some of the saturation levels were cranked up to amplify the rich colors of the costume and makeup, and a bit of texture added to give the image a more painterly look.

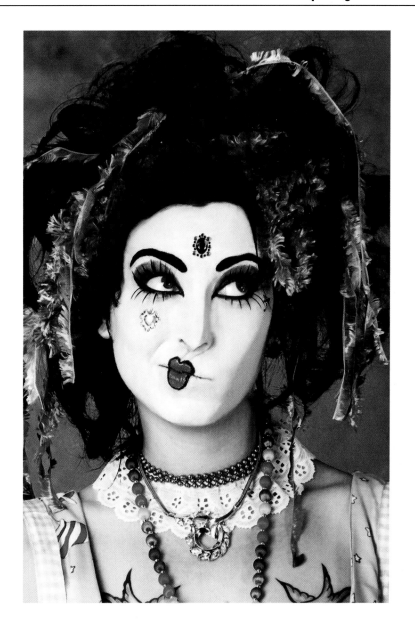

Sultry Glamour

IMPURE THOUGHTS—TONY BERLING

Within the Cleveland Photographic Society, photographer Tony Berling is best known for his remarkable photographs of wolves (one of which appears later in this book). More recently, however, Berling has begun branching out into a less dangerous type of photography—portraits and glamour. This picture, "Impure Thoughts," was selected for the book because it perfectly embodies the kind of photograph that provides a sultry, glamorous look that has definite sex appeal without venturing beyond PG-13 territory. Indeed, this picture is effective because the image leaves so much to the imagination. Model Rae Gentry's facial expression says it all.

Tony Berling's engaging shot was taken in a studio, using a sofa-sleeper that had been moved over to the natural light coming in a window. "For this type of shot I prefer natural light, because it gives a nice softness to the shot. Berling threw a white photo backdrop onto the sofa so it had the appearance of a bed sheet. He snapped away with a Pentax K20D equipped with a 50-135mm f/2.8 lens, using a focal length of 80mm, an aperture of f/4 (to keep the background out of focus), and a shutter speed of 1/160th second at ISO 400.

Studio shots of this type are frequently taken using strobe (with its effective short duration/fast shutter speed). If you do shoot by available light at a relatively slow shutter speed of 1/160th second, you'll want to hold the camera very steady or, possibly, use a tripod. In Berling's case, his Pentax camera has shake reduction technology built into the camera that's quite good, offering at least three stops worth of stabilization in the x and y directions (up/down and side to side) as well as rotational stabilization (if you turn the camera from one side to another while shooting). So, his 1/160th second shutter speed was easily fast enough to produce a sharp picture with Berling's 15-megapixel Pentax. If you use Nikon or Canon equipment, an image-stabilized lens may be your solution when shooting at such slow shutter speeds. When he'd selected a shot he liked, Berling converted the image to a sepia version.

Eventually, there may come a time when you want to take this type of photography to the next level. Perhaps you want to build your photography portfolio with some glamour shots, and want to help aspiring models build their own books. At that point, you'll want to hook up with local groups and clubs (such as the Cleveland Photographic Society) or, better yet, a

reputable online resource that pairs photographers, makeup artists (MUAs), hair stylists, models, and others. Two nationwide organizations that I use include www.meetup.com and www.modelmayhem.com. Depending on where you live, there may already be a Meetup group devoted to photography that includes models or access to models. If not, you can start your own Meetup. Model Mayhem is less generic, devoted exclusively to photographers, models, studios, and others who either are already professional or aspire to be.

Tony Berling's model Rae Gentry can be found on Model Mayhem (www.modelmayhem.com/raeg), as can the talented makeup artist he used for this shoot (Jenna Lowe, www.modelmayhem.com/artistrybyjlowe). "Using experienced folks makes life a lot easier for any photographer. Surrounding yourself with talented people and running a relaxed and fun session where everyone is comfortable will always make a photographer's job much easier to produce incredible shots."

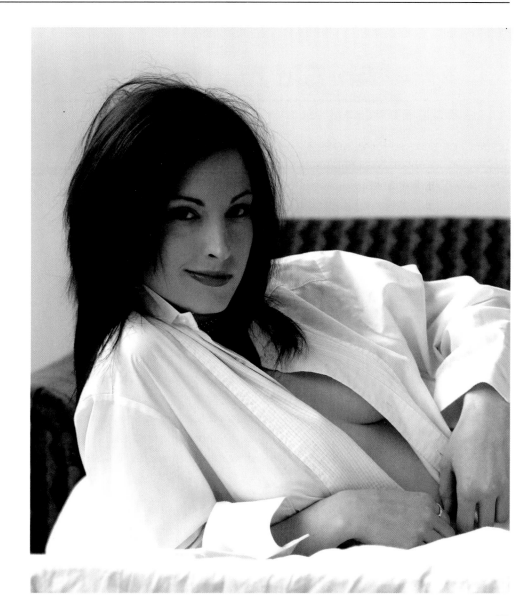

An Old Masters Classic

CLASSIC BEAUTY—DALE/JEN SIMMONS

If you think glamour photography is challenging, try photographing nudes sometime. Dale and Jen Simmons make it look easy with this photograph that mimics the presentation and mood of an Old Masters classic, but that's far from the case in real life.

That makes the Simmons' photo that much more impressive. All the elements—lighting, posing, facial expression, and an overall concept—all came together to create a timeless shot. If a great nude photo is on your Bucket List, you could do worse than to come up with one like this.

For this photo, the Simmons' goal was to make a photo from what they call "magic." "The same magic that the Old Master painters had, which is why we named it as we did. The only way to get this kind of magic is when the artist sees the model as the most beautiful

girl in the world, both inside and out. And from her perspective, the model has to *truly* want to be there; trust the artist implicitly; be very relaxed; and adore the artist's work!" Dale says. "This all blends…and magic is made!"

This portrait of Tina was made timeless by the use of lavish textures and earth tones in the scene's set. The Simmons' posed her in a classical pose similar to those used by painters throughout art history. "We studied the elements of classical nudes, and attempted to re-create the mood and compositional feel of those paintings that we were most drawn to," Dale notes.

A Canon EOS 40D, a zoom setting of 56mm, and an exposure under studio strobes of 1/250th second and f/11 at ISO 200 captured the image. The

photographers note that most people who view the picture would be surprised at how close the finished image was to what actually came out of the camera. They did only minor retouching and color correction, and a bit of sharpening.

"Then, even though the pose made this image look like a classic painting, we wanted to push it a little further," Dale says. "We applied a few filters to give it more of a painted look. We can't remember which ones we used but for a look like this it is likely that we used surface blurring, a dry brush effect, or a combination of the two." He says that it is important to become proficient with Photoshop Layers, especially the opacity and Layer Masks when using Photoshop filters, as "no filter is perfect the first time you apply it."

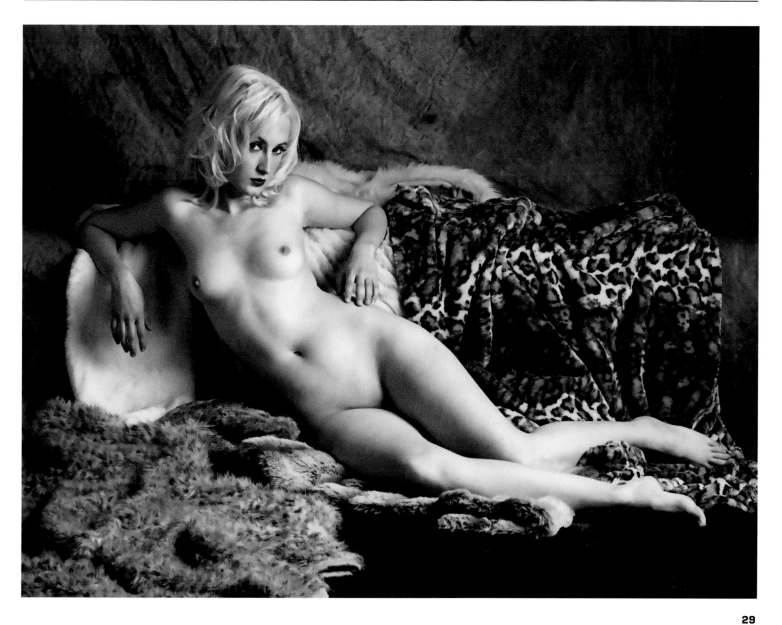

An Intimate Self-Portrait

Self-Portrait—Nathalie Lovera Snyder

Let's ramp up the difficulty level even one more notch. Glamour photography and nude photography made my list of Bucket List suggestions not because they are easy, but, in the words of JFK, because they are hard. That's why I'm more than a little jealous of the photographers in this book who seem to tackle photographing women and men almost intuitively.

That's why photographer Nathalie Lovera Snyder's intimate portrait of herself, tastefully and glamorously nude, is such an impressive accomplishment. After looking at this picture and some of the fine self-portraits that accompany the author bios in this book, I'm urging you to undertake this challenge yourself. Clothed or unclothed, a picture of the photographer, taken by the photographer, can be extremely revealing.

Snyder is letting her own self-portrait do most of the talking on her behalf. It shows her in a pensive mood with arms and legs strategically arranged, and a spider ring on her left ring finger as the only adornment. This is a classic pose that I think I first saw on the cover of a photography magazine several decades ago, but it's still an effective arrangement. The photographer reports that "I was just experimenting with nude photography/self-portraits, and set up one main light to the left side, and a second light a little further back on the right." She placed a fill light bounced off an umbrella right behind the camera, and used a self-timer to trigger the exposure after she'd gotten into position.

Of course, a self-portrait isn't quite that simple, either technically or compositionally. From a technical standpoint, posing is probably easiest if you use a mirror to see how you're arranged and how the shadows and highlights are falling from your light sources. The best solution is to hook up your camera to an external monitor, preferably installed roughly at camera position, so when you're facing the monitor to check out your pose, you're also looking towards the camera lens.

A camera's self-timer is definitely not the best way to trigger the shot, because, with many cameras, you must jump up and reset the timer after each picture before you can take another. A little better are the self-timers found on some camera models that can be set to take several photos a few seconds apart after the delay has elapsed. I tend to use a radio remote to trigger the camera/studio lights, holding the control in my hand.

Those nuts-and-bolts details are the easy part. More difficult is deciding how you want to portray yourself, and how much of yourself and your personality you want to reveal. Your choice of personal image is probably as revealing as the final photograph itself, as you can see from the portraits of the photographers contributing to this book, arrayed in Appendix A. You'll find a variety of styles. If my arm is twisted, I can be forced to admit that my personal favorite, other than Nathalie Snyder's self-portrait featured here, is the photograph of himself that John Earl Brown submitted for this book. No offense to the other fine photographers represented, but having had the chance to know John Earl for awhile, I can attest that he really *nailed* the guy.

And, if you choose to put a portrait of yourself on your personal Bucket List, that should be your goal. If someone who knows you sees the photo and is convinced that you've really captured your own spirit and flavor, then you've nailed it, too.

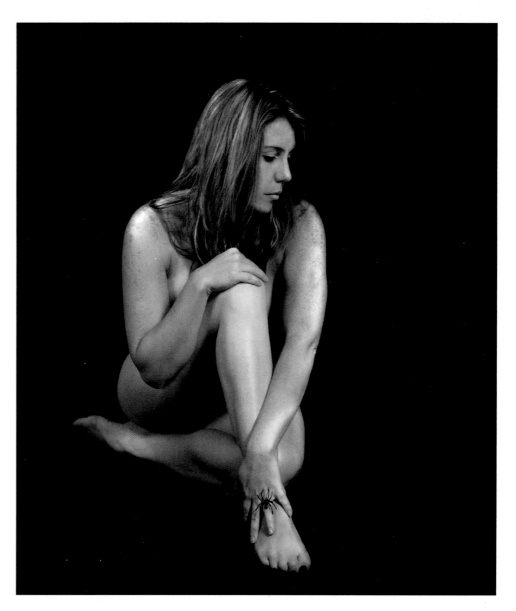

Old-Time Glamour

Vogue—Dennis Goebelt

You never hear anyone say, "They don't take glamour photos like they used to!" because certain kinds of pictures not only never went out of style, they're gaining new fans as the latest generations of photographers rediscover Hollywood glamour, as captured by Dennis Goebelt's great image titled "Vogue." The young woman in this picture reminds me of the famous publicity photograph of Jane Russell ensconced in a haystack for the 1943 movie *The Outlaw.* There's more hay and less clothing in this rendition, but the glamour is still there in full force.

There's a lot to be said in favor of old-time glamour photography. It has the simple innocence of an earlier age, and captures the power of nostalgia on several different levels. Those who lived through an era recall it happily, those who wish they'd been alive then can experience the attitudes and values of an earlier time, and anyone who is finding an old-time epoch for the first time can discover what made something popular in the first place. Old-fashioned glamour is a suitable objective for anyone looking to add some variety to their photography Bucket List.

Goebelt says that "Vogue" was produced during a "Fall Season" shoot at his studio. "My subject was one of my favorite models: Ms. Saliese Anne Funk," Goebelt says. "Her natural talent requires only minimal direction. She instinctively knows what to do for the lens. Shooting with a great model makes the photographer's job a lot easier!"

He used a basic two-light setup with one umbrella and a large softbox providing the illumination. The final image didn't require a lot of editing in Photoshop. Goebelt did some selective blurring and sharpening, and a bit of discreet "rearrangement" of the straw in some areas, but not much else.

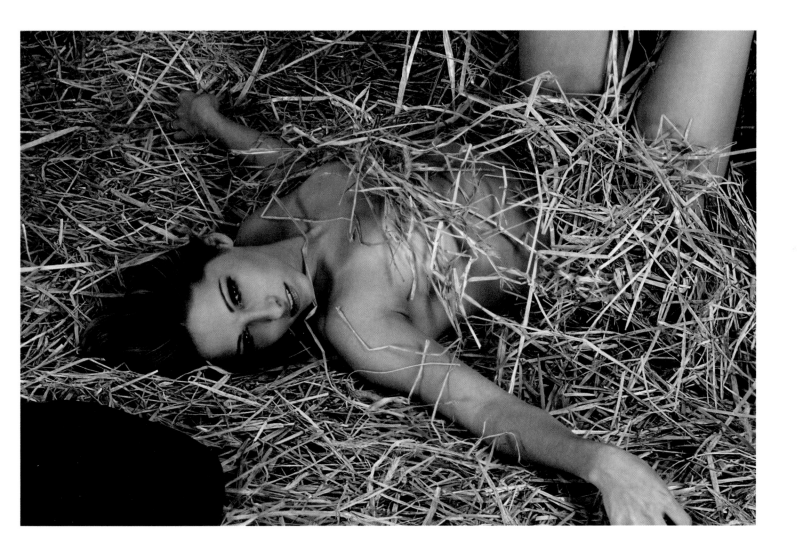

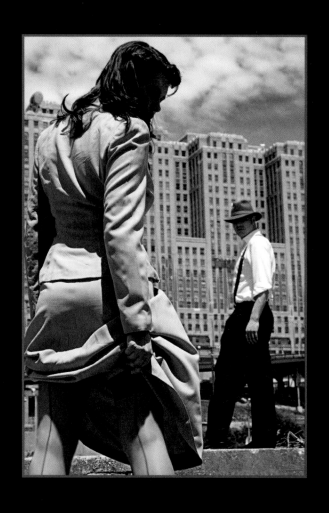

2 Special Moments

As you progress on your photographic journey through life, you'll encounter—or create—a variety of special moments that you'll want to capture. These moments can easily make your personal "all-time best" list. Some involve milestone events in the lives of you or your loved ones—a new baby, a wedding, a child's first steps. Others are events that you seek out, such as thrilling moments at a concert by one of your musical idols, or fantasy scenes that you create yourself. If you already haven't captured a scene like these in your photographic career, you'll want to be on the lookout for opportunities like those pictured in this chapter. There are many black and white images here, which wasn't intentional; it just happened that many of the featured photographers decided to create images in monochrome. You'll also find lots of photographs of children in this chapter, as many special moments revolve around them. But you'll discover a few surprises, too.

An Homage to Noir

LISTENING IN/A TENSE MOMENT—DALE AND JEN SIMMONS

Reproducing a memorable photographic style can be an exciting outlet for creativity, as you can see from this pair of photographs by the photo team of Dale and Jen Simmons. They draw on the look of film noir classics like *The Maltese Falcon*, and the covers of noir detective novels of the 1940s and 1950s to create a pair of riveting images steeped in nostalgia and mystery.

"Listening In," shown in this page, was the Simmons' second serious attempt at shooting the "noir" genre. "We try very hard to pre-screen models to find ones who will throw their shyness out the window and act out parts at our direction," Dale says. The scene depicts

what the pair describe as the classic story of the dark-haired secretary who loved the private eye… and then trouble walked in with her blonde hair…garter belt…and of course her sad story.

"To set the scene up we moved our studio desk into the changing room so we could shoot through the door and have it look like an office. We added an old-fashioned lamp and camera to add to the time period," Dale recalls. He says that there is actually a 1940's-era typewriter on the desk but it is hidden from view. The lighting on the back wall was accomplished using a studio strobe, in the tiny changing room, behind a set of blinds hung between two light stands.

"A Tense Moment," shown on the next page, tells a story of its own. "Looking at this photo it is difficult to tell if the femme fatale is simply straightening her stocking or whether she is about to pull a knife or gun on the detective!" Dale Simmons notes. He says, "The key to re-creating a photographic style is authenticity in the details. When we did 'Film Noir' themed images, we purchased vintage clothing on the internet

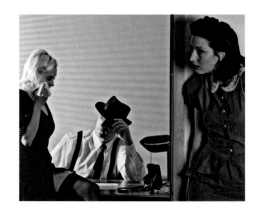

that was from the 1940s, and used authentic vintage back-seamed stockings. We also pay a great deal of attention to the background elements."

Dale and Jen studied movies from the time period to get a feel for the camera angles and shadowy elements used by the cinematographers, which helped to set the mood. For this photo, the pair scouted a great cityscape the day before, "looking for a gritty Gotham." The site is actually Tower City in Cleveland, taken from a less traveled location down by the Cuyahoga River. The image is composed around three levels of depth, with the cityscape in the background, the detective in the middle, and the mysterious lady dominating the foreground. Getting the "larger than life" point of view required lying in the gravel and shooting at an upward angle. A Canon EOS Rebel XT was used for this shot, with an exposure of 1/200th second at f/11 (for sufficient depth-of-field at the 50mm focal length used) and ISO 100.

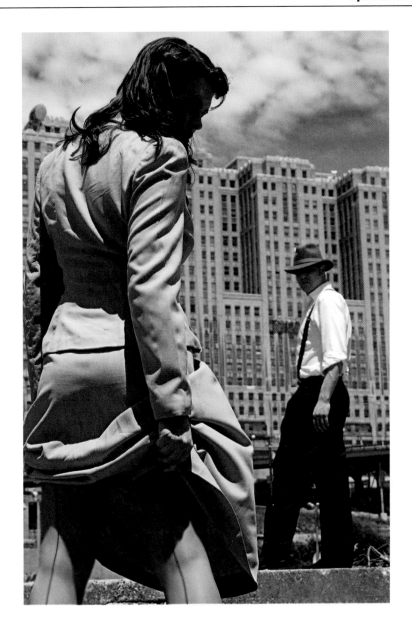

A Living Legend in Concert

"Doctor" Ralph Stanley—David Busch

It was an evening I'll always remember. Bluegrass legend Ralph Stanley had already mesmerized the audience with his Grammy Award-winning rendition of the Appalachian dirge "O Death," from the cult film "O Brother, Where Art Thou?" But minutes later, when he strapped on his custom-made instrument for the only number on which he played banjo that evening, the crowd went wild. Dozens of worshipful fans rushed the stage to snap photos. Others stood up to get a better look as the octogenarian's—whose career dates back to the days of Bill Monroe—fingers flew over the keys, erasing any doubt that they'd lost any dexterity over his 60-year career. Amid all the hub-bub, I was fortunate to capture this shot.

I'd photographed musical legends before, from Janis Joplin to B.B. King, but Stanley's performance was something special. I was pleased to move the "Living Legend" task over to the "Done" column of my career "To-Do" list.

Concert photography is challenging from several standpoints. One hurdle is simply gaining access to photograph your idols. Mick Jagger or any of his bandmates is certainly a living legend, but you'll need powerful press credential mojo to cop a shooting position anywhere in the same Zip code with these kings of the arena. I photograph more than a half-dozen different Grammy Award-winning acts each year, but concentrate exclusively on appearances at smaller, more intimate venues, including a few where I am a regular and stage-front access is easy to obtain. I also enjoy photographing legendary performers who happen to be doing solo tours, or who have left the groups that made them famous. Denny Laine without Paul McCartney and Wings? Mick Taylor or Jack Bruce after they left The Stones or Cream (respectively)? Former Byrd Roger McGuinn? All easy pickings.

Not so easy is grabbing a decent shot under contrasty stage lighting. I shoot so many concerts that I end up standardizing on a particular set of techniques. Because I write camera guides for both Canon and Nikon cameras, I know that full-frame models like the Canon EOS 5D Mark II and Nikon D3/D700 (which I used at the Stanley concert) have big fat pixels with lots of light-gathering power. They can all be used at concerts at sensitivity settings up to ISO 3200, although I typically use ISO 800 to 1600 unless the lighting is extremely dim. Those ratings let me shoot at 1/80th to 160th second at f/2.8 or f/4 with a 70-200mm f/2.8 zoom lens cranked out to 135-200mm for most shots.

The secret to being able to use such slow shutter speeds is good timing, and making sure the image stabilization/vibration reduction feature of the lens is turned on. I used to shoot concerts with the 70-200mm lens mounted on a monopod, without stabilization. But I found that the anti-shake features of the lens did a better job of thwarting camera motion, and timing my shots to avoid shooting when the musician was turning, twisting, or moving rapidly allowed sufficient action-stopping at 1/80th to 1/160th second. Indeed, those shutter speeds allow flying fingers of musicians to blur a little in interesting ways.

With a long lens shot nearly wide open, careful focus is a must to take best advantage of the shallow depth-of-field. I leave autofocus on, and make tiny corrections by nudging the focus ring of my zoom with the first two fingers of my left hand. Concert photography requires a bit of technique and coordination, but it's really nothing compared to the magic of "Stanley-style" banjo playing.

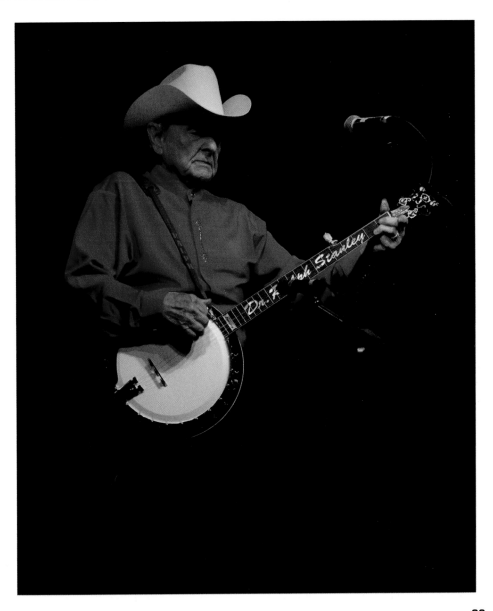

Unconditional Love

SMOTHERED WITH LOVE—KATHLEEN NELSON

While everybody loves a cute baby, unless you're the parent, most of them tend to look pretty much alike. So do most baby pictures. One problem is that the average photo tends to show nothing but the baby, often in an unnatural position as if they were propped up for a department store quickie portrait. A truly memorable photo of a child will show the kid's relationship to the new world which he or she is just beginning to discover. A baby reacting to a puppy, kitten, older sibling, or, in this case two adoring parents makes a much more appealing shot.

Kathleen Nelson claims that she "didn't use any special techniques" to grab this charming image, but, in truth, recognizing that the baby was in a happy mode and then asking the proud parents to plant a kiss on his rosy cheeks is a technique that many casual photographers overlook. The response of the baby to the unexpected attention makes this a photo that will be memorable for a lifetime.

"I took a number of images, but this was my favorite," Nelson says. "It's actually one of my all-time favorite images, and it makes me chuckle whenever I see the bewildered expression on the baby's little 'squished' face." The

photographer shot with a Canon EOS 5D equipped with a 24-105mm image-stabilized lens, set to a focal length of 28mm (which is quite wide on this "full-frame" camera). The ambient light in the room called for an exposure of 1/200th second at f/8, but Nelson augmented the illumination by bouncing a Canon 580 EX electronic flash off the ceiling.

She cropped the image and boosted the exposure in Adobe Lightroom 2.0, then made some selective tonal adjustments in Adobe Photoshop CS4 to even out the skin tones. ("The father had a much deeper skin tone, while the baby's skin was very light," she says.)

Wedding Magic

FOCUS ON LOVE/NEW BEGINNING—ISABEL MARTINS

Aside from, say, capturing the first human footsteps on the Moon, few photographic endeavors have such high stakes as wedding photography. Even though marriages themselves may not be the once-in-a-lifetime events they once were, each ceremony is still a special moment that can't be repeated or restaged, and absolutely *must* be imaged perfectly by the photographer on the first attempt. The best wedding photographs must capture an ephemeral moment, embody the romantic dreams of the bride and groom, while offering pleasing memories for family and friends. You may not aspire to become a wedding shooter, but, as an avid photo fan, you'll probably be asked to take some "special" photos at the nuptials of a relative or friend, either as the main photographer or as a supplement to the paid professional. You may simply want to add a

great wedding photo to your personal digital photography Bucket List.

Isabel Martins was originally a nature photographer, so, "for my wedding photos, I tend to prioritize outdoor settings, surrounded by the kind of nature scenes that give me room for creativity," she explains. "I get better results and consequently the session is more rewarding."

Martins likes to check the outdoor settings at or near where the wedding or reception is in advance, mentally picturing the poses she'd like to take, so that, on the event day, she already has in mind what she wants. She also has an alternative site handy in case the weather changes, or another unexpected occurrence takes place. She likes to use spontaneous moments and explore them to their fullest potential.

For the photo on this page, "Focus on Love," she used a Nikon D200 with a focal length of 40mm, using an exposure of 1/60th second at f/4 and ISO 200, taking advantage of the shallow depth-of-field at that wide aperture to provide a basic blur of the background. A strong blur filter diffused almost the

entire scene, except for a sharp area in the middle, centered around the couple's faces. The large photo on the opposite page, "New Beginning," was taken with the same camera and similar settings of 1/45th second at f/3.5 using a focal length of 50mm.

Most wedding photographers I know, mindful of the "failure is not an option" nature of this genre, carry at least one extra camera body, multiple electronic flashes (if used), zoom lenses with overlapping focal lengths so that one can sub for another if necessary, and take great care when handling the photographic "originals." It's common to have an assistant copy memory cards to a laptop computer right at the ceremony, and even more common to use a "second shooter" to provide additional and backup photographic coverage.

Indeed, wedding photography has it all: creative opportunities, fast turnaround, high pressure, and the most demanding of clients. Add a great wedding photo to your career "best shots" list, and you can be proud, indeed.

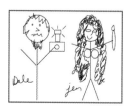

Growing Up

DANCE CLASS—DALE AND JEN SIMMONS

For kids, special moments come at life's milestones—those first steps, first days of school, and those first tentative attempts to gain special skills. For parents and youngsters alike, kiddie dance or martial arts classes, beginner music lessons, that first tee-ball or soccer practice, are all precious times that can be effectively captured as unforgettable images.

Dale and Jen Simmons recognized the possibilities when asked to photograph a class at a Cleveland dance school for an advertisement. The shooting conditions themselves were a particular challenge. "It was everything you wanted out of a shoot," Dale remembers. "Low light, subjects who couldn't stand still to save their lives. No image-stabilized lens to compensate for camera shake. I must have had a steady hand that day."

The photographic team had just finished their intensive study of the *noir* genre of cinematography, and the concept of having the main subject—a little girl—in the foreground, and a secondary subject—in this case, her teacher—in the background still resonated. "We took some pretty standard pictures, but then we decided to get creative, and apply some of the compositional elements of the noir style to a subject that was very much *not* noir in nature—and it came out wonderful!"

Although the instructor can be seen stretching in the background, the emphasis is on the pensive little girl, accentuated by the low angle. A wise mentor once recommended shooting photographs of children, down low, from their own level. Such an angle allows you to see the world from their viewpoint, which can be a revelation.

Ordinarily, the little snippet of another class member, seen at the right edge of the image, would be considered bad form, or even an unwanted merger. But, in this case, I think the almost-unseen participant adds a bit of framing to the little girl, the right side of a triangle formed by the poster above and teacher at left that echoes the triangular shape of the girl herself. My favorite film director, Akira Kurosawa, frequently used triangles in his compositions to add a little tension to the frame, and relied on squares to indicate

a static arrangement. In this quiet moment, the shapes keep the image from being stagnant, and lead your eye into the center of the frame.

The finished shot does have a slightly nostalgic look, thanks to its muted sepia tones, with a pink overlay highlighting the young dancer's costume. Back in the late '40s, early '50s, hand-colored black and white photographs were all the rage (full-color portraits didn't establish themselves as the norm until about the time the Beatles arrived). So, this photo has a lot of the same hand-painted quality that gives it a particularly dreamy appearance.

Even at ISO 800, an exposure of 1/30th second at a wide f/5.6 aperture was needed with the 53mm focal length used. The toning was done in Photoshop, where a pink layer was added on top of the sepia image, and then a blurred overlay added to provide the fantasy aura for the photograph.

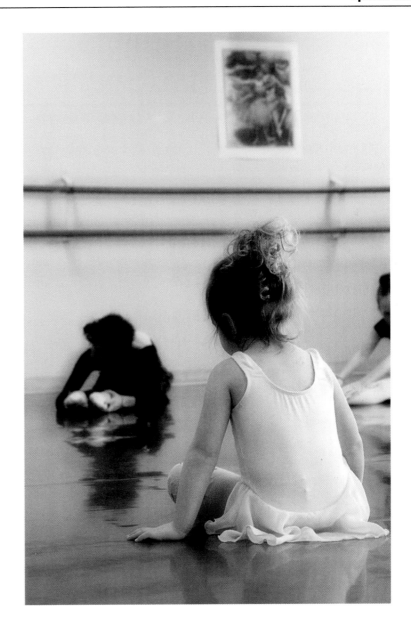

A Child's Anticipation

WAITING FOR DADDY—NATHALIE LOVERA SNYDER

As a parent, I can say that one of the most special things about raising children is that brief decade during which your kid actually likes you. Until the teenage years approach, most youngsters like almost nothing better than doing stuff with either or both parents, even despite competition from Spongebob or, in the case of my own brood, Power Rangers and Ninja Turtles. So, any parent will fall in love with a photograph like Nathalie Snyder's "Waiting for Daddy," which captures that precious time when a father's coming home is a big event. Such a picture makes a wonderful souvenir that parent and child can laugh over when the offspring eventually reaches the age of 25 or so and discovers that Mom and Dad weren't quite

the ogres the teenage years made them out to be.

Snyder was doing a photo shoot of a friend's baby. The infant's big brother, Evan, had his nose pressed up against the glass of a window, waiting for his father to come inside. "I turned around and saw the lovely natural light hit his face and create that reflection on the window," Snyder reports. "I just had to take the shot."

"Waiting for Daddy" is an impromptu, if imaginative, portrait, and, as such, Snyder has used one of the classic portrait lighting techniques—window illumination—which actually predates photography by a number of years. Old Master painters, most notably Rembrandt, used the window and ceil-

ing lighting of their studios to illuminate softly-lit portraits with rich shadow detail to augment the soft dramatic lighting.

In this case, the photographer adds an interesting wrinkle, because her young subject is so close to the window glass that his reflection adds an interesting mirror effect. One of several black and white images in this chapter, this one uses monochrome to strip away all the elements of the image except for the young boy, his reflection, and the window he's looking through with rapt attention.

Snyder wielded a Canon EOS digital SLR for this photograph, which meant that the 58mm focal length she used is

equivalent to the full-frame 85mm-95mm range considered ideal for head-and-shoulders portraits of this type. The sensitivity setting of ISO 400 called for an exposure of 1/100th second at f/2.8 handheld. The wide aperture provided the limited depth-of-field that the photographers featured in this book tend to favor for their most intimate photos, and in this case the shallow focus (and lighting) de-emphasized distracting details in the background (note the youngster's right hand resting on the window sill). Soft light coming through a window can produce a rim-lighting effect that's often quite nice, but in this case, the photographer used the camera's built-in flash as fill to illuminate the left side of her subject's face. The balanced lighting creates a touching image of a young fellow caught up watching his father approach the house.

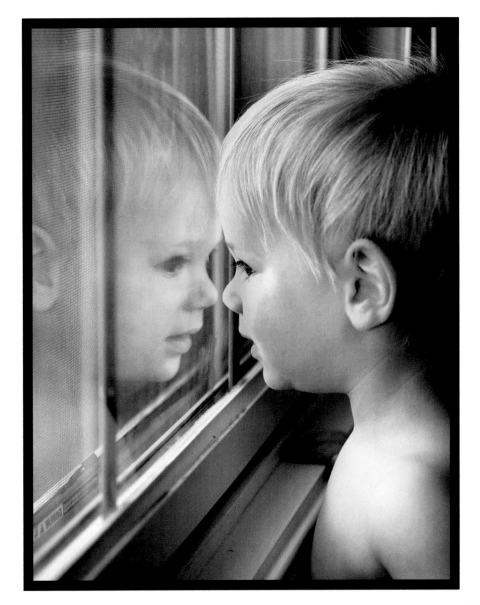

Spanning Generations

HELPING HANDS—JIM FRAZER

An older person's hand resting on that of a younger person's has been used before in photographs that represent the spanning of generations, but in this case the technique has quadruple meaning. Awesome! The photo was taken during an event at a booth with the theme "Helping Hands," and shows the older woman offering a helping hand to the young girl as she plants her handprint on a canvas.

The image also symbolizes the helping hands across generations and, if that weren't enough, the picture was taken during the Cleveland Photographic Society's Community Service Projects, where the organization volunteers to provide illustrations for groups who need them for their brochures and

other publicity. Another recent activity was the "Homeless Stand Down," during which informal portraits were taken of homeless people, who were provided with free prints.

"This photo was taken during the Society's project to aid a local non-profit organization," Frazer says. "It was taken at a booth themed 'Helping Hands,' where participants showed their support by adding their hand-prints to a large canvas." The area around the exhibit was crowded with bustling children, all eager to dip their hands in paint, and then "sign" the canvas with their imprint. Frazer says it was a challenge just to get a clear shot (an "extra" hand is shown at lower right in the photo).

The photographer snapped the photo using an Olympus E-510, a "Four Thirds"-format camera with a 12-60mm f/2.8-/4.0 zoom lens that's the equivalent of a 24-120mm zoom on a full-frame camera. At ISO 400, center spot metering, which measures two percent of the image area in the middle of the frame, called for an exposure of 1/400th second at f/3.8.

Post processing of the RAW image began in Lightroom. Frazer cropped it from its initial portrait orientation to landscape so that the focal point was on the child. The image was then converted to black and white, and converted to a TIF file for further processing in Adobe Photoshop Elements. The photographer added some vignetting and sharpening.

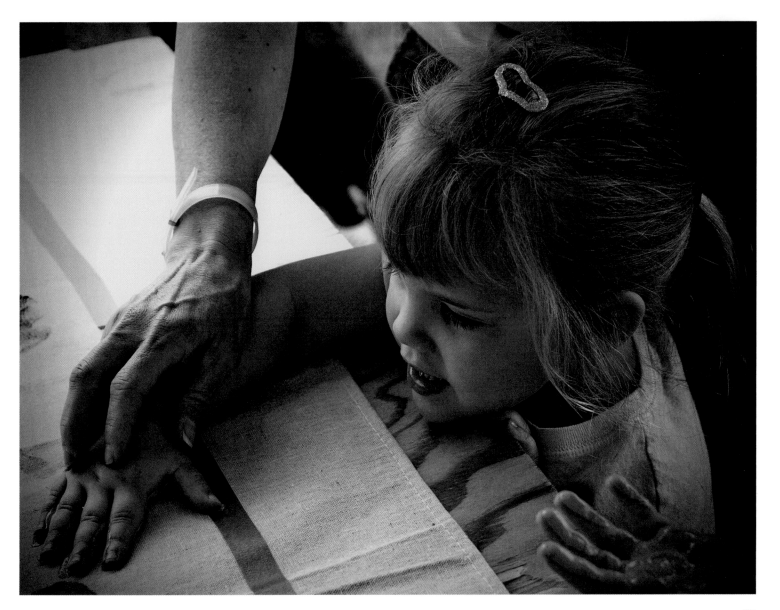

A Still Life—With Human

WINE GIRL—GEORGE SIPL

Still life images date back to the tombs of the Egyptian pharaohs, where their depictions of food and drink were thought to provide nourishment for the deceased ruler. More recently, still life compositions have been prized not for the tasty tidbits, potent potables, or other objects they portrayed but for the flexibility they provide the artist/photographer in arranging the subject in attractive (and often allegorical) ways. Unlike portrait subjects, the still life is often more pliant and a good deal more patient.

With his image "Wine Girl," George Sipl combines the two to give us two images in one: a still life image of a wine bottle, carafe, and glass, accompanied by a pensive portrait of a young woman. While the wine elements take front and center, the young lady is looking off to the right, making us wonder exactly what she is thinking.

In truth, she's probably not thinking about wine, because this two-images-in-one photograph actually *is* two images in one, having been cleverly merged by Sipl from a pair of separate images, creating a tightly composed composite from two different shots. The merger is obvious once you know exactly

what to look for. The wine glass in the foreground is in sharp focus—the carafe less so, and the wine bottle at the rear is entirely blurred from the shallow depth-of-field. Yet, the young woman's hair part and left eye, located *behind* the bottle, are sharp.

While it would have been possible to selectively blur parts of a single image that happened to have exceptional depth-of-field, that's not the case here. "The girl was photographed with one diffused light from a constant source," Sipl explains. "The wine bottle and glass were taken at a separate time. I combined the two images using Photoshop." The originals were taken

with an Olympus E-3 at 1/250th second at f/6.3 and ISO 800, with an Olympus 70-300mm lens set to 141mm (the equivalent of 282mm with this Four Thirds format camera).

The photographer applied skin smoothing to the young woman's face using the Gaussian Blur filter in Adobe Photoshop, and details of the bottle were softened using the Healing Brush to better fit the composition. The final image was converted to black and white and selectively sharpened using Nik Software. The combined images offer a photograph that's more than a simple still life, and more than a portrait, combining the features of both types of picture and an element of mystery.

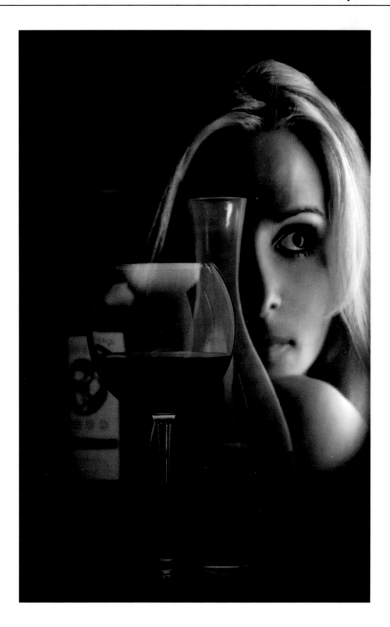

The Power of Nostalgia

REMEMBER WHEN—SHANNON RICE

Shannon Rice's third photograph for this book, "Remember When," shows how nostalgia captures the imagination of so many photographers, both old-timers like myself, and talented younger shooters like Rice, a child of the 1980s. Although neither Rice nor her model were alive when folding cameras might have been used to take a self-portrait, this image captures the look and mood of the era perfectly (so they tell me!).

Everything works in this image, from the hairstyle to the vintage clothing look, to the makeup, pose, and the battered old camera, which probably would have been handed down from generation to generation in those days. The photo's warm look is rich in nostalgia. Sharp eyes might note that no roll film frame number is peeking through the circular window on the back of the camera, and that the model's ears might have been pierced a few more times than was typical in those days, but most viewers will be so absorbed by reminiscing that they will scarcely notice an anachronism or two. I personally like the plain background, which tells of a young woman who stood in front of a blank wall to take a self-portrait, perhaps to ship off to a boyfriend fighting in a distant war.

Rice is fully immersed in people photography these days, both in environmental and studio surroundings, and this one, despite its casual look, was taken under controlled circumstances, in a studio using clamshell lighting, with speed lights bounced into umbrellas positioned at top and bottom. The photographer said she focused on the camera itself, rather than her model, to emphasize the "picture-taking within a picture-taking" nature of the image.

She used her Olympus E-500 camera, with lens set at the 40mm zoom setting (equivalent to 80mm with this Four Thirds camera and its 2X "crop" factor).

An exposure of 1/40th second allowed the ambient light in the studio to fill in shadows while the speed lights provided the main exposure. The ISO 125 sensitivity setting allowed using an aperture of f/3.5 to minimize depth-of-field and focus attention (so to speak) on the camera the model was holding. Rice says that very little post-processing was needed. "Just a little clean-up, and conversion to monochrome," she recalls.

If an old-timey photograph has made it onto your personal photographic Bucket List, you'll want to pay the same attention to detail that Shannon Rice did, combining authentic-looking clothing, hair styling, and makeup of an era, with suitable props, and appropriate pose and, most important of all, the right attitude.

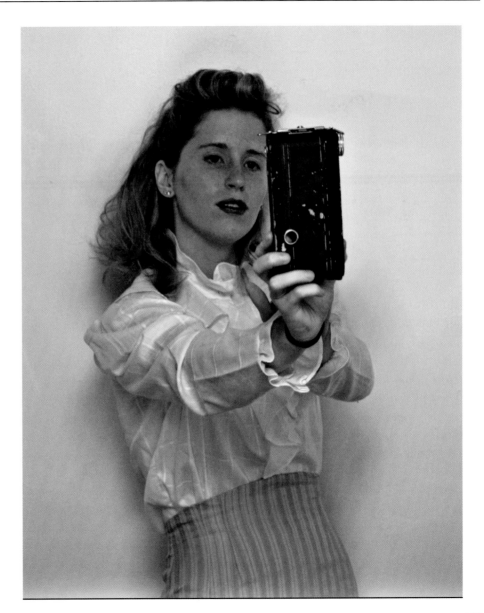

3 Photojournalism

As the name suggests, photojournalism combines two crafts, photography and journalism, to provide images that somehow tell a story. That photographic narrative must incorporate three important elements to qualify as true photojournalism. The picture-story must be *objective*, providing an unbiased and accurate representation of the event or scene that has been captured. In professional photojournalism, the slightest manipulation of an image—even cropping—is forbidden if it alters the reality of an image. But objective does not mean that the image can't have a message. Photojournalism that shows the face of poverty—like at least one picture in this chapter—can rouse our feelings through its realistic and unmanipulated representation.

Photojournalism must also be *timely*, in the sense that the image relates in some way to an event that happened at roughly the same time that the photograph was taken. Timeliness doesn't mean that after some particular moment has elapsed, the picture no longer qualifies as photojournalism; the original image simply must be contemporaneous with the event it relates to. Mathew Brady's Civil War photographs can be considered photojournalism; the shots you took last summer at Gettysburg probably are not (unless they have some context with a recent event there).

Finally, photojournalism must provide a *narrative*, and tell a story of some sort. You don't need to wrap up a saga in a single photo, or even in a series. But the image should have some context that connects it to the facts of an event or scene that the viewer can relate to.

I'm applying these rules rather loosely for the images selected for this chapter, because only a couple of the photographers represented here have actually shot photojournalism professionally. But all these pictures represent the kind of story-telling images you can aspire to as you assemble your own personal Bucket List of pictures to shoot for.

Always Faithful

MARINE TRUMPETER—KOLMAN ROSENBERG

Photographer Kolman Rosenberg spotted this U.S. Marine Band trumpeter, sweat pouring down the sides of his face, and immediately thought of Ed Clark's iconic *Life* magazine photo of Navy CPO Graham Jackson, tears streaming down his cheeks, as he played the accordion while Franklin D. Roosevelt's body was taken away. Rosenberg's "Marine Trumpeter" captures the spirit of the few, the proud, and the superb musicians who also happen to serve in the military.

Although many members of the Cleveland Photographic Society shoot photojournalism from time to time, Rosenberg is the group's "go-to" PJ guy because of his love for and long experience in the field. He was ESPN's go-to guy as well in August, 2009, when more than a dozen and a half of his still photos, most in black and white, were used to illustrate a memo-rable video story on Sports Center about two area high school wrestlers—one blind, and one an amputee—who define the meaning of friendship. (At this writing, the clip can be seen at http://sports.espn.go.com/espn/otl/news/story?id=4371874.)

Rosenberg's photo of the Marine musician was shot at a "Take Pride in America" celebration in Northeast Ohio. "I was photographing the U.S. Marine Band while they performed in the football stadium. It was dusk and I found that I needed to increase my ISO to 800 in order to get the exposure that I was looking for to stop the action. I was shooting in RAW."

The photographer cranked the 200-500mm Tamron zoom mounted on his Nikon D200 all the way out to 500mm, and shot wide open at f/6.3 and 1/400th second. That exposure allowed a sharp image of the trumpeter, put the musicians in the background out of focus, and froze the motion of the soldier's flying fingers. Because the lens and camera were mounted on a tripod, camera motion, too, was minimized at a shutter speed that's really marginal for the seven-pound camera/lens combination.

Rosenberg's choice of ISO sensitivity and exposure settings harks back to the golden age of film photojournalism, when Tri-X Pan (one of Rosenberg's favorite films, and a PJ standard) would be shot at ratings of E.I. 800 to 1600 just to make a shot possible. "I would encourage photographers to increase their ISO when necessary to get the shutter speed and aperture they need," he explains. "Digital noise may be an issue, but it's better to get the image with possible noise, than to not get a useable image at all."

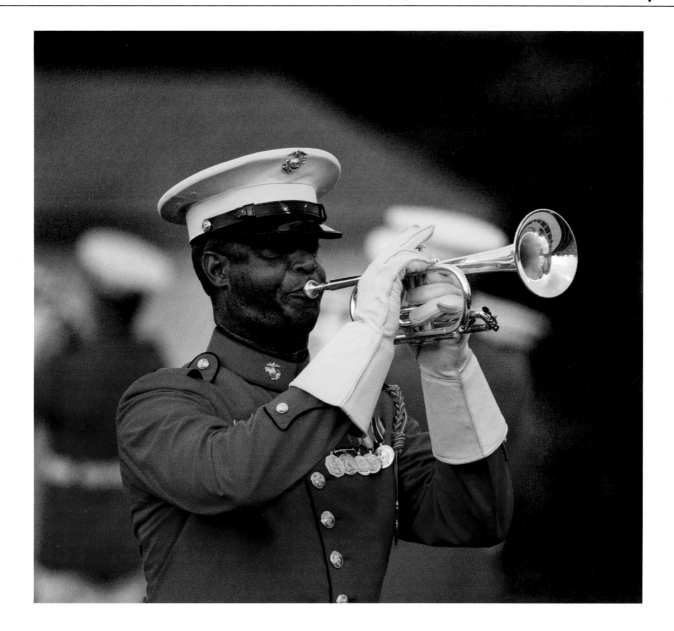

9/11 Aftermath

REMEMBER OUR HEROES—JAMIE UMLAUF

Sometimes, the repercussions of an event can be moving, too, long after the event itself has transpired. Photojournalism coverage of the September 11, 2001 terrorist attack on the World Trade Center didn't end in 2001, of course. The aftermath, including work at Ground Zero, interrogation of associates of the terrorists at Guantánamo, and other events all have merited news reporting and exposure.

Indeed, if you want to give yourself a photojournalism "assignment," one worthwhile project might be to illustrate, in pictures, some event or scene that reflects your own response to the tragedy. Of course, photojournalism, like all forms of journalism, is supposed to be objective. But that didn't prevent

Associated Press photographer Joe Rosenthal from winning a Pulitzer Prize for his stirring photo "Raising the Flag on Iwo Jima." Sometimes, the very nature of an event injects itself into the image, making unimpassioned coverage impossible, even for the best professional photojournalist. Who can be totally objective when a child is injured, a South Vietnamese general puts a bullet into the head of a captive, or nearly 3,000 innocent people are killed in a terrorist attack?

Jamie Umlauf took this photograph, "Remember Our Heroes," at the United 93 Memorial in Shanksville, Pennsylvania. The current makeshift memorial sits about 500 yards from the crash site; a permanent structure is

scheduled for completion at the crash site itself (which is currently closed to the public) by the 10th anniversary of the tragedy in 2011. The focal point of the temporary memorial is a 40-foot chain-link fence on which some of the more than 150,000 visitors each year leave flags, rosaries, hats, and other items. At intervals, these items are collected by National Park Service volunteers, who store them until the permanent memorial is finished.

This photo shows one section of the fence. "During the summer of 2008, I was visiting Somerset County in Pennsylvania with my friend for her family reunion. Her family took us out to visit the memorial and it was an incredibly emotional moment for me.

As we pulled up to the open field, a deep sadness fell over me and I began to feel angry at the same time. Then I saw the wall of gifts and memorabilia left behind for the heroes that died on Flight 93. I felt a sense of pride that I tried to capture in the photographs I took that day."

Umlauf took advantage of one of the in-camera special effects offered by her Canon PowerShot SD750 camera. Before taking the photo, she set the camera to its Color Accent "Special Scene" mode, and highlighted a red tone. When activated, this mode highlights any portion of the image that has the selected tone, and renders everything else in black and white. The red of the flag, the color of the victims' blood, makes a chilling photograph against the stark monochrome of the rest of the photograph. The photographer says that the only post processing done to this photo was to adjust the exposure in an image editor.

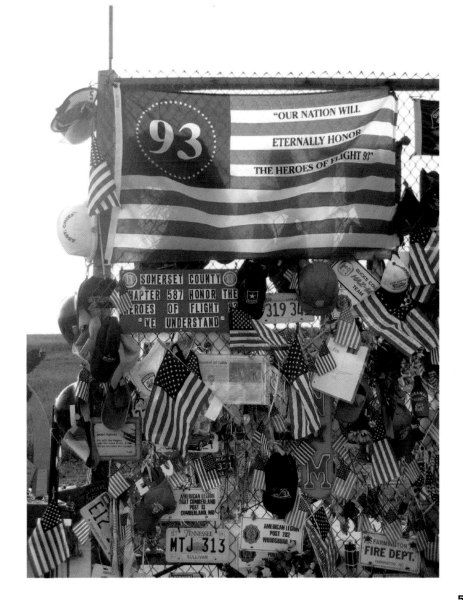

The Face of Poverty

BEGGAR WOMAN—NATHALIE LOVERA SNYDER

Poverty isn't an abstract concept; it's a reality throughout the world, and it becomes more real when we see the faces of those who live in its grasp. Good photojournalism, street photography, and documentary photography can provide us with a glimpse of places and conditions that may otherwise be unknown to us, and Nathalie Lovera Snyder has combined all three perspectives in this photograph of a Mexican beggar woman.

Most of us have never heard of the historic town of Morelia, even though it is the capital and largest city of the Mexican state of Michoacán. Fewer have had the opportunity to visit its magnificent Baroque cathedral, begun in 1660. UNESCO has named the city a World Heritage Site, but, as in any town, the poor eke out a living as best they can. Snyder, originally from Venezuela, was visiting Morelia when she noticed the beggar sitting quietly outside the gate of the cathedral.

"She looked so absolutely beautiful and kind." Snyder says. "I just knew I had to take her photograph. So I went up to her and asked for her permission; she was very lovely and gracious about it and gave me a little smile." After taking her picture, the photographer hugged the woman goodbye. "She looked up at me and said, 'God bless you!'" The brief encounter resulted in this moving photograph.

I think Snyder's image has a timeless quality about it, due, in part to her use of black and white rather than color.

The woman's clothing, wrap, and, in particular, the 350-year-old cathedral where she sat, don't indicate a particular time or place. The photo could have been taken in the 1920s, 1930s, 1940s, or any other time, at any other place where the poor wait to receive donations. So, although captured in Mexico, Snyder's photograph shows us the face of poverty at any time, or any place.

The technical details here are hardly important, but Snyder's Canon EOS camera was set for ISO 400, and she used an exposure of 1/160th second at f/5 (a wide aperture that helped throw the background of the cathedral gate out of focus), with her zoom set to a focal length of 51mm.

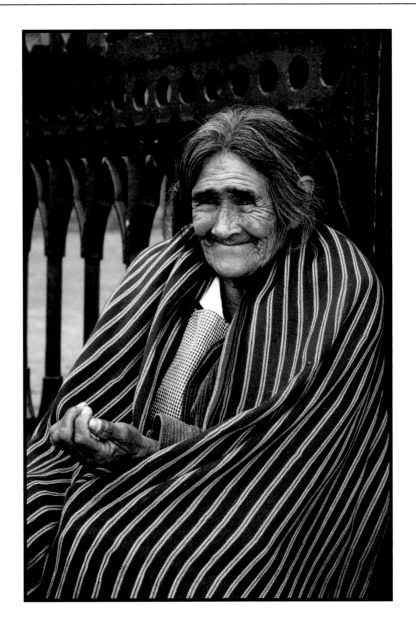

The Face of Peace

HUMAN SERENITY—DAVID S. SAUNDERS II

David Saunders provides a perfect counterpoint to Nathalie Snyder's look at poverty with his own take, which emphasizes not the impoverished circumstances of the subject but, rather, his ability to make the most of his condition and enjoy himself through the magic of music. Just as Snyder's portrait looked beyond destitution and hardship to show a warm human being who happened to live in poverty, Saunders shows us a man whose gifts are in music and satisfaction, rather than in material things.

The photograph only hints at this musician's interesting story. His clothing is rough—especially the worn slippers and coarse, mismatched stitching around the hems of his pants, and a chipped pan is placed on the ground in front of him to collect donations. But a tiny amplifier clipped to his shirt, connected to a speaker that can be seen peeking out of the bag on his left, show that he is making the best of his condition. The man is poor, but he's working hard at making an honest living.

The photographer says the image was a gift of circumstance. While living in a small town outside Shanghai, China, in 2007, Saunders was driving to a friend's apartment when he saw this homeless man on the sidewalk, playing a fiddle-like instrument called an èrhú (二胡). Rather than wrestle with his camera while trying to pay attention to the less-than-predictable traffic in the area, he asked his friend to drive on the way out and pause at this scene.

"I fired off three shots between pedestrians passing in front of this man, and this was my favorite shot," Saunders says. "Looking at it afterwards, I was struck by the serenity on the man's face. He was seemingly accepting of his circumstances and remained at peace with his music instead of focusing on his poor luck."

Saunders' Canon EOS XTi camera had a Canon 70-200 f/2.8L IS USM lens mounted, zoomed to the 73mm wide end of its range for an exposure of 1/160th second at f/5.6 and ISO 100, using Aperture Priority to lock in the relatively wide lens opening. In post processing, the image was sharpened, including selective sharpening around the top of the instrument. Saunders boosted the richness of the colors, increasing the saturation of the background the most, and the subject himself to a limited degree. The image editor's Levels controls were adjusted to improve contrast and then the image was cropped to remove foreground distractions.

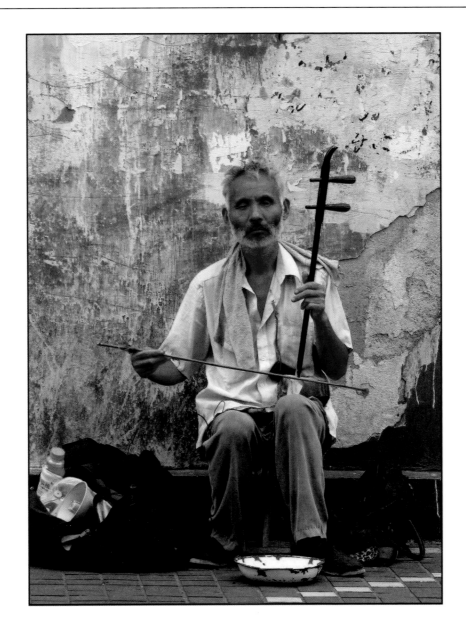

Spirit of the West

HORSE DRIVE—RON WILSON

I know photographer Ron Wilson didn't intend his image "Horse Drive" as photojournalism. He was aiming for a pictorial representation of the American West. But I've had the privilege of viewing his lengthy presentation of images from his sessions at an Oregon ranch, and found the stirring series of pictures told a story worthy of any exercise in photojournalism. Although the round-up is staged annually, the images look as authentic as anything you might have seen in two weeks on the Oregon Trail. Because this photo of wrangler and mustangs didn't quite fit in the chapter on animals, I've deposited it here.

Wilson happens to be one of the most eclectic photographers in the Cleveland Photographic Society, regularly doing studio work, including portraiture, dance/ballet, pets, pictorial photography, and specializing in photographs of the Amish. One of his presentations is entitled, "My Favorite Slides," and shows nothing but photographs of the smooth, sloped playground gear we grew up with. A lot of his work—particularly the dance, Amish, and night photography—has a distinct photojournalistic bent. So, Wilson's Western-themed photographs of galloping horses fit in quite comfortably with the photographer's other work.

"Horse Drive" was taken at a photo shoot at the Rock Springs Guest Ranch, in Tumalo, Oregon. "The wranglers would run the horses past us, regroup them, and run again," Wilson says. "This was taken in the late afternoon."

The time of day really "made" this photo, as far as I am concerned. The low angle of the sun illuminated the dust that the horses' hooves kicked up, and provided a rich golden tone that's straight out of a painting by Frederic Remington. The sun's glow, coming from the right, provides a sidelight that outlines the horses and, in particular, the cowboy, making his rope stand out against the dark background.

In the waning light, Wilson set the sensitivity of his Nikon D100 to ISO 400 and shot at 1/160th second at f/5.6 with a Nikon 24-120mm zoom lens. His exposure choice was perfect for this subject; the ISO 400 setting had just enough noise to supply a little grit to the image (a higher ISO probably would have looked too grainy), and the 1/160th second shutter speed was *almost* fast enough to freeze the action, while allowing a little motion blur in the jostling animals and rider. You'll discover that a bit of such blur can add realism and excitement to an action shot like this.

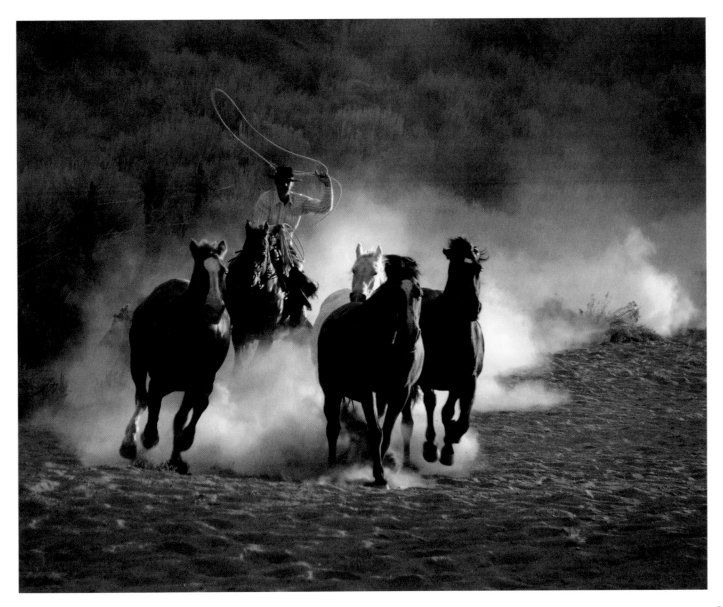

Monarchs of the Air

RED, WHITE, AND BLUE—MICHELLE LEIGH

SOARING ANGELS—DAVID S. SAUNDERS II

Humans have had a fascination with flying for thousands of years, certainly long before Ninth Century scientist Abbas Qasim Ibn Firnas attached wings to his arms and attempted to soar off a tower in Cordoba, Spain. David Saunders and Michelle Leigh are two Cleveland Photographic Society photographers who independently covered the Cleveland Air Show along Lake Erie in August, 2008. Each captured a different aspect of the annual show, and provided different glimpses of the wonders of flight.

Michelle Leigh captured a red stunt plane in the midst of an aerobatic display, white "smoke" billowing from a fog oil vaporizer mounted on its underside. The photographer was struck by the rich combination of red and white from the aircraft and its trail, and the blue of the sky, hence the "Red, White,

and Blue" title for the image. The lofty altitude of the stunt plane called for a focal length of 200mm to capture the scene. With an ISO setting of 200, Leigh used an exposure of 1/1000th second to freeze the action, and an aperture of f/5.6.

Saunders photographed the Blue Angels, the goodwill ambassadors of the U.S. Navy and Marines who perform at about three-dozen air shows each year. As the jets approached at high speed from behind the observing crowd, the photographer aligned his lens with their approach and fired off several exposures as the F/A-18 Hornets flew directly overhead. The planes were close enough to the ground that a zoom setting of 100mm on his image-stabilized Canon 70-200mm f/2.8 lens framed the four aircraft precisely. A shutter speed of 1/640th second at f/5 perfectly exposed the Hornets against the clear blue sky.

The Ravages of Time

BUS-TED—BARB PENNINGTON

Every picture tells a story, according to Rod Stewart, Modest Petrovich Mussorgsky, and this rusted hulk of a bus, now decaying in a field in Northeast Ohio. As captured by photographer Barb Pennington, the vehicle's remains retain enough of its original character to reveal a great deal about the bus and the journey that led it to this final resting place.

For example, most motor coaches of this era provided transport to the public, but the PRIVATE signage seen at top right indicates that this particular bus served in a more restricted capacity at the end of its life. Was it owned by an individual who toured the country in comfort within its spacious interior? Perhaps some band used it as a touring bus? Were the right windshield wiper and other missing parts donated to another bus for a life-prolonging

transplant? What did those powerful airhorns glimpsed on top sound like?

Pennington recalls that she spent a long time going over every inch of the old bus, and photographing it with her Nikon D200. "I signed up to participate in a Cleveland Photographic Society field trip to a 'Volvo Graveyard,'" she says. The site was a collection of old vehicles used for parts by a Volvo repair specialist, and had a treasure trove of cars, trucks, and vans of various makes.

"I had no idea why I was even doing this, or why would I want to walk around a field of junk car parts. Pennington says. "I stumbled upon this old bus and was fascinated. I spent a long time there and explored every inch of what was left. I got lost in the where it had been and who sat in these seats? Who were the drivers? It

obviously served so many so well. I felt good about recording it in history."

It was a bright day, so even at ISO 100, her camera's center-weighted exposure called for 1/1500th second at f/8. The sun was coming from the right, so this shot might have been a candidate for a polarizing filter to reduce the glare on the windshield. However, I think in this case the shiny glass provides just enough added touch of mystery to the murky interior, which can barely be seen. The windshield offers a nice contrast with the rough texture of the rusted metal, too. Pennington adjusted levels in an image editor, and applied a little sharpening to the image, but I'm glad she resisted the temptation to increase the saturation in post processing. The rust is already vivid, without being garish, and helps present a chilling picture of a once proud machine that has gracefully gone to seed.

Up, Up, and Away

BALLOON TAKE OFF—TODD LIEBENAUER

Like the winged aircraft shown earlier in this chapter, hot air balloons capture the imagination with the gift of flight they brought humankind. But these lighter-than-air craft, which predate the Wright Brothers by 120 years, offer something more to the photographer. Many of them are brightly colored and decorated, and often come in odd shapes that rival their cousins in the Macy's Thanksgiving Day Parade. But, best of all, hot air balloons may hover only a few feet off the ground, rise majestically to approachable heights, and, in particular, don't zoom past your lens at hundreds of miles an hour. Balloons offer many different kinds of shooting opportunities, and allow more leisurely, studied capture.

That's why the Albuquerque International Balloon Fiesta has been called "the most photographed event in the world" by the *New York Times*. The nine-day event attracts 750 different balloons and tens of thousands of participants and spectators to Balloon Fiesta Park each October. Photographer Todd Liebenauer snapped "Balloon Take Off" on the first morning of the mass ascension.

"As you can see, a lot of the balloons were already airborne," Liebenauer says. "I was very lucky to have a great mix of clouds and blue sky in my background." He captured the image with a Canon EOS 40D camera mounted with a Canon EF-S 17-85 4-5.6 IS/USM lens. This wide-angle view was taken at f/11 and a shutter speed of 1/500th second, with sensitivity set to ISO 200.

Although the original image looked good, the photographer did a little minor tweaking in an image editor, finding, in effect, a picture within a picture, as shown on this page. "First, I rotated the image to make the horizon parallel with the bottom of the image. Then I cropped about an 1/8th of the left side and about 1/3rd of the bottom out of the image." When the original exposure was made, it was underexposed so Liebenauer used levels to make the image a little brighter, and brought out the clouds with the brightness and contrast controls. Color saturation adjustments made all the hues brighter.

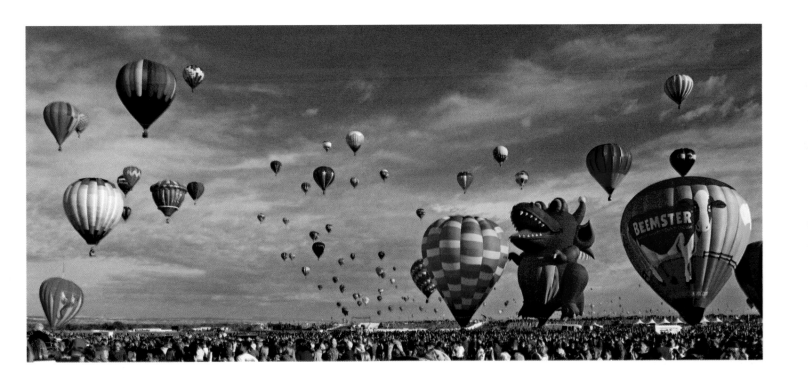

Freezing Action

SURFER DUDE—JIM FRAZER

Jim Frazer's "Surfer Dude" is a perfect example of the kind of action photograph that looks best when every bit of motion is frozen in its tracks—either by a fast shutter speed and/or through the use of the ultra-high "shutter speeds" offered by the very brief duration of electronic flash. While some "frozen in time" sports shots look as if the subject were posed and told to stand very still in an awkward position, this image screams action from every pixel, almost like one of M.I.T professor Harold Edgerton's famous bullet-bursting-balloon shots. Frazer has captured a moment you can't actually see in real life.

These days, with camera shutter speeds of 1/4000th to 1/8000th second common, and ISO sensitivity settings that make them viable under a variety of lighting conditions, stopping action isn't as much of a challenge as it used to be. The hard part is knowing what subjects can benefit from the technique. Motor sports almost always look better at shutter speeds slow enough to allow the wheels of a vehicle to blur and eliminate the illusion that it's actually just parked on a racetrack. Baseball, football, and many other sports sometimes need the bit of motion that a slightly blurred hand, foot, or ball can provide.

But the shower of water that bursts from this young man's surfboard, coupled with his carefully balanced pose on the board, offers all the movement the image needs. Frazer says that this photograph of his grandson was taken at a water park resort. "He was fascinated with the Flow Rider and spent most of his time surfing there. I used a flash both to improve the lighting and to freeze the water drops. I took 20 shots and this is the one I liked best."

Frazer used an Olympus E-510 camera with a 70-300 mm f/4.0-5.6 lens at 70 mm (the equivalent of 140mm on a full frame camera with this Four Thirds model). Center-weighted metering, combined with the electronic flash, called for an exposure of f/4.5 and 1/125 sec at ISO 400. A small amount of post processing of the RAW image was done in Adobe Lightroom. The photographer cropped the image slightly on the top and the left. Using the Levels command, the black point was adjusted upward to 20 and the clarity setting adjusted to 40. The tone curve was adjusted to increase the contrast. The last step was to convert the image to TIF format and export it to Adobe Photoshop Elements where it was sharpened for printing.

A Championship-Winning Score

HURDLERS, SIX POINTS, LOOK MA, NO HANDS!—DAVID BUSCH

Because photojournalism is, after all, *journalism*, the same Who, What, When, Where, and Why rules apply to the images, just as they apply to the printed word. When I began working for a daily newspaper, my photo editor imprinted this lesson on my brain after my first assignment at a college basketball game. Pointing to an image I'd circled in grease pencil on a contact sheet, he said, "That's a great sports photograph. It's well-exposed, the action is sensational, and you really captured the tension of the moment. But we can't use it."

Why not, I demanded, if it was such a great sports photograph? He stabbed a finger at the tiny frame. "This guy is a second-stringer who was in the game during the waning moments of the first half, after the home team had racked up a huge lead. What I really need is a

shot of the winning basket, scored in overtime after the visitors made a spectacular comeback in the second half. It doesn't even have to be great." I was already a decent photographer, but I was not yet a journalist. I learned my lesson. In action photojournalism, the Five W's—especially the Who, What, and When of a sports contest—are most important.

You should keep them in mind as you add a great sports photo to your portfolio. A great shot is something to aspire to, but only a great shot of a *great moment* is worthy of your digital photography Bucket List. You needn't capture an iconic image like Morris Berman's shot of a bloody Y.A. Tittle kneeling in the end zone at a New York Giants game. Don't expect to be nominated for a Pulitzer Prize, like the AP's David Tenenbaum, who pictured

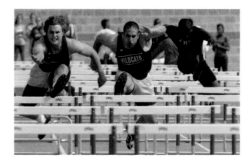

flag-draped hockey goalie Jim Craig at the 1980 Olympics. But you *can* capture a hurdler winning a state title in a closely-fought race, as in the photograph on this page, or show the go-ahead winning score in a championship football game, like the one on the facing page.

The key to getting a memorable sports photo, of course, is timing. But you can help your cause considerably by taking into account the other elements that help you be in the right place and take

the right photograph at the right time. Where you position yourself at a sports event can have a direct bearing on your photo opportunities. In or near the pits at an auto race provides a great view of the track as well as close-ups of the incredible pressure as crews service vehicles. At football games, you'll get one kind of picture at the sidelines, and another from the end zone. Soccer matches seem to revolve around the action at the net. Golf is at its most exciting on the greens. Each sport has its own "hot" spots.

Stopping the action—either fully or partially—is another element of getting a great sports photo. You may not want to freeze all the motion, but you should be able to provide *enough* action-stopping for the picture you want to take. From your camera's perspective, motion looks different depending on its speed, direction, and distance from the camera. Objects that are moving faster produce more blur at a given shutter speed if the camera remains fixed. Subjects that cross the field of view

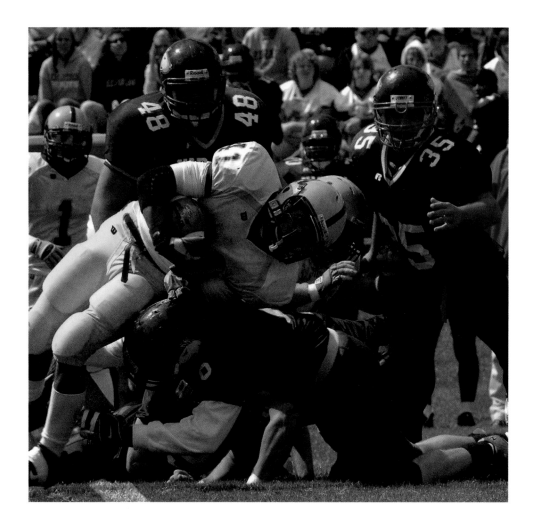

appear to move faster than those heading right toward the camera. Things that are farther away seem to be moving more slowly than those in our immediate vicinity. You can use this information to help apply the amount of freeze you want in your image. The more action-stopping you want, the higher shutter speed you need.

Although a fast shutter speed can stop action, you can also freeze subject motion by other techniques, including *panning* and waiting for a *pause* in the action. For the image on the opposite page, I combined a reasonably fast shutter speed, a little panning, and an almost imperceptible pause to produce a chilling shot, which I call "Look Ma! No Hands!" The phrase originated not, as you might expect, from the Edward Scissorhands movie, but from a '60s era television commercial that featured

a kid careening down the street on a bicycle. It's an apt title for this photograph of a daring motorcycle rider, soaring 30 feet in the air between two ramps.

I used a moderately fast 1/250th second shutter speed to capture the fellow at the exact moment when he let go of the handlebars to drift across the field of view of the enthralled spectators, before grabbing the bars again and pulling himself to a seated position just as the cycle touched down on the landing ramp. The feat was possible because air resistance slowed down the rider and his vehicle once they took to the air, providing an almost-slow-motion view as they drifted past. You'll find that such slow-downs in action—usually at the peak of a trajectory like this one—make a perfect opportunity to

grab an image when your subject isn't really moving that fast at all.

And finally, I tracked the flying rider and cycle horizontally as they flew past, so, because of my panning motion, the subjects really had very little lateral motion relative to the camera. Following the action, too, is an effective way of eliminating motion blur. Ordinarily, when panning, the background becomes quite blurry (compared to your main subject), because of the camera motion. But in this case, the background (the sky) was several thousand feet away, so the movement of the camera was very slight in relation to it. The result? A sharp picture with almost no subject motion blur, thanks to the combination of my shutter speed, the "floating" subjects, and my panning.

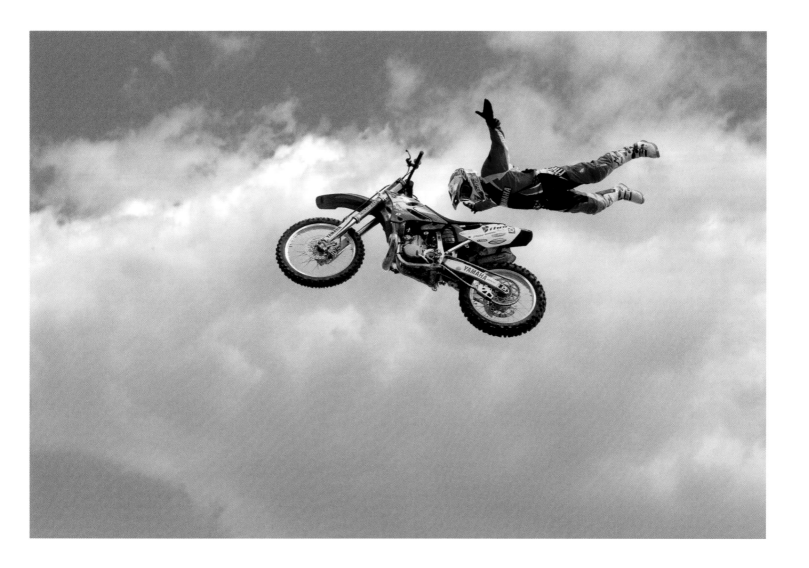

A Sibling's Bond

BOSOM BUDDIES—BARB PENNINGTON

Those of us who had siblings, or who have been parents to more than one child, understand the special bond that brothers and sisters have for each other. Photographer Barb Pennington has captured that bond in her photograph, "Bosom Buddies," which shows two twin girls posing for a picture that gives new meaning to the term "op art."

Sibling revelry is something most of us can identify with. The possible exception might be comic Steven Wright, who claims he was an only child…eventually. (Thanks to his childhood quicksand box.) Closest of all are said to be identical twins, who share the same DNA, and sometimes a great deal more. If you want to study the topic of "nature versus nurture" up

close, do as many researchers—and ordinary people—do each summer, and visit Twinsburg, Ohio, in August.

Each summer, as many as 2,000 "multiples" (twins, triplets, quadruplets…) congregate for the annual Twins Days Festival, which includes a Double Take parade, and a whole weekend worth of activities, including talent competitions and lots of multiples getting to know each other. The event also draws families, friends, gawkers, and, especially, photographers looking to capture interesting photos. Don't worry! The twins and triplets (etc.) are there, in part, to celebrate their unique standing and participate happily in conversations and photo opportunities. The most common thing I've witnessed when attending

this festival is the sight of two or more sets of siblings posing with pictures of other multiples they've just met, or taking pictures of each other. (One year, I spotted twins that were each carrying Rolleiflex twin-lens reflex film cameras!)

Pennington, a consummate people photographer, recalls that she found multiple photo opportunities at the most recent Twins Day fete she attended. "I spent the day capturing twins of all ages, shapes, and costumes. It was the end of a long hot day. I was walking to the exit when I turned around and looked up the hill. There walking with a lot of attitude were Laquala and Jaquada."

The photographer says that her eyes were focused on the great vertical lines, the twins' hair and the striped bosoms. "I asked them to pose but to face each other slightly. They did, and we all broke out in big smiles when we saw the picture I got. It really showed their relationship."

Pennington grabbed the shot using a Nikon D70 with 18-200 VR (vibration reduction) zoom lens set to a 116mm focal length. The Program exposure setting called for an exposure of 1/150th second at f/5.6 at ISO 200. The picture turned out great as-is (I especially like the implied "heart-like" shape drawn by the girls' hair and outfits in the center of the frame.) But the photographer used her image editor's Curves and Levels commands to adjust the tonal values, cleaned up the background with cloning tools, then applied a Gaussian Blur filter and Spot Healing brush to touch up her subjects' complexions.

4 The World of Nature

The world of nature is certainly the broadest category of photography included in this book, both in terms of subject matter and styles. Nature photography embraces the majestic scenics of an Ansel Adams; wildlife taken from vast distances; and intimate close-ups of smaller critters, flowers, or microscopic life.

Nature photography can emphasize pictorial and aesthetic aspects of an image, even transforming the wonders of the world into abstract compositions. Or, nature photography can verge on photojournalism with, say, a picture story on endangered wild mustangs in the American West. It can venture into documentary territory to show us the typical life's journey of a wolf. Nature photography can show us the world in color, or in black and white. The restrictions are few.

One of these restrictions is that the "hand of Man" (that's the term most often used; I prefer "hand of Humans") not taint the image, as if human beings were not part of nature. The rationale, of course, is that humans *change* the natural arrangement of things, and if you want to depict the works of Mother Nature most purely, the meddling of the human race should play the smallest role possible in the image. Indeed, the Cleveland Photographic Society, as well as other organizations, has both "Non-Strict Nature" and "Strict Nature" categories for its competitions and displays. In the former category, animals photographed in zoos and nature preserves are acceptable, and an unobtrusive pastoral fence or two might be tolerable in a landscape. In the latter category, animals must be photographed unfettered, in the wild, and even the quaintest country barn cannot defile a scenic photograph.

In the interest of diversity, this chapter will be a "Non-Strict Nature" version, with at least one bridge, a city skyline, and, if not the "hand" of humans, their footprints, appearing in the photographs arrayed here. In addition, I'm lumping the entire natural world of animals into a chapter of its own, which follows this one.

High Dynamic Range Magic

DESERT EVENING—VARINA PATEL

The current trend towards HDR (High Dynamic Range) photography is just a new name for something that hard-working photographers like Varina Patel have been doing for a very long time. Patel lovingly does the job manually and, arguably, with better results. For "Desert Evening," she composited two pictures that were specifically crafted to be blended into an image that more accurately reflected how the scene appeared to the unaided eye.

The photographer and her husband, Jay, were conducting a workshop in Death Valley, helping a group of students capture the impressive cloud formations and beautiful sunsets. "Some of our students pointed out these beautiful pink cacti near the roadside and we stopped to photograph them under spectacular evening skies," Patel says.

With a Canon 10-22mm zoom mounted on her Canon EOS 50D, Patel took three bracketed exposures, starting with a basic exposure of 1/2 second at f/11 at ISO 100. The camera was locked down firmly on a tripod to eliminate movement between shots. The shutter speed was changed between exposures, which is mandatory when capturing images for HDR. If you adjust the f/stop instead, the depth-of-field/focus (and therefore the size of some of the subject matter in the frame) will change, making it impossible to combine the multiple shots precisely. You can make the shutter speed adjustments manually, or set the camera to Shutter Priority (Tv on the EOS 50D), and allow the camera to do the bracketing.

Patel gave herself an edge by using a graduated neutral density (GND) filter for the shots. A GND has increased density on one half, fading to clear on the other half, and can be adjusted so only the brightest parts of the image—in this case, the sky—are filtered. That reduces the contrast between the two halves of the image. Although GNDs are available in screw-in circular form, a better bet is to use a rectangular filter that slips into a holder mounted on the lens. That configuration allows moving the filter up or down to align with the horizon more precisely.

For some types of scenes, a GND alone can balance the sky and foreground adequately, but Patel says that "the range of light in this shot was too broad to be handled accurately using the equipment I own. I combined two of my bracketed shots using careful manual techniques to produce a final image that is as close as possible to the reality I remember," she explains.

Two Pictures in One

CANNON BEACH—RON WILSON

Many of the images in this chapter are pictorial and aesthetic gems, but Ron Wilson's photograph of Cannon Beach in Oregon stands out because it is, at the very minimum, at least two great pictures in one, and, as you immerse yourself in its sumptuousness, you'll find three, four, or even five mini-masterpieces within the frame. Yet, Wilson didn't limit the appeal of his picture by trimming it down; he gives us the full image with all the richness that keeps you looking at it for a long, long time.

The upper 60 percent of the photo, showing a beautiful sky over 235-foot Haystack Rock, attended to by its stony acolytes (dubbed "The Needles"), is a great photo in its own right. The clouds, misty sea, roiling waves, and the flocks of soaring seabirds (which can be seen in the original image), make for a

scenic that any photographer would be proud of. Then, there is the lower portion of the photo, showing some of the estimated 2,000 sea birds that nest on the basalt monolith. You can crop out most or all of Haystack Rock itself, and still have an interesting picture.

There are other, smaller, fascinating images within the frame. Take the right two-thirds of the photo, and you have an effective vertical shot. The line of pelicans, roughly center/left form an interesting "parade," and there are several other little tableaux within this shot—captured with a Nikon D100 having a mere 6 megapixels of resolution. Even the color palette of the scene, a combination of warm earth tones, cool sky blues, and the splotch of green on Haystack Rock, works.

Of course, it helps that Wilson had his camera mounted on a tripod, which maximized the sharpness of the image. "It was taken at Cannon Beach in the late afternoon. I used a low angle to emphasize the foreground," Wilson recounts. Shooting with an 80-400mm Nikkor lens meant that, even with the lens set to its widest focal length, a telephoto viewpoint resulted, compressing the array of birds to make them seem even closer together than they actually were. With the D100 set for Aperture Priority, Wilson used a lens opening of f/16 to provide adequate depth-of-field for the broad expanse he was capturing, and took the shot at 1/90th second at ISO 200. His RAW image required only minimal adjustments in Photoshop.

Nature's Pastels

LOWER ANTELOPE CANYON—KATHLEEN NELSON

The soft pastel hues, exotic textures, and breathtaking angles taken by the rocks have made Antelope Canyon one of the most iconic sites for landscape and nature photographers. Located on Navajo land near Page, Arizona, it is the most-photographed of the so-called "slot" canyons formed by the erosion of furious flash flooding during the rainy season in the American Southwest. Kathleen Nelson's image of the "Lower Slot Canyon" at the Navajo Tribal Park was actually one of several submitted by Cleveland Photographic Society photographers for the Bucket List project. All were wonderful, but Nelson's won out for its delicate balance of highlights and shadows, captured under very difficult lighting conditions, and the way the curves of the walls echoed each other.

Tours provide access to both Upper Antelope Canyon, which is the most frequently visited, and Lower Antelope Canyon, which requires a more challenging hike and climb, and is more favored by photographers than casual visitors. "One enters this canyon through a crevice in the ground and then makes their way down a metal ladder type stairway," Nelson explains. "Once in the canyon the beauty is overwhelming."

For photography, the light has to be just right, however, she warns. "I visited the canyon in April and spent about three hours photographing the bouncing light through the different areas of the canyon. The light seems perfect around noon but changed constantly and remained good for the entire three hours I spent there."

The long stay was well worth it, she says, because the colors of the canyon walls vary significantly as the light from the sun changes. According to Nelson, a tripod is a must, and a remote shutter release to trigger the camera without shaking, because exposures can be

long. "Lower Antelope Canyon" was taken using a Canon EOS 20D with Canon 17-40mm zoom lens. She set the sensitivity to ISO 100 to ensure maximum image quality, but that required an exposure of 6/10ths of a second at f/11.

"There is a lot of dust in some areas of the canyon so one must be very careful when changing lenses. The camera's sensor may need cleaning at the end of the shoot," she warns. The RAW image was post processed in Adobe Lightroom 2.0, lowering the exposure and adjusting the tonal curves to accommodate the broad range of lighting on the canyon walls. "I increased the overall saturation slightly and then added a bit more saturation to the oranges, blues, purples, and magentas," Nelson says.

The Bounty of Nature

GREEN APPLES—NANCY BALLUCK

Photographer Nancy Balluck calls this a "lucky fluke," but looking at how everything pulls together in her picture "Green Apples," I'm forced to think of golfer Gary Player's observation, "The harder I work, the luckier I get." The photo breaks a couple rules—those green fronds growing from somewhere "off-screen" to the left are technically "mergers"—but there are enough positives, including the shimmering reflections off the water and rich glow of autumn colors, to make this image a real winner.

"This shot was a lucky fluke, which doesn't happen very often," Balluck says modestly. "I was taking a digital color photography class and one of our assignments was to use our white balance settings in various weather conditions. The only weather condition I had not yet shot was a cloudy, overcast day." She was at work and had only a tiny Nikon Coolpix 7900 point-and-shoot camera with her.

"A thunderstorm had just passed through and the clouds still hung heavy so I grabbed my little Nikon and ran outside to shoot under cloudy conditions. After taking a few uninspiring shots I turned to walk back into the building and noticed a lot of rotting green apples submerged in watery muck underneath the apple tree. I didn't want to use my flash and didn't have my tripod with me so I gambled by taking a lot of shots, hoping that maybe one would come out without being blurry. I got lucky."

The photographer's camera was set on "automatic everything, except for the white balance" which she had adjusted to the Cloudy setting. At the low sensitivity setting of ISO 50, the exposure was 1/18th second at f/4.9 (which is the smallest f/stop available with the modest f/2.8-4.9 38-114mm [equivalent] 3X zoom on the Coolpix).

"I'm surprised that this photo came out so sharp!" Balluck marvels, noting that the camera has no image stabilization—only a post-shot Blur Warning. "In Photoshop I had to do some minor cloning on top of the apples because there were some hot spots and I had to clone out some weird things in the murky water. I also adjusted the contrast a bit and increased the saturation until this photo had the impact that I wanted."

A Perfect Rose

St. Patrick—Neil Evans

One perfect rose is often used to represent a simple, impeccable token of love (although Dorothy Parker opined that she'd rather receive "one perfect limousine" instead). In nature photography, roses often become idealized subjects because of their beauty and near-infinite variety. (One source says there are roughly 100 different species of rose, and around 7,000 different varieties.) Capturing one perfect rose is a challenge worthy of anyone's Bucket List.

Cleveland photographer Neil Evans is especially devoted to capturing these blossoms, and has turned the endeavor into a fine art—in more ways than one. His techniques and choice of subjects, such as this beautiful St. Patrick, a

hybrid tea rose, are as flawless as the blooms he presents to us.

In most cases, flower photography is a combination of macro photography and portraiture, calling for a command of close-up techniques and a mastery of lighting, so that the subject can be captured in a way that is both aesthetically pleasing and representative of the particular type of flower being photographed. The keys to good flower photography—beyond selecting a blossom that lacks noticeable defects—are proper focus, lighting, and exposure.

Focus involves both depth-of-field (the parts of the flower that you want to appear sharp) and positioning the plane of focus, so that only the parts you

want to be sharp, are. Notice how the center of Evans' rose is exquisitely sharp, while the petals around the edges are soft and diffuse. That draws your attention to the center of the image. Evans mounted his Nikon Coolpix 5700 on a tripod, zoomed the lens to an actual focal length of 27mm (the equivalent of 106mm on a full frame camera), and focused, using the equivalent of f/7.8 to provide maximum depth-of-field. (The Coolpix 5700 can focus as close as 3cm/1.2 inches from the front element of the lens.)

Good lighting helps "sculpt" your image, through diffuse illumination to provide a soft look, or more contrast to enhance texture. Here, Evans uses softer lighting, which emphasizes the

silkiness of the petals. He happened to use the available light to illuminate a potted St. Patrick rose that "I had placed among the foundation plantings in front of my house, facing East. I had placed a black foamcore board behind it," he says. With the Coolpix 5700 mounted on a tripod, he did not use a flash, which might have washed out the flower.

Only proper exposure can give you the full range of tones, in this case with rich detail in the shadows, but without allowing the highlights to wash out. With the camera set on Aperture Priority (to ensure that the small aperture Evans wanted was used) the Coolpix's 256-segment matrix metering system called for an exposure of 1/31 second at ISO 100. He says that the only post-processing needed was some cropping and Levels adjustment in Adobe Photoshop Elements.

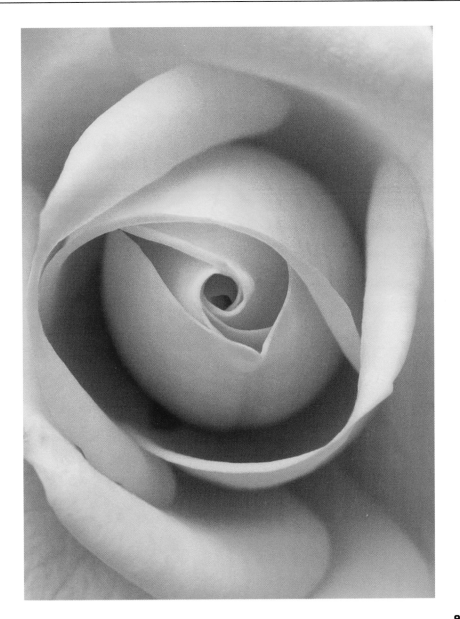

Nature's Saturated Palette

FUCHSIA DAHLIA—PEG MIKLUS

Although scientists have discovered myriad ways of producing artificial dyes and pigments, for many centuries the most vivid compounds used to tint our clothing, bodies, and hair; add hues to our paintings; and even change the color of our food, have all been found in nature. Peg Miklus has captured the rich, saturated palette of nature in this simple photograph of a dahlia, much as, elsewhere in this chapter, Kathleen Nelson imaged the subtlety of nature's pastels. Miklus's "Fuchsia Dahlia" was selected for this book not because it is a great floral photograph (which it is), but because it showed the dazzling possibilities of using the colors found in the world around us.

This photo also demonstrates that you don't have to be satisfied with the colors nature provides, if an image can be made even more dramatic by making a few adjustments, as Miklus did in post-processing to increase saturation to the vivid levels you see here. The image was made at a farm in Brecksville, Ohio, during a summer field trip scheduled by the Cleveland Photographic Society for its members. "Within a bed of dahlia flowers, I selected this one to concentrate on because of its vivid color definition and the way the sunlight was reflecting off the petals," Miklus says. "I had taken a couple shots, all at about the same exposure and shutter speed using a macro lens and tripod."

The photographer notes that taking pictures close up can be very challenging, and since the time that she captured this shot she's taken the time to experiment with different f/stops and shutter speeds and learned that, "You definitely need a sturdy tripod to position your-self and your camera." Miklus's camera of choice was a Pentax *ist DL digital SLR, with a Pentax 100mm macro lens. At ISO 200, she exposed this shot at f/16 to maximize depth-of-field, and used a shutter speed of 1/125th second.

Then, in Adobe Photoshop Elements, she adjusted the histogram slightly to brighten up the image, which was "a little too dark. Then I did some retouching using the Spot Healing Brush to remove a couple small dots of dirt that had kicked up on several of the petals," she says. Although the colors were already rich, Miklus tweaked the Hue/Saturation slider to brighten the sparkling magenta and yellow tones even more, then applied a 50 percent Unsharp Mask filter to really make the image pop.

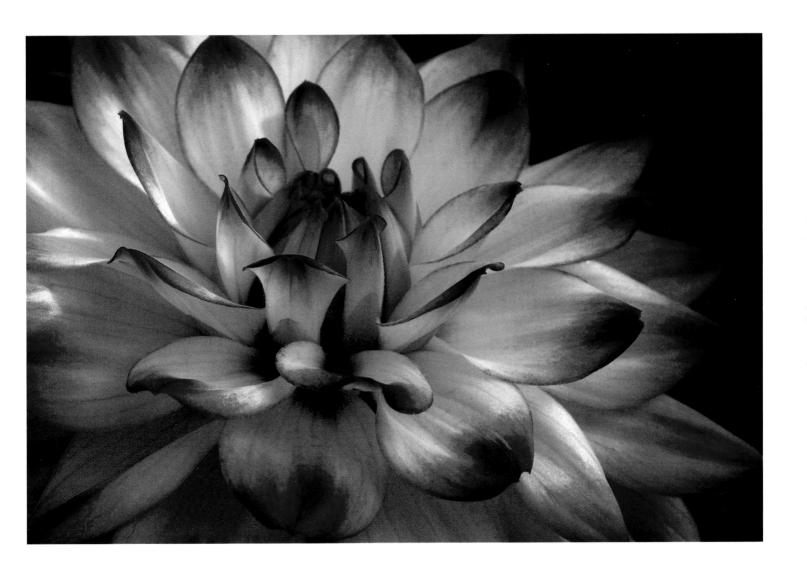

Nature's Power

SUMMER STORM—CHARLES BURKETT

The power of nature can be seen in mighty waterfalls, traced through the Grand Canyon, and viewed in horror during the ravages of hurricanes. But nothing is more awe-inspiring than the forces of lightning, as powerful arcs of electricity crackle between clouds and ground.

Anyone who has ever assembled a list of "must-take" photographs has most certainly included photography of lightning on their agenda. Unfortunately, few of us actually manage the trick. As it turns out, lightning storms happen to occur during times when most of us would rather be safely indoors. Charles Burkett was both braver and luckier than most the evening he captured his photograph, "Summer Storm."

"I had attended a meeting of the Cleveland Photographic Society and became fascinated with the intermittent lightning that was lighting the summer sky on the way home," Burkett says. "It was almost like the heavens were speaking." When he got home, Burkett headed to the roof. He set up his Nikon D80 camera on a tripod and quickly realized that "I was not going to be able to trigger the shutter quickly enough to rely on capturing individual lightning bolts. It was simply too fast. I ended up taking a series of pictures in rapid succession at times when the lightning bolts were flashing continuously. It was like panning for gold: you have to screen enough gravel to find the chunks of gold. It took over 1,000 exposures to get a handful that were interesting. This shot was the best."

Using an ISO setting of 1600, Burkett's exposures were two seconds at f/5, using a focal length of 34mm. Burkett finally realized that being on the roof of a five-story building when lightning was about was not a good idea. "I was fortunate that I hadn't become a part of the very lightning I was trying to photograph!" he observes.

If you want to try photographing lightning yourself, I recommend waiting for an isolated thunderstorm or squall, far enough in the distance that the strikes are visible in their entirety. Ideally, the storm should not yet have rain showers, which scatters the light, producing low-contrast images rather than crisp discharges of electricity. A skyline, like the one in Burkett's photo, can add some interest, but the light pollution reduces the length of the exposure you can use. If you photograph a truly dark sky, instead, you can use a Bulb or time exposure of 2 to 30 seconds, and the lightning, when it occurs, will provide the only illumination.

A Winter Wonderland

IDYLLIC WINTER—JOHN EARL BROWN

Those of us who live where there are four distinct seasons have multiple opportunities to record Nature's yearly cycle of changes, here exemplified by John Earl Brown's wonderful image, "Idyllic Winter." Not everyone is so lucky, of course. I once lived in Rochester, NY, which typically experiences nine months of Winter, and three months of poor skiing weather. (During my first year there, the first snowfall was in late September, and the last of the season was the following May.) Others live in parts of the country that has only a hot/rainy season, followed by a hot/brushfire season. No matter where you live, though, if you want to

capture seasonal changes for your photographic portfolio, you'll make a special effort to visit places where you can enjoy scenes like the one shown on the opposite page.

Of course, no one has actually ever encountered the exact scene pictured, because it is, in fact, a clever composite, produced by stitching two compatible images together. John Earl is a fine art photographer and Photoshop master (as you'll see in three of his images presented in Chapter 6) who creates painterly visions from ordinary scenes. In this case, he tackles a very difficult subject—a snow scene populated with trees, a bridge, and a nearly frozen

stream—to present a high contrast image that manages to retain important detail in both its highlights and shadows.

Armed with a Canon EOS Digital Rebel, Brown set his 18-55mm kit lens to a 34mm focal length, and took a pair of pictures using an exposure of 1/250th second at f/13 and ISO 200. On an overcast day, that combination produced a moody shot that fits our expectations of what an idyllic winter should look like.

"The one aspect of this image that becomes apparent after you view it for awhile is the large amount of depth

from the foreground to the background," Brown says. "That's because the photo is two pictures: one on the bottom and one on the top." Usually, he continues, two photos are seamed together to create a panoramic image, "but I used this technique to provide a unique perspective."

To achieve the effect successfully, the two photographs of different Winter scenes were taken within minutes of each other under the same lighting conditions with the same exposure and same camera angle. Using his photo editor, Brown then eliminated the seam with the Clone tool and Healing Brush. "The only other enhancements were global contrast control," the photographer concludes.

A Rich Textured Landscape

COW CREEK MORNING—DON KELLER

Death Valley, California is the lowest, hottest, and driest location in all of North America. So, Cleveland Photographer Don Keller was a witness to an exceptionally uncommon sight—flooding in the valley, a 3,000 square mile expanse bounded by the Amargosa mountain range on the east and the Panamint Range on the west; with the Sylvania Mountains and the Owlshead Mountains forming the northern and southern boundaries. Keller's "Cow Creek Morning" is an eye-catching pastiche of oranges and blues, wet sand, and majestic peaks in the background. For a landscape photograph, you couldn't ask for a more compelling palette of textures.

Keller was visiting Death Valley as part of a workshop with Craig Tanner of The Mindful Eye. Tanner is a teacher

as well as advertising photographer who bases a lot of his commercial photography on landscape images, while selling many fine-art landscapes, as well. Arriving a couple days early for the seminar, Keller was on his own when he discovered that he'd been treated to what he understands is a rare phenomenon.

"A few days before my arrival Death Valley had received more rain in two days than the annual average of 1.6 inches," he says. "A total of 1.8 inches of precipitation fell in 48 hours, flooding the low valley surfaces." The area near the Cow Creek Maintenance center attracted Keller for some early morning shooting. "I walked approximately one half mile from the road and found many beautiful compositions including 'Cow Creek Morning.'"

The photographer used one of his favorite techniques of shooting from a very low perspective with a wide-angle lens. With a 10-20mm lens mounted on his Nikon D300 camera, he set the focal length to 10mm and set his camera support down low near the desert floor in the early morning hours. With the camera set for Aperture Priority, he made the shot with an exposure of 1 second at f/16 (to maximize depth-of-field for the extremely wide field of view). A polarizing filter, effective because the sun was off at the recommended 90-degree angle from the lens axis, helped minimize glare on the sheen of water that still covered the sand. That allowed the mountains and sky to reflect on the glassy surface. The only post-processing required, Keller says, was some Levels and Curves adjustments.

Footsteps in Time

STEPS TO THE SADDLE—DON KELLER

French photographer Arnaud Claass once said, "In painting, the curve is a hill; in photography, the hill is a curve." That's a way of saying that while painters use abstraction and patterns to create an imaginative image of a subject, photographers use these techniques to deconstruct an existing scene into its component parts. Both approaches create art that doesn't look precisely like the original subject, but which evokes feelings related to the subject matter in some way.

Don Keller's "Steps to the Saddle" is another Death Valley image, one that's part pictorial, part abstract, and part allegory. If you'd like to disconnect the shapes and forms of the image from its pictorial component, just turn this book upside down and view the shot from an entirely different perspective. The sand dune image becomes something else completely, thanks to your imagination. I see the pockmarked belly of a giant brown whale, gliding past like the opening scene from *Star Wars IV: A New Hope*. What do you see?

This shot was taken during one of Keller's visits to a Craig Tanner (of The Mindful Eye) photo workshop in Death Valley. "We spent several hours in the Mesquite Flat Sand Dunes," Keller recalls. "One of the dunes had a beautiful shape which reminded me of a saddle and became a favorite target for me. 'Steps to the Saddle' was made one early morning shortly after sunrise by getting very low with a wide-angle lens. The angle of the sun produced dramatic texture in the sand."

Vertically oriented "landscape" shots like this one have long been used to provide a certain kind of look. The perspective is especially useful when the foreground—whether it's a body of water, a field of flowers or grass, or, in this case, sand dunes—can benefit from the emphasis that a wide-angle lens can provide. Keller used a 10-20mm zoom, set to the 10mm focal length, in this case. The viewpoint looks best when the subject matter in the background is large enough, and strong enough, to

maintain interest even though the ultra-wide view pushes it "back." Conversely, you would not want to use an ultra-wide lens if the foreground were bland, and important details were found in the background.

For this shot, Keller's Nikon D300 was set to ISO 400, which gave him an exposure of 1/400th second at f/11 using Aperture Priority. A polarizing filter made the colors look richer, the sky darker, and may have, I suspect, added the vignetting seen around the corners. In this case, the corner darkening only helps focus attention on the rest of the image. He says that the post-processing adjustments needed were the usual Levels and Curves tweaks in his image editor.

A World in Miniature

MY HOUSE IN A DROP—CAROL SAHLEY

What a great photograph this is—from a number of different perspectives! It shows languid drops of water suspended from a branch, each drop forming a tiny lens that images a miniature picture of the photographer's house. The moment was ephemeral, the picture sharply realized, and the result is a macro shot that's not quite like the usual close-up image you're likely to encounter. I'm hoping the imagination that Carol Sahley put into this image will impel you to add a world-within-a-world image to your own photography to-do list.

I've respected the photographer's creative vision and am presenting "My House in a Drop" as she intended it. But I can't resist recommending one little experiment. Turn the book upside down, and examine it from that angle. Instead of semi-abstract droplet views of an inverted house, the picture is

transformed into a series of six tiny "snow globes" with a correctly oriented home entrapped inside. I almost want to reach out and shake the tree to start the unseen snowflakes tumbling. This is a great image, and a lot richer than you might think on first glance.

Sahley says that capturing refractions in water drops can be a real challenge, but yields fantastic results once mastered. "This technique requires a wind free day and lots of light, preferably after a good rain," she explains. "Remember you can always make your own rain using a spray bottle if necessary!" She recommends choosing a small aperture (Sahley used f/11 for this shot) to ensure a good amount of depth-of-field.

"I was trying to capture a flower reflection in the water drop, and saw that by varying the angle and the distance of

the lens to the water drop, I could capture reflections of objects a greater distance away. After trying many different angles, I was surprised to see that I was able to fit my entire house in a water drop! With careful positioning, you can fit almost anything in a water drop. Be creative!" the photographer urges.

The right equipment is important, according to Sahley. She used a 100mm Canon dedicated macro lens and a monopod for extra stability. Her Canon EOS 40D was set for 1/100th second at f/11, and she cropped, applied some sharpening, noise reduction, and color correction in her image editor. One of the best things about macro photography is that the most mundane subjects make great fodder for images. A branch, a few drops of water, and a house in the background were all that were needed to create this classic shot.

The Colors of Infrared

BARK UP A TREE/NEW GERMANY STATE PARK—RICK WETTERAU

Once he fell in love with infrared photography, Cleveland Photographic Society member Rick Wetterau was determined to explore every nuance of this experimental form of photography. One of his shots, "Bark Up a Tree," shown on this page, demonstrates the possibilities of a technique called *channel swapping*, while the other image, "New Germany State Park," on the opposite page, explores the possibilities of HDR (high dynamic range) infrared photography.

Wetterau used a Nikon D80, which has been converted to full-time IR use for both shots. The conversion involves removing the infrared-blocking filter found in virtually all digital cameras, and replacing it with a filter that blocks most of the visible light, instead, and passes the infrared wavelengths through to the sensor. The modified D80 can be used to take IR photographs without the need for a dense filter over the lens, nor the long exposures required with a non-converted camera.

With a Tokina 10-17mm fisheye zoom mounted on the D80, Wetterau found himself hugging a giant cottonwood tree as he captured the canopy of this tree and several others nearby. At ISO 100, and the lens set to 10mm, he used an exposure of 1/160th second at f/6.3. Then, in Photoshop, the photographer used the Channel Mixer to dial down the Red channel's Red setting to 0 percent, while boosting the Red Channel's Blue setting to 100 percent. Then, in Photoshop, the photographer used the Channel Mixer to invert the values in the Red and Blue channels.

For "New Germany State Park," Wetterau discovered a beautiful, tranquil lake nestled between stands of tall

pines in Western Maryland. He captured three different images, with a focal length of 24mm, each exposed at f/8, but separated by one "stop" of exposure each, at 1/60th, 1/125th, and 1/250th second. This time, he combined the three images in the Photomatix HDR software. The high dynamic range effect provided a full range of details in the highlights and shadows, and the photographer added some snap by boosting the saturation of the sky and water, tweaking the Levels, and making some Sharpening adjustments in Photoshop Elements.

5 Creatures Great and Small

I didn't include photographs of animals in the previous chapter on Nature for several reasons. Non-human living creatures deserve a chapter of their own, of course. There are many challenges involved in picturing animals: they may move around actively, often aren't willing to sit still while we set up our cameras and compose our shots, and have distinct personalities that we photographers probably want to capture. In other words, creating images of critters is more like photographing people than like grabbing pictures of other parts of Nature's realm.

And, of course, our view of animals is colored by their relationship with people. Some creatures are far removed from their connections with Nature, having become our pets and companions. Others, less domesticated and more wild, relate to people with fear, distrust, or aggression. These aspects all make photographing animals more interesting and more challenging. This chapter offers a cross-section of animal photography, including creatures in the wild, barnyard critters, and pets. You'll see animals as we see them, and, in a few cases, from their own point of view.

World's Funniest Animal

"BORN TO SURF"—JOE POLEVOI

It's hard to say, "This is absolutely the best Dog Surfing Competition photo I've ever seen!" with a straight face. But then, if your goal is to shoot a photo of the world's funniest animal, the dog-eat-dog world of animal aquatics is a good place to start looking. You don't need to be a fan of America's Funniest Home Videos, or spend an hour a day at the "I Can Has Cheezburger" website (http://icanhascheezburger.com/) to know that our non-human friends of all species can do hilarious things.

But then, "Hilarious" is Joe Polevoi's middle name. Arguably the Cleveland Photographic Society member with the best sense of humor, Joe is always amusing the group with his mock Photoshop transformations (you'll see a couple in Chapter 8) and with his ability to capture funny pictures that, like "Born to Surf," need no image editing to amuse.

Polevoi's shot was taken at a dog surfing competition, held in San Diego, of course, an internationally known hotbed of doggie wave riding, with at least three major canine contests annually (you can read more at http://www.sddogsurfing.com). "It's a fun event, and perfect for photographers who enjoy candids of folks and animals enjoying themselves," Polevoi says. "Most of the pooches appeared nervous on their little surf boards, while this bulldog looked cool and determined. Instead of scenes showing crowds cheering, I zoomed in on him with his neat life jacket and drooling face."

In my younger days, I did a little surf photography with a Nikonos film camera that let me get right out into the waves at Huntington Beach, California, but my best shots were, like Polevoi's, taken from the shore. The chief obstacles are keeping your camera dry and free of sand, and getting a good angle. You'll need a long lens to capture canines hanging ten, and the photographer used a 70-300mm zoom on his Canon EOS 40D camera, with an exposure of f/11 at 1/1000th second. Unlike the photographer's typical Photoshop masterpieces, this image required only some sharpening and contrast adjustments.

An Animal's Point of View

"THE CRAB"—VARINA PATEL

Most photographs of animals reflect our view of those creatures and their world. With "The Crab," Varina Patel shows us what the world looks like from the perspective of a tiny crustacean. This is a knockout image in so many ways, it's almost a treatise on what you *should* do to photograph a small creature in its native environment.

First, it's a high-key image that really pops out at you. The brilliant white sand in the foreground blends seamlessly with the white expanse in the background, thanks to the extremely shallow depth-of-field. The larger granules just in front of the crab serve it up to us as if on a platter, providing a frame for the creature, who is peering

at us timidly with its pair of stalk-mounted eyes. The warm brown of the animal's exoskeleton contrasts with the slight off-white of the foreground, so the crab's shell is instantly the center of attention. You almost feel as if you were another crab, viewing a rival who has grabbed the best hidey-hole for itself.

Patel captured this image during a visit to Anne's Beach, a narrow strip of sand on Lower Matecumbe Key in Islamorada, Florida. "I borrowed a friend's lens to try it out," she says. "These tiny crabs dived back into their holes if we came too close, so I lay down on the sand with my eye to camera, and waited for them to get back to

business. This little fellow wasn't interested in being still for a photo, but with a fast shutter speed, I was able to capture him against the white sand of this beautiful beach."

The friend's lens was a Canon EF 100-400mm f/4.5-5.6 L IS USM lens, mounted on her Canon EOS 50D camera. Patel used an exposure of 1/500 sec at f/5.6 at ISO 100. She notes that the narrow depth-of-field isolated the creature, and, with the even lighting, there really wasn't much to do as post-processing. "I did clone out a very slight motion blur around one eye, although it would not have been visible unless printed at a very large size."

Animals with Personality

"HIGH DYNAMIC GOAT"—CAROL SAHLEY

I have personally met the Pygmy goat, Mimi, pictured here, and can attest that this barnyard denizen does, indeed, have a distinct personality, one that's worth capturing, although I'm obligated to warn you that opening a bag of potato chips around her is done at your own peril. This shot of Mimi standing guard over her domain shows that, despite her small stature, this goat is firmly in charge. The image is also a demonstration of what you can do with HDR (high dynamic range) processing.

"This is a high dynamic range photo of my Pygmy goat Mimi," Sahley says. "High dynamic range photography combines several images of the same subject, taken at different exposures."

She set her Canon EOS 40D camera to automatically take a bracketed series while preparing to take an HDR image of the barn in the background. Sahley says that it is difficult to take HDR pictures of animals, as there can be absolutely no movement of the subject for the three shots, or the combined image will be blurred and contain ghosting.

As she was preparing to shoot with a Canon 10-22mm lens set to 10mm, "Suddenly something caught Mimi's eye in the distance. Luckily, the camera was already set to auto bracket, so I fired off three shots quickly while she stood riveted and motionless on the table.

The three images were processed in HDR dedicated software called Photomatix."

While many photographers use a one-stop bracket to separate each image in an HDR set, Sahley set her lens to f/8 and used exposures of 1/125th, 1/400th, and 1/1250th second (about 1 2/3 stop between them) at ISO 160. The HDR composite shows detail in the highlights as well as the shadowed areas of the barn (and Mimi). The sun, partially hidden away by clouds, forms an eerie "halo" around Mimi's profile. The entire image has a surrealistic, otherworldly look about it.

Wild Instincts

"CALL OF THE WILD"—TONY BERLING

Photographing wild animals in their natural habitats is one of the most rewarding and interesting forms of nature photography. Indeed, most "big game hunts" in Africa and other places these days are pursued with cameras rather than guns. Hire an experienced guide, and you can track down polar bears in arctic conditions, visit lions, elephants, and hyenas in the savannas, and see feral Mustangs in the American West. If capturing truly wild animals in the act of being themselves is your goal, expect to spend many hours in the effort.

A more reasonable alternative, however, is to visit a preserve in which the animals are allowed to run free. In the Midwest, where I live, we have a 10,000-acre preserve called the Wilds, with plenty of rhinos, giraffes, and other open range animals (www.thewilds.org) and Wolf Park (www.wolfpark.org) where photographer Tony Berling captured this photo of Tristan, alpha wolf of the pack.

Located near Lafayette, Indiana, Wolf Park is one of the top non-profit education and research wolf facilities in the country. "It's a unique experience that any photographer can enjoy," Berling says. "You are permitted to go in an enclosure and take photographs among a pack of wolves. At times, it can be a very interactive experience."

His visits to the park have allowed Berling to compile some tips that apply to photographing other wild animals as well. "My best advice I can give is always respect a wild animal when you are in their home," he explains. "Also, know your subjects' natural behaviors so you can be in the proper position to capture the shot. Animals can always read a person's feelings, so the more relaxed you are with them the more relaxed they will be with you." He adds that in wildlife photography, instinct, subject knowledge, following a basic set of rules, and speed all play a key role in this type of environment. Things can move very quickly and you have to adjust your camera settings on the fly to adapt to your changing environment.

The shot was taken with a Pentax K10D camera using an f/2.8 50-135 zoom lens, cranked out to its maximum focal length. The wolf was captured at 1/125th second and f/3.5 at ISO 200. "I used this wide aperture to specifically blur the background, and focused on the wolf's furry neck to give emotion to the shot," Berling says. "I like the colder feel of the image, as Tristan was standing on a frozen pond."

The photographer says that very little post-processing was done on this image because, "I believe wildlife shots should be left in a natural state," Berling concludes. "I applied only a slight brightness and contrast adjustment and used a tighter crop to give more emphasis on the head of the wolf."

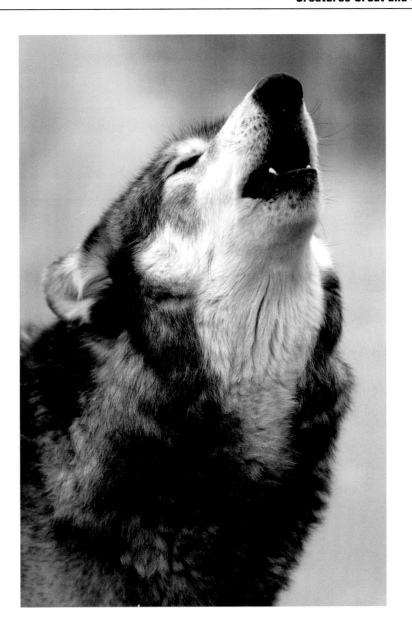

The Miracle of New Life

"BABY ROBINS"—DAN LE HOTY

Mother Nature is a harsh mistress, but also a gentle momma. For every moment that Nature is "red in tooth and claw" (as Tennyson put it), there is an amazing miracle of birth and growth, like the one shown in Dan Le Hoty's "Baby Robins," shown on the next page. These private moments are difficult to capture, but can be very moving. As with all wild animals, you'll need to be diligent, alert, a little sneaky, and, above all, cautious if you want to add a tender scene like this one to your Bucket List of photographic aspirations.

"Baby Robins" shows two infant robins, naked except for wisps of nascent feathers, in a nest that was painstakingly built, fiber-by-fiber, by their mother specifically for this brood. Two more eggs contain siblings that have yet to hatch. The photographer has captured a fleeting moment in the life-cycle of these migratory songbirds. In learning about this image, I discovered that baby robins open their eyes after about two days, and leave the nest 14 days after hatching.

"I took the picture straight down, without disturbing the nest." Le Hoty says, just as the tiny hatchlings, sightless until their eyes open, opened their mouths expectantly, hoping to be fed by one of their parents. The photographer captured the image with a Sony DSC-F717 Cybershot camera, a 5-megapixel model with an electronic viewfinder.

In the waning light of dusk, he set the camera's sensitivity to ISO 400, and used an aperture of f/22 to maximize depth-of-field. There's only the smallest hint of motion blur from the shutter speed of 1/30th second, but I think it adds a real-life bit of excitement to the shot. This is a real photograph, taken on the spur of a moment. Le Hoty says that cropping, some slight adjustment using Levels in Photoshop, and a bit of sharpening were the only changes made in post-processing.

Anthropomorphic Animals

"Baboon"—Barb Pennington

"Gorilla"—Sharon Doyle

I loved both these shots of primates that had very real human expressions on their faces, and wanted to pair them together to show how humankind's closest cousins can be presented in a sympathetic way.

Barb Pennington captured her thoughtful "Baboon" during a visit with friends to the Cleveland Zoological Park. "I stood in front of the glass and felt sad for these animals, as kids continually tapped on the glass and cameras flashed," Pennington recalls. "After the crowd moved on, the baboon sat down on the floor and leaned over to the right until his head touched the floor. I stood in front of him and our eyes connected. I clicked the shutter and got this shot. I thanked him. I think he silently replied 'My pleasure!'" The photographer captured the image with her

Nikon D300, and a 70-200mm image-stabilized Nikon zoom lens set to 105mm, and was able to photograph the baboon at 1/6th second at f/5.6. In her image editor, she used the Clone Stamp and Spot Healing Brush to clean up floor debris and enhance the catch light in his eyes.

Sharon Doyle's "Gorilla" pictures a pensive primate with eyes so human in appearance that you can't help but wonder what he is thinking. Snapped in an indoor enclosure under low light conditions, Doyle's photograph was taken through the glass using the existing illumination. She had a Canon 24-70mm f/2.8 L image stabilized lens on her Canon EOS 5D. At 70mm, she squeezed off a remarkable handheld shot at 1/5th second and f/4 at ISO 800. Image stabilization and a steady hand helped! Doyle reinforced the somber mood by converting the image to black and white, with a little sharpening and adjustment of the shadows.

Back to the Wild

"Barn Owl"—Rob Erick

Rob Erick's "Barn Owl" is an example of how to take a distinctive photograph of a fairly common subject. Humans seem fascinated by owls. We think they are exceptionally wise (they are not). Commandos use their hoots as "secret" signals while creeping stealthily through jungles. Harry Potter and his friends rely on them as extra versatile carrier pigeons and pets.

Owls are associated with dozens of stereotypes, including a few of the photographic variety, which Erick has studiously managed to avoid. Because they have front-facing eyes and earholes, owls are almost invariably photographed full-face, with the emphasis on those knowing and vigilant eyes. Such a picture can be a fine image, but probably not different enough to be worthy of your lifetime Bucket List.

"Barn Owl" is certainly a photograph you might want to emulate. Erick captures the nocturnal animal in sun-dappled shade, cloaking its features in a mixture of light and dark. Moreover, this bird of prey isn't staring cryptically at the camera. Instead, it seems to be looking at some object, possibly a potential meal, off camera. I really liked the texture of the bird and sharp relief of its feathers.

This picture was taken at the Back to the Wild wildlife rehabilitation center in Castalia, OH (www.backtothewild.com), during a Cleveland Photographic Society field trip. It was captured under natural lighting conditions outdoors in shade with sunlight filtering through a large overhead tree. "The bird simply glowed under these lighting conditions and I wanted to create a dramatic portrait of its stately manner," Erick

explains. The photographer used a Nikkor 70-300mm zoom set to its 200mm focal length, and captured the image with an exposure of 1/250th second at f/5. Minor changes in Levels, sharpening, and a bit of a saturation boost were applied in Adobe Photoshop Elements.

By this time, you've surely noticed that many of the best images in this book used longer lenses and/or relatively wide apertures to concentrate attention on a subject, while throwing the background out of focus. I happen to love this approach for people, animals, plant life, and even inanimate subjects like statues or architectural details. If you do like Erick did, coupling an aperture that's large with a shutter speed fast enough to stop both subject and camera motion, you can come up with a winner.

Human/Animal Interaction

"Titmouse Feeding"—Neil Evans

Like the Fonz, there are times when I can be wr…, wr…, wr… *wrong*. During the judging sessions that selected the photos for this book, I noted that I loved the titmouse pictured, but was distracted by the gloved human hand in the bottom third of the photo. At least a half-dozen of the other members of the panel objected in the strongest terms. "You're missing the whole point! The human feeding the bird *makes* this picture," they insisted.

Now that I've had time to rethink the image, I have to agree. This shot is an excellent capture of human/animal interaction, showing how even the most timid and vulnerable of tiny birds can learn to trust humans who take the time to give them food.

Neil Evans took this shot of a titmouse being hand fed at the Nature Center in Northeast Ohio's Brecksville Reservation. "On weekends, they postpone their regular feeding so that people can hand feed the birds, which are mostly chickadees and tufted titmouses." Evans explains. "One lady comes early, and the hungry birds really flock to her."

Evans stood about a yard away snapping off photographs with his Nikon D50 of the woman's left hand, which was full of peanuts. He used a 105mm macro lens with vibration reduction, which helped block any residual camera motion at the close focusing distance. The camera was adjusted to its Auto ISO setting, which selected a sensitivity of ISO 640.

The photographer set the camera to continuous shooting, and cranked off a series of images exposed at 1/500th second and f/3.0. (Even with vibration reduction/image stabilization active, a photograph taken at macro distances can suffer from camera motion at a relatively fast shutter speed.) Evans says that he's taken hundreds of shots like this one during the winter, and liked this one the best. He cropped it tightly in Adobe Photoshop, adjusted the levels, and performed some minor sharpening to produce this captivating image.

Cats Know More

"CAT STARE DOWN"—JIM FRAZER

Some people will tell you that they don't own their cats; the reverse is true. Aloof, but loving, independent, but willing to rely on humans, cats are in some ways the most wild of domesticated animals. And they always seem to know more than you think they should. It's hard to tell whether the best part of this picture is the high-key, high-contrast look of the photo, or the expression that seems to hide behind the feline's eyes as she stares down her "owner."

"This picture of our cat was taken as she woke up while sleeping on a chair on our porch," Frazer says. "She was peeved that I woke her up as I was getting ready to take her picture so she gave me that chilling 'cat stare.'"

Fortunately, Frazer wasn't intimidated, the lighting was good, and the shot turned out well enough. Then, the photographer decided to add to the mood he sensed by enhancing the original image in Adobe Lightroom and Photoshop Elements.

The basic picture was taken with an Olympus E-510, mounted with a 40-150 mm f/3.5-f/5.6 lens. The zoom was adjusted to its 150mm focal length, which, on this Four Thirds model, is the equivalent of 300mm on a full frame camera. Using center spot metering that measured the light reflecting from the animal's nose, Frazer arrived at an exposure of 1/200th second at f/5.6. Although the lens was wide open, the image was sharp enough and had sufficient depth-of-field to emphasize the cat's piercing gaze.

"Post processing of the RAW image was done primarily with Lightroom," Frazer says. "I first converted the image to black and white. I adjusted the black point and increased the contrast. Then I cropped a little more to focus on the eyes and nose."

The next step was to bring out more detail in the lighter fur areas. Then, Frazer exported a TIF image from Lightroom to Photoshop Elements, where he applied cloning in the lower left and right corners of the image to eliminate some distracting background. The image was then sharpened for printing.

Face of Innocence

"Young and Playful"—Joe Polevoi

If you're a sucker for cute baby animals, you can blame Mother Nature. I once attended a lecture by my favorite dead scientist, Stephen Jay Gould, who pointed out that baby animals of many types (including humans), have larger heads (proportionally) than adults; shorter and chubbier limbs; bigger eyes; smaller jaws, mouths, and noses; and softer skin, scales, fur, or feathers. Humans (and other animals) have been conditioned to have an innate desire to protect, nurture, and love creatures with these infantile features, even those of other species. So, the next time you say "Aww!" over a baby kitten, realize that it's the innate parent in you that wants to smother the poor creature with attention.

That said, it's easy to see why a photograph of an innocent baby feline or puppy was a sure bet for this book, and Joe Polevoi's "Young and Playful" was cuter than most. There's no getting around the fact that, unless you're a heartless villain, your own personal Bucket List will include an adorable animal of some sort. You might as well get used to that, and refine your search to the cutest, most innocent creature possible.

"We named this fur ball Lucky, because his mother must have abandoned him in our garage when the kitten was about two weeks old," Polevoi says. "He made sure we heard him and knew he was there. He deserved that name. He has turned out to be something special!

The kitty's expression was so good, I decided to crop very close to capture the look and fur detail."

The photographer captured this wonderfully backlit image with a Konica-Minolta 7D digital SLR, equipped with a 28-85mm Minolta Maxxum zoom lens. With a sensitivity setting of ISO 400, he used an exposure of 1/125th second at f/6.7. Though Polevoi is known within CPS for his Photoshop transformations, don't look for any antennae or fangs in this photo. He used Photoshop only to boost the saturation a little and increase the sharpening to make the fuzzy furball's coat more vibrant.

Motherly Love

"Mom's Kisses"—Will Sebastian

Will Sebastian's "Mom's Kisses" is a textbook example of how you, too, can take an effective wildlife photograph if you combine all the proper elements. The picture tells a little story, of a mother caring for her offspring, in a way that almost has you imagining their birdy conversation, ending with the fledgling sighing, "Oh, Ma!" in pleasure, tinged with a touch of exasperation.

Look at all the things that work together in this photo. Sebastian took the time to learn about the habits of the creatures he sought to photograph, and knew exactly where to hide to capture these ducks poised on a log floating in the water. The photographer selected a low vantage point, giving us, more or less, the water fowl's point of view from close to the level of the water.

The Canon 400mm lens mounted on his Canon EOS Rebel XTi allowed Sebastian to position himself far enough away that the birds weren't scared off by the presence of a human. Finally, he had to be patient, in order to wait for wildlife to become comfortable enough to continue about their daily lives while he took pictures. (More than one jungle hunter on television and in the movies has lost prey blundering around upwind. Photographers need to be stealthy *and* patient.)

The photographer applied more than a little photographic skill to the making of this image, too. Once more the photographer has used a large aperture (in this case, f/5.6, the widest f/stop available with his Canon L-series lens) to isolate the subject from its background. The illumination appears to be coming above and/or slightly behind the two ducks, adding a little halo glow around their feathers at the perimeter, and the exposure of 1/250th second at f/5.6 and ISO 400 is spot on. Everything comes together so that Sebastian needed to make only minor color and tonal correction adjustments in his image editor.

The Insect World

"ALIEN VISITOR"—CAROL SAHLEY

Carol Sahley, who brought you the macro shot of inverted water drops in the last chapter, explores close-up photography further with this portrait of a grasshopper that she calls, "Alien Visitor." She's right, of course. Insects and their kin are so different from us that they might as well be from another planet. Odds are that our first extraterrestrial visitors will resemble grasshoppers more than they do us.

So, the insect world is well worth your study. In the United States alone, approximately 91,000 different species of insects have been described, with an estimated 73,000 additional species still awaiting classification. You'd best get started, now, as you have a huge job ahead of you.

Sahley particularly likes insects as macro subjects. "Macro photography lets you see a world you didn't even know was there," she points out. "A simple walk in any backyard with a macro lens presents an enormous range of photographic opportunities, from insects and spider's webs, to flowers and reflections in water drops."

The 100 mm Canon macro lens used for this picture was the first extra lens Sahley bought to supplement the kit lens furnished with her Canon EOS Digital Rebel XT. She's glad she got it. "A macro lens can reveal things unseen with the naked eye. Insects up close take on an otherworldly, Jurassic appearance," she explains. "This

grasshopper was on the picnic table and stood patiently while I took many shots."

While a tripod is always a good idea when shooting close-ups, "Alien Visitor" was taken handheld, using an exposure of 1/200th second at f/8 at ISO 200. She used the camera's built-in flash to provide a crisp, high contrast image. Focusing on the grasshopper's head, the shallower depth-of-field at f/8 allowed the rest of his body to blur. Sahley says no major image editing was done. She corrected the color, cropped, and sharpened the image, and it was ready to enjoy.

Macro Moment

"Patriotic Dragonfly"—Vince Vartorella

I couldn't choose between the grasshopper photograph on the previous pages, and this one of a dragonfly, so I'm including both. The color scheme and the fact that it shows the entire insect in sharp relief make this one special. The venue—which is *not* in the usual watery haunts of these creatures—was also of interest.

Another factor that favored including this photo is that dragonflies can be tricky to photograph. You see them flitting about, hovering here and there before moving on, rarely catch them resting on something long enough to photograph, and never, ever see them walking from place to place. (Although dragonflies have six legs like all insects, they are unable to walk.) So, if you find yourself in a position to get a good image of a dragonfly, grab it! (The picture, not the dragonfly.)

"I took this photo at a party for a friend, " Vartorella says. "He had rented a large red, white, and blue inflatable bounce toy for the kids and there was a tent with a support rope set up in line with it. This dragonfly would fly around and land on this same spot on the rope every few minutes and just wait for someone to photograph it."

Vartorella was taking pictures of some friends and was keeping his eye on this little guy for a while. "I got into position so that the inflatable was behind him and took several shots, getting closer each time. He never moved and I was able to get within a foot, which was as close as I could get with my 28-105mm lens."

Although the photographer didn't have a tripod, it was a very sunny day, so handheld shooting worked just great. "It was funny, because no one could figure out what I was shooting until I showed them the picture on the camera," he says. "He was a very cooperative subject and the conditions were just right to make this an easy to get macro shot with no extra lighting or supports."

The image was captured with a Canon EOS 10D digital SLR, with an inexpensive but great example of a 28-105mm Sigma lens. "Patriotic Dragonfly" was shot at 1/1000th second at f/8 at ISO 400, with the lens zoomed out to the 75mm focal length. The only post processing done was cropping, a little sharpening, and modest adjustments on the levels in an image editor.

Nature's Symmetry and Patterns

"FROG SCHOOL"—DIANE FUNK

From patterns, to symmetrical arrangements, to fractal shapes, Nature seems to organize things in ordered ways. Most living creatures show left/right symmetry (that is, their left sides and right sides are mirror images of each other); patterns can be found in everything from snowflakes to zebras; and fractals, a geometric shape that can be split into individual parts, each of which is roughly a reduced size copy of the whole. (My personal favorite fractal are broccoli florets.) Humans tend to find pleasure in Nature's symmetry and patterns, and so do, apparently, frogs.

In Diane Funk's "Frog School," each of these placid amphibians inhabits its own private lily pad, probably to provide ample room for the individual frogs to snare a tasty meal as bugs pass by, without interfering with the others. This photograph invariably produces smiles, either for the pattern produced by the arrangement of the frogs on their pads, or, perhaps from the stolid looks of the patient, implacable creatures. The green colors of the lily pads, frogs, and water tie the whole image together.

Of course, for photographers, frogs can be as elusive as their insect repasts, and Funk spent a great deal of time trying to capture an image of the creatures, even though they resided just steps from her home. "The frogs were in my lily pond by my back door," she says. "For days, I tried to shoot them before they dove underwater when they saw me coming. I had my camera in hand every time I was out." The effort paid off; for one day, the four frogs sat waiting for her when she brought her Canon Powershot G3 to bear. The compact 4-megapixel camera was set on Auto, and she grabbed the shot with a snap. Only very moderate cropping was required to derive this amusing shot.

6 The Fine Arts

I learned the enormous scope of what we call *fine arts* in college, where, while I was earning my Bachelor of Arts degree, I studied shoulder-to-shoulder with those aspiring to careers involving painting, sculpture, music, dance, theatre, architecture, photography, and journalism. About the only thing we all had in common was that our efforts were all focused on aesthetics and concepts rather than utility.

When all is said and done, photography, like those other arts mentioned, is rather useless (compared to, say, auto mechanics) except for the pleasure it gives us in creating or viewing it.

Architectural Abstract

UNION OF STEEL—JEFF GRAY

Architectural photography almost deserves a chapter of its own, and, in fact, you'll find touches of it in this chapter and the two that follow. A loose definition of architecture is the design and construction of buildings and other structures for use by humans (and that use can include shelter, worship, monuments for the noteworthy, or housing for animals).

Great office buildings, magnificent dwellings, humble abodes, the kitschy hotels that line the Las Vegas strip, mighty cathedrals, or the pyramids of Egypt all qualify as architecture worthy of our attention. Architectural photographs can be made of the exteriors of these structures, or taken indoors to reveal the rooms and warrens inside. Such images can be vividly realistic, or mere abstract patterns.

Abstraction is the approach taken by Jeff Gray in creating his "Union of Steel" image, shown on the opposite page. It's a powerful image of geometric shapes repeated over and over, and viewed from two different angles, providing a mesmerizing pattern that, coupled with the monochrome tone, says "steel" more vividly than any caption could. The longer you look at this image, the more abstract it becomes, until, finally, it's no longer a building

but, instead, becomes the diamond shapes, with triangles and hexagons hidden within.

Gray captured his image with a Canon EOS 5D and a 300mm focal length, using an exposure of 1/100th second at f/4.5 at ISO 100. He trimmed the image in his image editor, making sure the precise alignment of the pattern was retained. "When photographing architecture of this type, you absolutely must line up the image exactly to get all the lines straight. All I did in Photoshop was to crop and convert the color image to black and white."

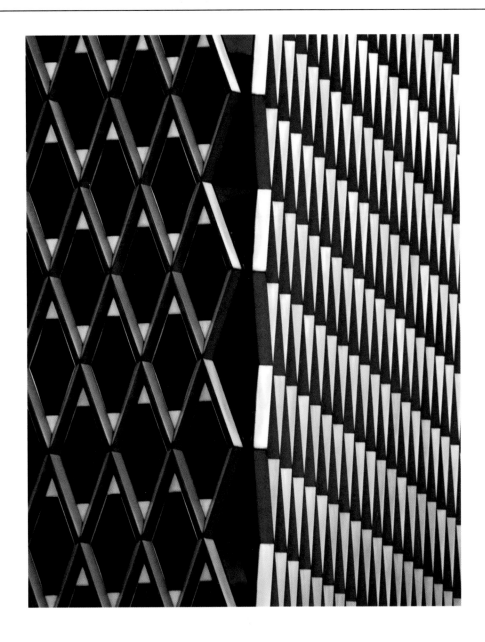

Homage to a Legendary Photographer

CROSSING OVER—JOHN EARL BROWN

I've been following the work of legendary photographer Jerry Uelsmann since the mid-1960s, captivated by his work with composite photos merged from multiple negatives through masterful darkroom manipulation. This was long before the miracles of digital photography and Photoshop became available. Uelsmann was a young man back then, and is thus still active today. If you are shamefully unfamiliar with his work, put this book down, go visit www.uelsmann.net, and then come back. To his fans, Uelsmann is the Ansel Adams of surrealistic photography—and a lot more.

John Earl Brown is a fan, too, and selected the master for homage while working on a project to emulate the style of Uelsmann. His effort, "Crossing Over" is truly an example of producing work "in the style of" rather than "as a copy of," and thus is a worthy piece of art in its own right.

"I decided to use the two crosses in a picture that I had previously done that were erected on the side of an Interstate highway, obviously commemorating deaths in a traffic accident," Brown explains. Working in Photoshop with six images all taken with a Canon Digital Rebel XTi, the sky was incorporated as a background layer and then the cupped hands were added over that. "I used the image of raindrops in a pond in the cupped hands as a background for the two crosses because they stood out more than their original background by the roadside."

He then added the birds to complete the idea behind the narrative he visualized. The Clone and Eraser tools were applied at varying opacities to blend the different layers together. "After I completed the image I became curious as to the weather on the day of this accident. The dates of the men's lives were on the two crosses, and I discovered that on the day they died, that area had .81 inches of rain."

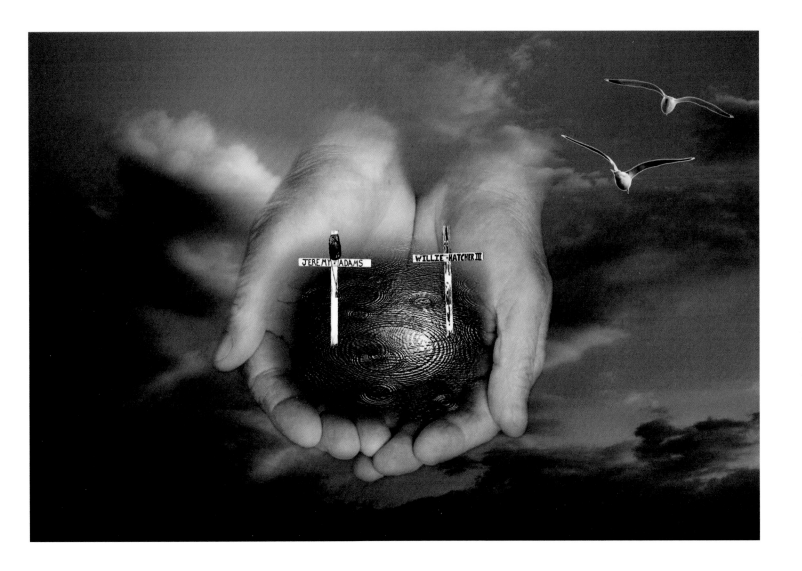

Trompe l'Œile

Direction—John Earl Brown

The term *trompe-l'œile* is French for "trick the eye," and technically refers to two-dimensional art that's been produced using an optical illusion that makes it appear as if it were three-dimensional. The phrase, without the hyphen, has been warmly adopted into the English language, and I decided to mis-use it to describe John Earl Brown's unsettling photo of a parking lot located near the icy shores of Lake Erie. I couldn't think of better words to describe it.

While not a 3D image, this one, titled "Direction," definitely fools the eye. The eerie arrow appears to be floating on or above the surface of a body of water, made even more surrealistic by the appearance of trees in the background. This is one of the shots that I spotted early during the initial judging of the 2000-plus images submitted for this book. Despite several rounds of "blind" judging ahead (the panel members didn't know the titles or makers of individual images), I was certain that this one, along with the Uelsmann photo on the previous page, would make the cut. I personally felt that it was one of the most interesting images offered.

"This was taken in a parking lot by Lake Erie on a very cold wet day in February," Brown explains. "The black asphalt and trees were covered with freezing rain and the lake behind the trees was shrouded in fog. These conditions made the white arrow in the parking lot stand out." He used a very low camera angle (roughly two feet off the ground) to emphasize the "floating" arrow. With the 18-55mm zoom lens mounted on his Canon Digital Rebel set to its 31mm focal length, an exposure of 1/125th second at f/10 at ISO 100 captured the original image.

In post processing, Brown boosted the contrast, and gave the foggy sky behind the trees a bluish color using a Hue/Saturation adjustment in an image editor. Then, to provide the interest of a light source within the image, where none existed, the photographer dodged one area at the upper edge. The result is a chilling image that forces you to think every time you examine it.

Parkcrest Reaching Out

Get involved in one or more of the projects that serve the less fortunate in our community and the world.

Toy Giveaway
Join Parkcrest KIDzone in supporting the Annual Long Beach Rescue Mission Toy Giveaway. Donations of new unwrapped toys can be brought to church from November 30 to December 13.

Sharing The Holidays
"Adopt" a Parkcrest family going through a tough time by providing dinner, gift cards, or gifts for the kids. Sign up November 14 through December 13.

Turkeys & Hams
The Long Beach Rescue Mission, Christian Outreach in Action, and our Parkcrest Food Bank are in need of donations of turkeys and hams to support their Holiday Meal giveaways. Donations accepted through December 21.

Family Adoption Ministry (FAM)
"Be the Miracle" by providing food & gift cards for foster & adoptive families not eligible for state aid. We're collecting items through December 6.

New Life Beginnings
Donate gift cards so the single moms at this local shelter can be empowered to buy Christmas gifts for their children. Donate gift cards through December 20.

Green Card Project - Food Drive
Provide non-perishable holiday & other food items for this project sponsored by one of Parkcrest's High School students. The goal is to feed 500 families. Donations will be received through December 13.

Image as Metaphor

THE COVENANT—JOHN EARL BROWN

Photographs don't always need to be explicit. Sometimes, their message can be cloaked in metaphor that needs to be decoded before you can understand exactly what the photograph is about. All of John Earl Brown's photographs make you think, and this one, "The Covenant" will have you thinking more than most, especially once you understand a little of the history behind the metaphor. The image is actually about transitions, particularly those that this room, located in a building listed in The National Register of Historic places, has undergone.

Originally erected in 1861, the building now known as The McGuffey School opened as a Cleveland high school, became The School for Incorrigible Boys in 1911 (I'm not making that name up), and later served as offices for social services agencies, before becoming a school once more until it closed in 1975.

"It existed for more than a hundred years before it sat empty and became inhabited by birds and used as a shooting gallery by local drug addicts," Brown explains. Then, five years after it was finally condemned, it was ironically restored for use by The Covenant, a drug treatment and prevention facility.

"My goal was to create a photograph that captured the transition that took place and the spirit of what was taking place there now," Brown notes. "The windows are in the third floor gymnasium that still has its original hardwood floor. I added the birds as a metaphor for the transition of the building and the transitions that are occurring now."

In other post processing, Brown made a selection of the white areas of the windows and placed them on a separate layer with some Gaussian blur to add an ethereal feel to the image. The original photograph at The Covenant Adolescent Chemical Dependency Treatment & Prevention Center, Inc. was taken with a Canon Digital Rebel, an 18-55mm lens zoomed to its widest focal length, and exposed at ISO 400 for 1/125th second at f/6.3.

You may also mark the project and enter your name and contact information below and drop it off at the Information table and you will be contacted.

Name:

Phone or e-mail:

The Makings of Music

DULCIMER STRINGS—KOLMAN ROSENBERG

Anyone who loves songs, tunes, or instrumental pieces will want to find different ways of expressing the miracle that is music. Concerts are the obvious choice—and you'll find a concert photograph in Chapter 2—but there are many other options. You can take pictures of musicians up close, perhaps as their fingers fly over their instruments. Or, you can photograph the accoutrements of music, including the instruments themselves, as Kolman Rosenberg did for his image "Dulcimer Strings."

Although it looks like a carefully contrived studio shot, perhaps shot in a light tent, that is not the case. In this example, the tent that offered the diffused lighting effect was a *real* tent, of the camping variety. Rosenberg captured this image while

in photojournalism mode as he attended the Little Mountain Folk Festival in Lake County, Ohio. "I came upon a display of dulcimers and wanted to take a photo using relatively shallow depth-of-field with just a portion of the instrument and its strings in focus," he says.

The photographer reports that he had to get down on his knees and was handholding the camera, a rather unsteady position. "The dulcimer was in a tent with low light levels, so in order to get a fast enough shutter speed, 1/200th second, I increased my ISO to 800 and used as large an aperture as possible to get the desired range of focus," he recalls. He shot the image using RAW format with a Nikon D200 and Nikkor 28-200mm zoom lens set to the 105mm position.

"I was rather close to the subject as well, to further decrease the depth-of-field," Rosenberg says. "I took several shots, at various apertures to compare the areas in focus and chose this shot taken at f/18." The photographer compromised on the aperture because the close focusing distance provided sufficiently shallow depth-of-field, but, while the music in the background was blurred, it was still clear enough to make out the fact that it was Stephen Foster's "Camptown Races," which, Rosenberg says, added a bit of historical context to the instrument.

He converted the RAW image in Photoshop, adjusted the Levels, made some Brightness/Contrast adjustments, and sharpened the image with the Unsharp Mask too.

Ballet in Motion

MOVEMENT IN RED—RON WILSON

Ballet combines two performing arts—instrumental music and dance—that can be appreciated by all, and which needs no translation to be enjoyed. Although it is a formalized type of dance, ballet can take many forms, including classical, neoclassical, and contemporary (which adds elements of modern dance). Cleveland photographer Ron Wilson is a generalist who shoots just about anything, but happens to specialize in certain kinds of photography that he especially loves, including the Old West (seen earlier in this book), the Amish, and dance.

"Movement in Red" is a studio shot with a professional dancer, and makes use of a special technique that you'll certainly want to try on your own. This image is, in fact, a combination of two exposures on a single frame—one taken with electronic flash, and the second using the ambient light in the studio. Wilson mounted his Nikon D100 camera on a tripod, and used a flash meter to check the correct exposure with the strobe, which was placed to the left of the camera. He discovered that, at ISO 200, an aperture of f/18 would be needed to capture a sharp, well-exposed image of the dancer.

But the actual exposure was taken using a relatively long shutter speed of 2 seconds. Even at f/18, the long exposure was enough to produce the secondary image seen as an ethereal "ghost" trail in the final shot. Depending on whether you've set your camera to use *front curtain/first curtain sync*, or *rear curtain/second curtain sync*, the ghost exposure will be imaged either *after* the flash has fired (front curtain sync), or *before* the flash has been triggered (rear curtain sync). In all cases, you'll end up with two images in one, and a wonderful effect like the one Wilson achieved.

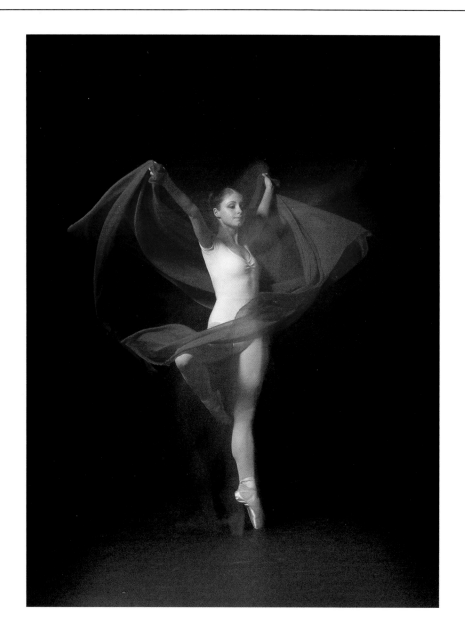

The Dance

TAKE A BOW/QUADRUPLE EXPOSURE—DAVID BUSCH

For "Take a Bow," I sat in the front row with my Nikon D3 mounted on a tripod. I watched the movements of the dancer carefully through several practice sessions, and noted a moment where she stood facing the audience, and then bowed down towards the floor away from her partner. At the dress rehearsal, I set the camera for a two-second exposure, and then triggered the shot just as she began her bowing motion, freezing at the end of the movement to allow capturing a distinct image of her bent-over form.

"Quadruple Exposure" was another "watching them practice makes perfect" shot. I set the camera to make four exposures in rapid succession on the same frame, and then pressed the shutter release at the beginning of the motion to be captured. You'll need a camera that includes multiple exposure capabilities to duplicate this technique.

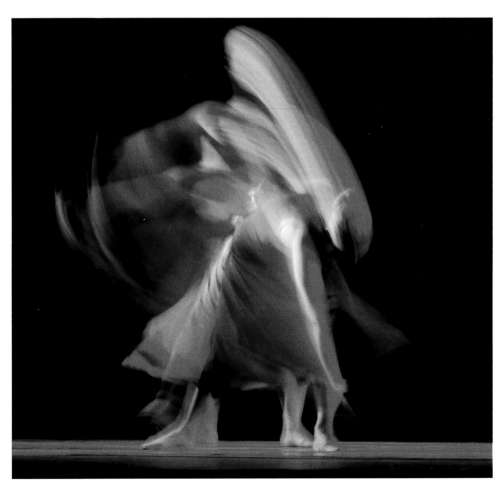

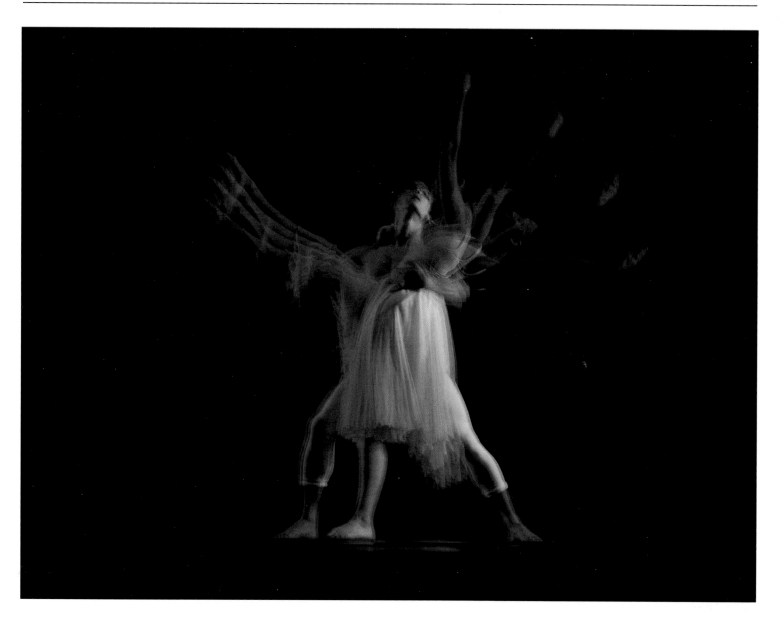

Hands at Work

CHALK FESTIVAL—ROB ERICK

The Cleveland Museum of Art has famed works by Caravaggio, Picasso, El Greco, Matisse, and Renoir, but for one weekend each September, none of these masters is as popular as the contemporary artists who participate in the Museum's annual Chalk Festival. It's a celebration of a tradition begun in 16th Century Italy by beggars who copied paintings of the Madonna in chalk on the plazas outside cathedrals.

According to photographer Rob Erick, Cleveland's version has professional artists mixing with families and individuals who pay a nominal fee to create their own colorful artwork on the slate walkways that flank the South entrance to the Art Museum.

"For this image, I zoomed in from a distance to capture the detail and color of an artwork jointly created by members of two very different generations," Erick observes. An older person sketches at left, while a youngster adds some details with a vivid piece of blue chalk at right. Only the hands and the artwork itself are shown, allowing part of the scene to tell the story of the whole.

Erick used his Nikkor 70-300G zoom lens handheld at the 300mm setting to capture this shot with an exposure of 1/160th second and f/5.6. The photographer must have had a steady hand, because most photographers would have difficulty getting an image this sharp at such a slow shutter speed with a lens set to its widest aperture.

Photoshop Elements was used to even out the tones in the contrasty scene with some minor dodging of shadow details, and burning in of some of the hottest spots. To bring out the vivid colors, Erick boosted the saturation a little, and then finished off with a touch of sharpening to make the details pop.

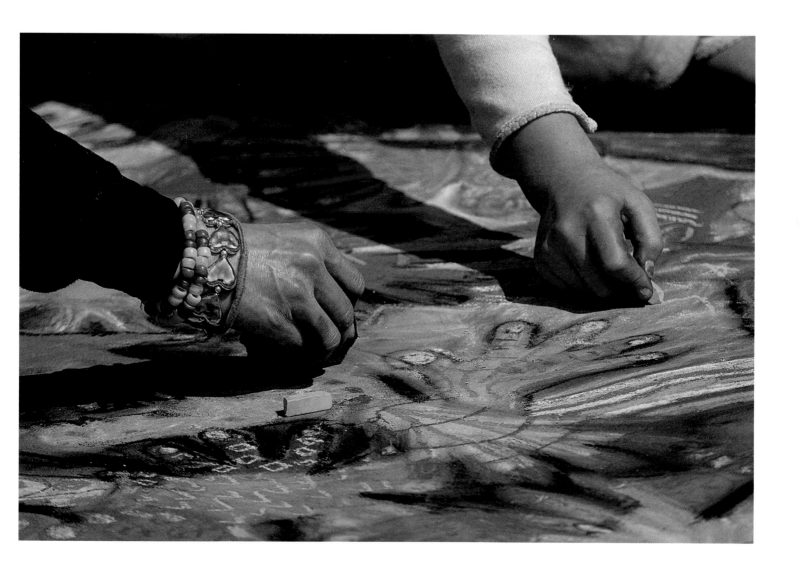

Mouthwatering Food

GRAPEFRUIT/STACK OF DONUTS—ELISHA CERINO

Food photography is a specialized type of product photography, and is a lot harder than it looks. The food must be prepared to perfection—especially from a visual standpoint—and needs to look fresh and scrumptious in the photo. Some kinds of foods spoil or melt quickly, so the time available to shoot them can be limited. Without the cues of smell and taste to enhance our perception of the food, the photographer must rely on sight to convey texture and appeal. In short, using photographic techniques alone, it's necessary to create a photograph that looks good enough to eat.

Involvement in the family restaurant business means that photographer Elisha Cerino was the natural candidate to prepare images for menus and the

website of Eddie's Pizzeria Cerino (www.pizzeriacerino.com) in Seven Hills, a suburb of Cleveland. Both "Grapefruit" and "Stack of Donuts" were shot on a special table designed, not for eating, but photography.

To capture the pink fruit, Cerino "placed the grapefruit on a photography shooting table in a room with north facing windows," she explains. "The table is made of plexi-glass and curves up in the back, which created the design in the background and the reflection/shadow in the foreground." The gorgeous lighting created the juicy-looking specular highlights on the surface of the fruit. The photographer's Canon EOS 30D camera was outfitted with a Canon TS-E 90mm f/2.8 Tilt-Shift lens, which allows tilting, shifting,

and rotating the lens body at different angles while the back of the camera remains fixed. These adjustments allow increasing the effective depth-of-field by keeping the sensor plane parallel to the tilt of the subject. The effect allowed Cerino to achieve a deep plane of focus even while shooting with a relatively wide f/4 aperture. At ISO 100, the evaluative metering system called for a 1/90th second exposure.

"Stack of Donuts" was taken on the same shooting table, with a monolight under the translucent table, pointing upwards and back. Cerino positioned a light with a soft box in front of and to the right of the camera, and shot with a 24-70mm zoom lens at 45mm, with an aperture of f/16.

7 Urban Life

Most of us live either in a large city or near enough to one that we are able to visit at least a few times a year to enjoy the vibrancy of life, cultural opportunities, and other advantages that large urban areas have to offer. If you live *in* a city, you're surrounded by photographic opportunities that are hard to resist, even though, for you, they are part of everyday life. If you're a rural resident (as I am) or suburbanite, urban life is an exotic mixture of new and unfamiliar sights that make appealing photographic subjects. One of the reasons I am glad I joined the Cleveland Photographic Society is that its members have given me ready access to photographic challenges—professional ballet, for example—that I hadn't had the opportunity to shoot on an up-close-and-personal basis in the past.

This chapter presents some images of urban life that haven't been represented in previous chapters that covered cities from other angles. You'll find more architecture here, of course, and street photography, which is most pulsating in the cities, has been shown in the "Special Moments" of Chapter 2. So, we're going to polish off some other urban angles here to provide you with additional ideas for your Bucket List set.

Waning Light of Day

TERMINAL TOWER ABOVE THE CLOUDS—SUSAN SHEAFFER CURTIS

Susan Sheaffer Curtis's "Terminal Tower Above the Clouds" shows an unusual view of what was once the second-tallest building in the world, taken, not from an airplane or helicopter, but from a nearby building that now stands even taller. Shrouded in clouds and the waning light of sunset, this picture presents an interesting angle of a building that is—at least for Midwesterners—somewhat iconic and remains, for those living elsewhere, an interesting structure.

Indeed, the 52-story Terminal Tower in downtown Cleveland was, in fact, the second-tallest building in the entire world when it was completed in 1930, the beginning of a decade-long skyscraper "boom." At 708 feet, it

remained as the tallest building in North America outside of New York City until 1964. Today, it's not even the tallest building in Cleveland; this photo was taken from the Key Tower, which stands 239 feet higher.

Curtis took the photo with a Nikon Coolpix 8400 from her office window on the 33rd floor of the Key Tower in downtown Cleveland one late afternoon in winter (you can see snow accents the rooftops in the original photo). "When the sun was beginning to set over Lake Erie," she says, "the unusual fog that hung low over the street, rose to a height below me, making visible the top of Tower City's Terminal Tower."

The blue sky above with a hint of color at sunset was an amazing sight Curtis says. "It reminded me of being in an airplane above the clouds. To reduce reflections, I tried putting the lens directly on the window glass. To get the composition I wanted, the camera had to be at an angle from the window so some reflection could not be avoided."

Because some office lights reflected on the glass, Curtis worked with the image in Adobe Photoshop to eliminate reflections using the Clone Stamp tool. "I also enhanced the soft detail and tonal quality through use of Curves, Shadow/Highlights, Color Correction, and Hues/Saturation tools." She also applied the Smart Sharpen filter to the final image.

A Majestic Skyline

PITTSBURGH AT NIGHT: VIEW FROM MT. WASHINGTON—ATHENA SALABA

Skylines make wonderful photographic images, and Pittsburgh has one of the most photogenic, poised as it is on the shores of the Allegheny and Monongahela Rivers, which combine to form the source of the Ohio River. The task of capturing the city in a photograph is eased by the excellent vantage point offered from Mount Washington, located on the other side of the Monongahela, and seen in Athena Salaba's photograph "Pittsburgh at Night."

Although technically smaller than Cleveland, Pittsburgh has a lot of interesting stuff, which makes it a prime destination for Cleveland Photographic Society photographers (which bused there on a field trip in November, 2007) as well as those who enjoy seeing or photographing its 151 high-rise buildings, two inclined railways that creep up the mountainside, a fort dating back to before the Revolutionary War, or the annual tradition of the Cleveland Browns losing to the Pittsburgh Steelers.

Salaba visited the Mount Washington neighborhood one clear June night. "For night photography of cityscapes I always mount the camera on a tripod," she explains. "I start with a manual exposure using an f/5.6 aperture, and then adjust the shutter speed for a correct exposure. I prefer to slightly underexpose my cityscape photographs, especially if there are some bright lights on the buildings."

This image was captured using a Nikon D40 camera with a Nikon 18-55mm f/3.5 - 5.6G lens, set to ISO 200. The manual exposure at the widest 18mm focal length was f/5.6 for 3 seconds. Minor post processing in Adobe Photoshop included slight cropping, as well as contrast and sharpening adjustments.

I second Salaba's suggestion to shoot night skylines of this sort with the camera mounted on a tripod. Use the self-timer or a remote release to trigger the shutter. Long exposures add some interesting light effects; in the original photograph you can see streaks of light from the cars moving along the parkway along the river's edge.

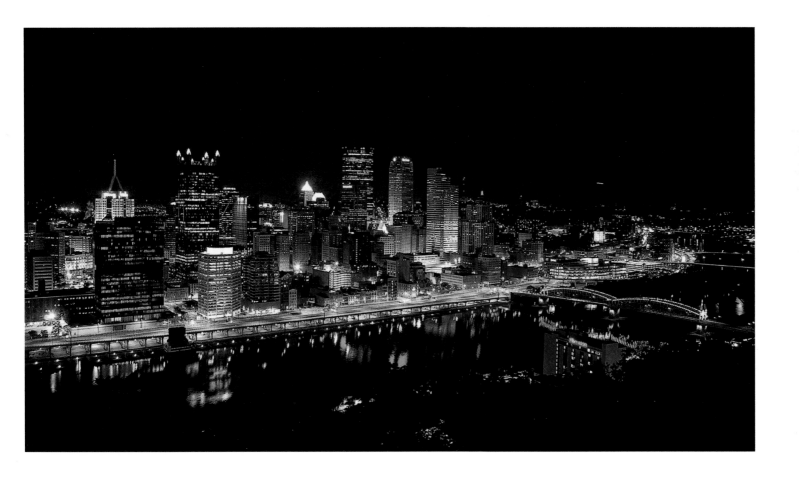

While a City Sleeps

3 A.M. IN THE CITY—RICK WETTERAU

Urban alleyways can be dark, dingy, and scary, especially in the early hours of the morning, and especially if you watch too many crime shows on television. If you're 6' 3" tall and as confident as Rick Wetterau and, maybe, are staying in a hotel in a relatively tranquil neighborhood, scenes like the one shown on the opposite page simply reek with pictorial opportunity. (Rick reports that *speed* rather than height is really the survival factor in environments like this.)

"I was out of town on business in Cumberland, Maryland, and noticed this alley across from the hotel," Wetterau explains. "I decided to get up early and take several images at night of the alley because the light and scenery was spectacular." Of course, if you've ever photographed an alleyway at night, you already know that the light levels can vary widely among the various nooks and crannies. Nooks can be brightly lit, while a cranny next to it is buried in shadow. Wetterau solved his dilemma by resorting to the HDR (high dynamic range) photography style he used for his infrared photo earlier in this book.

Mounting his Nikon D200 camera on a tripod, he set the exposure mode for Aperture Priority, to retain the same f/stop for each of the five shots he planned to take. HDR photography requires bracketing exposures using shutter speed adjustments only so that depth-of-field won't change. The five images were bracketed 2/3 of a stop apart, using an f/7.1 aperture, at ISO 400.

The five images were merged using the Photomatix dedicated HDR software tool, then hue, levels, and saturation adjustments were made in Adobe Photoshop Elements.

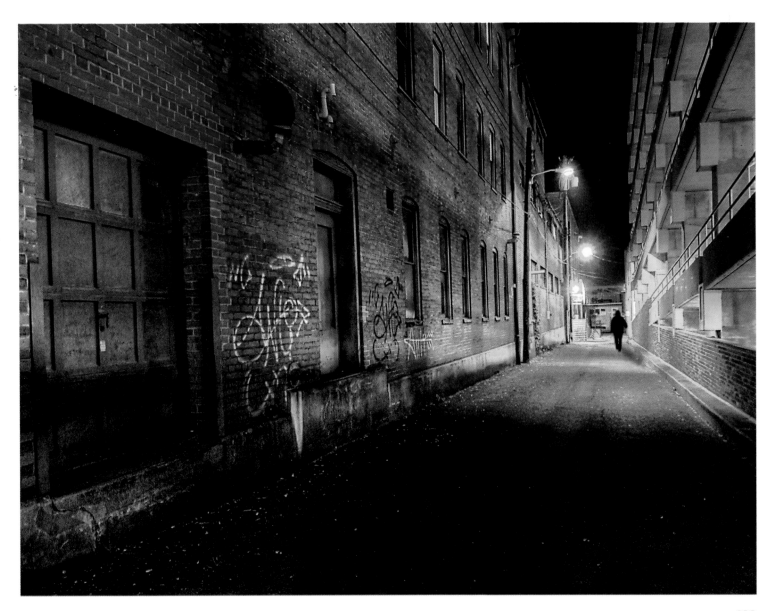

In-Camera Distortion

REFLECTION—ROB ERICK

I'm old enough to remember when filters were something you screwed onto the front of a lens, rather than applied in Photoshop, and image distortion was either something accidentally produced by the camera or viewpoint, or intentionally added using a gadget located somewhere between the subject and the lens.

Rob Erick didn't need any of those tools to create this image, unless you count the mirrored glass windows of a building in downtown Pittsburgh as a "gadget." His photograph "Reflection" was taken on a Cleveland Photographic Society field trip to Pittsburgh in 2007 (for the record, the Browns had lost to the Steelers on the *previous* weekend).

While a horde of the organization's photographers, including me, swarmed around the downtown area capturing images, Erick found himself on the roof of a parking garage, looking at an ornate terra cotta building.

Then, he turned around. "I saw the interesting structure as reflected in the mirrored glass of the building across from the garage. The funhouse effect drew my eye, as well as the juxtaposition of the old reflected in the new." He grabbed the image handheld, using a Nikon 18-70mm lens set to its maximum 70mm zoom position. The exposure on the heavily overcast day was 1/80th second at f/4.5. (Erick wasn't responsible for the organization elect-

ing to visit Pittsburgh in November.) In Photoshop Elements, he adjusted the Levels, Contrast, and Sharpening, then converted the image to black and white using the image editor's Desaturation command.

I'm a big fan of in-camera distortion like the kind Erick came up with. I've photographed myself, and other subjects, reflected in automobile hubcaps and chromed bumpers, imaged in the chest-plates of shiny robots, and reflected from windows that produce funhouse looks like the one shown here. For someone with imagination, the world is not the only source of fodder for interesting photographs—its reflections are equally interesting.

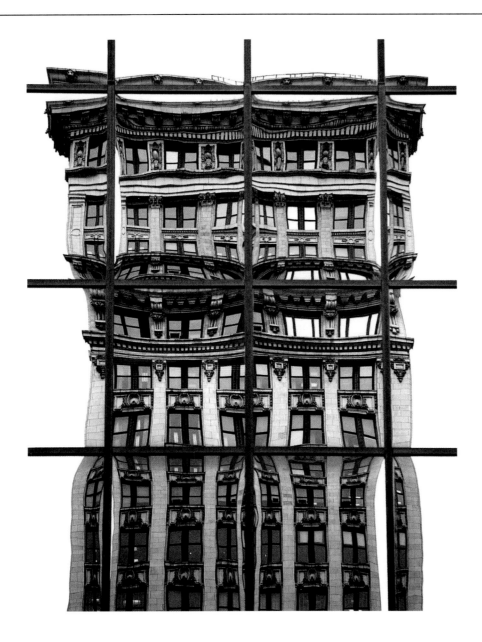

Patterns in Architecture

ROCK HALL—MARY RYNES

You can find fascinating images any-where you look in a city, particularly in the patterns formed by architectural masterpieces (or perhaps in less aesthetically pleasing structures). In fact, some rather ugly buildings can yield interesting shots when they are reduced to the patterns that form their shapes.

Fortunately, the Rock and Roll Hall of Fame in Cleveland is an attractive, futuristic building, and one that lends itself to photographic deconstruction, as Mary Rynes did here with her "Rock Hall" image.

She says that the photo was taken using her Konica-Minolta Maxxum 5D camera (an ancestor of the current Sony Alpha line), using the "Programmed" setting. She used a Tamron 28-200mm zoom lens, set to its widest 28mm focal length, and grabbed the picture with an exposure of 1/125th second at f/8.

"This angle seemed to provide the most varied patterning," she says, noting that originally, "this was not a shot that particularly interested me, but I needed a 'geometrical' image for a competition." She was pleased with the impact of the cropped and, hence, vertical design, and remembers that the image did place in the competition she shot it for.

There was little image manipulation involved, she points out. "Enhancement was obtained through my Photoshop Elements ritual," Rynes says. "I enhance auto levels, contrast, and, sometimes, color. I probably needed contrast in this case and not much else." Then, she proceeded to sharpen the image a bit, but only a little because, at the time she took this photo, the photographer was still grieving for her trusty film camera and was very much afraid of digital "noise." "It represents one of my earliest, easiest, and luckiest efforts."

Today, she loves her camera. "The incredible Minolta camera invites you to take this type of photograph. I might urge you to visit old wooden structures (flour mills and such) along the Cuyahoga river or to find a shore bird with a shadow and a reflection that provide a 'me, myself, and I' challenge," she concludes. "But, in any case, the digital approach to textures and forms is not apt to disappoint you."

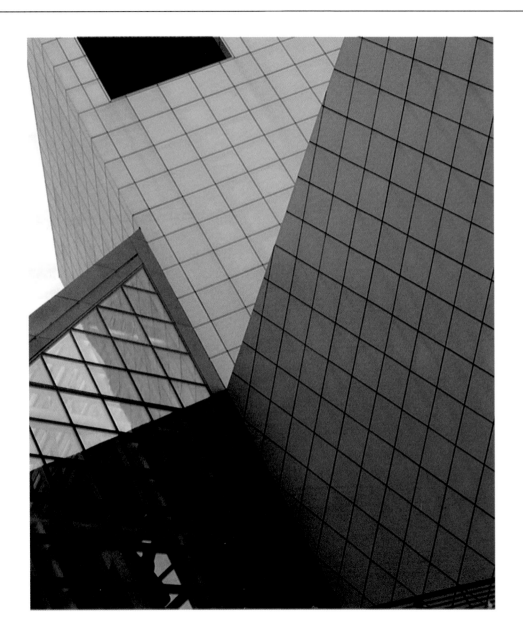

The Prospect of Death

ELEGY IN STONE—ROB ERICK

Cemeteries are, oddly enough, great places for photography, and certainly not the depressing sites you might expect. They're not only locations where one can "visit" the departed, many of them are also skillfully maintained and landscaped areas that offer beautiful locations, like the historic arboretum at Lake View Cemetery in Cleveland, the memorial park where photographer Rob Erick captured "Elegy in Stone."

Founded in 1869, Lake View Cemetery occupies 285 acres of land, and still is in active use for burials (which may be a poor choice of words). Modeled after the magnificent garden cemeteries of Victorian England and France, it includes beautiful horticulture and architecture, a chapel interior designed by Louis Comfort Tiffany, and monuments dedicated to famous "residents" who found their final resting places here, including President James A. Garfield, John D. Rockefeller, and Elliot Ness.

Erick says that the particularly powerful monument pictured "draws me every time I visit for its lifelike accuracy of the carving and the utter despair and grief it conveys." He continues, "The hot afternoon light created a glow on the figure that was particularly captivating on that day."

On various Cleveland Photographic Society field trips, I often watch Erick to admire his shooting style, and have to observe that he gets more use out of his AF-S Nikkor 70-300 G series lens than anyone I've ever seen. (Many of his best shots, including several others in this book, were taken with it.) For this one, the camera was handheld at the 70mm zoom setting, using an exposure of 1/320th second at f/9 in the bright sunlight. In Adobe Photoshop Elements, he made Levels adjustments to several areas, then used some Gaussian blurring to reduce the effective depth-of-field by softening the background. Then, the final shot was desaturated to produce the black and white image you see on the opposite page.

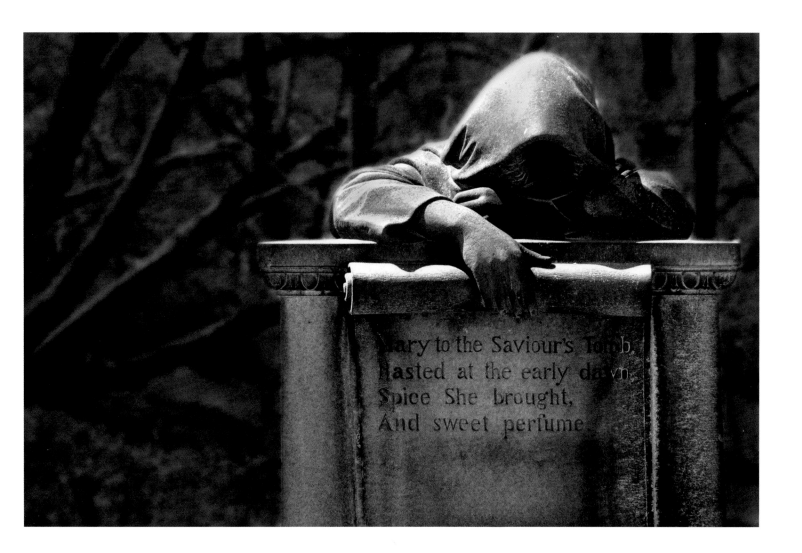

An Iconic Travel Photo

GOLDEN GATE—WILL SEBASTIAN

Many of us have mixed feelings when taking travel photos. On one hand, it's always good to take a photograph of something different, that hasn't been captured from the exact same spot ten thousand times before. If that's your goal, a sign noting "A Kodak Picture Spot" should be your warning to steer clear of a particular scene. On the other hand, some photos are almost mandatory when you visit a location, because of their iconic status. The Eiffel Tower, viewed down the Avenue des Champs-Élysées, the pyramids at Giza, or any shot of the Great Wall of China is instantly recognizable as a typical "postcard" shot of those sites.

If you want an iconic travel photo to include on your personal Bucket List,

the solution, of course, is to photograph a much-photographed sight in an interesting way. That's what Cleveland photographer Will Sebastian did for his "Golden Gate" image shown on the opposite page. Working from Baker Beach, which lies on the Pacific Ocean on the northwest portion of the San Francisco peninsula, he photographed the Golden Gate Bridge as it arches over the entrance to San Francisco Bay to connect with Marin County.

Sebastian wanted to use a slow shutter speed, in order to introduce blur into the moving water of the crashing waves. "So, I used a 3-stop neutral density filter and circular polarizer to allow a longer exposure in the afternoon light," he says. With a Canon

70-200mm f/4 lens mounted on his Canon EOS 5D Mark II, and sensitivity set to ISO 100, he mounted the camera on a tripod, connected a cable release to allow tripping the shutter without introducing camera shake, and took a series of exposures for 1/3 second at f/22. The lens was zoomed to the 70mm position on his full-frame, 21-megapixel camera. In an image editor, he made some minor color and tonal corrections, slightly rotated the image to line up the horizon, and cropped to the 1:2 aspect ratio that made it an effective panorama. (A high-resolution camera like the 5D Mark II does have some definite advantages when that type of cropping is desired.)

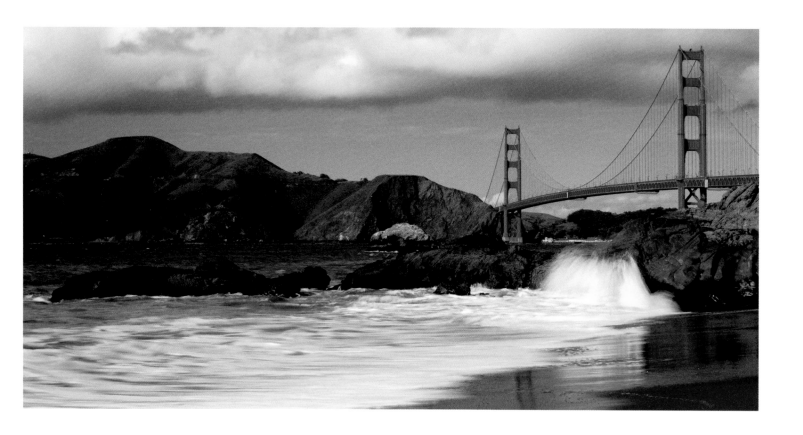

Up in Lights

GLITTER GULCH—RON WILSON

"Downtown" Las Vegas, rather than the Strip itself, has always been popular in movies as an establishing shot to show rather quickly that the action has moved to Sin City. In years past, the iconic image has always been Vegas Vic, the 40-foot tall cowboy who, for many years, waved and shouted greetings to visitors to the Pioneer Club on Fremont Street.

Now that the glitzy street has been roofed over to create the even more glitzy Fremont Experience, Vegas Vic remains, but other neon extravaganzas have gained favor as symbols of the downtown area of Las Vegas. Ron Wilson's capture of this sign for Glitter

Gulch shows one of the most popular— at least among *some* visitors to the city—attractions of the downtown area. (It's Fremont Street's only strip club.)

The club itself has been variously called either an eyesore or the last bastion of "old" Las Vegas. But the sign, on the other hand, is a glory to behold. It's bright enough that Wilson was able to capture the image at 1/200th second and f/5 at ISO 400, *handheld*. No tripod or time exposures needed. He grabbed this shot with his Nikon D200 and 24-120mm lens, using Shutter Priority exposure, and almost no retouching needed in Photoshop.

What transforms this from just another shot of a neon sign into something special? I think it's the way Wilson rotated the camera to shoot the image at an angle motivated, he says, primarily to be able to fully fill the frame in landscape format. The tilted image is dynamic and minimizes any distortion effects from the odd street-level perspective that looks up on the elevated sign. The composition really draws your eye from the cowgirl's boot up to the glittering "Glitter Gulch" logo. Painting images with light is always interesting, and neon signs like this are becoming more rare in these days of LED billboards, so I say grab a picture like this while you still can.

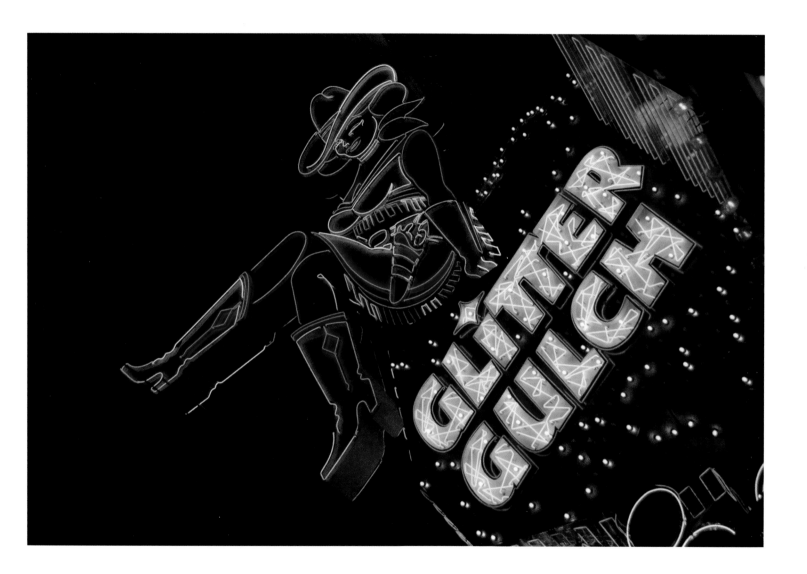

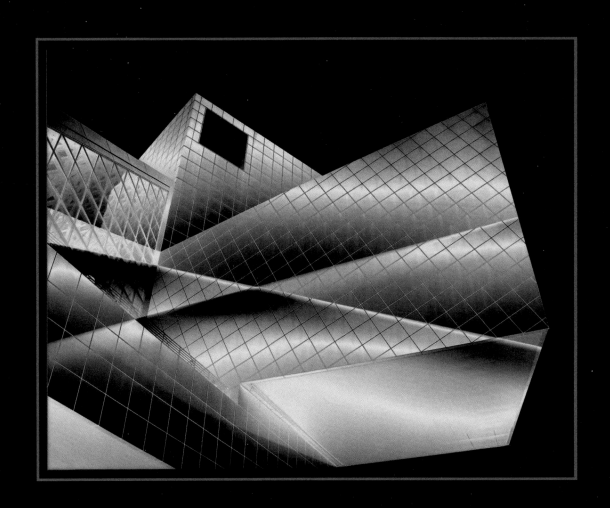

8 Special Techniques

This chapter contains a mixture of images that use special techniques to create eye-catching photographs that you're not likely to encounter in your everyday shooting. Some involve Photoshop transformations; others require only a savvy photographer who knows how to use the features built into the camera to capture unusual views.

While other chapters in this book included photographs that required special techniques and Photoshop magic to achieve, in many cases the manipulation was subtle enough that it wasn't easy to tell whether the image was a "straight" photo or not. You'll have no such uncertainty with most of the photographs in this chapter. They're wacky, wild, and worthy of emulation when it comes time to add finesse to your personal Bucket List of photographs you absolutely *must* take before you die.

Photoshop Magic

YELLOW MUSTANG AND STRANGE HOUSE—ED RYNES

Can't find an interesting subject? Create one using your image manipulation skills. With "Yellow Mustang and Strange House," Ed Rynes shows us that the most mundane of photos can become something special. The original shot, reproduced on this page, might have appeared in the Automobiles For Sale section of your local weekly shopper paper.

Then, Rynes went to work on it, using Photoshop Elements to isolate the car, house, and foliage so that he could apply a distortion filter to the house (alone), replace the background sky with black fill that he dotted with white speckles to mimic stars, and then reposition the plant life. With the saturation of the colors increased and adjusted, the final shot looks like nothing you've ever seen before—unless you grew up in the addled Age of Aquarius.

Fantasy Come True

THE SKELETON BIKE—TODD LIEBENAUER

Todd Liebenauer encountered the motorcycle-riding skeleton at the Cleveland Autorama and grabbed a shot with his Canon Digital Rebel XT using the camera's 18-55 kit lens. The built-in flash caused the eyes to glow, which was the photographer's inspiration to transform the image into something right out of the movie "Ghost Rider."

"A lot of processing in Photoshop was done to create this image," he says in a masterpiece of understatement. "The first thing I did was remove items from the background by cloning them out. To make the background all black, I created a new layer, reversed the image, and used parts of the left side to create a new right."

Once the background was all black, he realized that the reflections in the right mirror caused it to be almost all black and blend into the background too much. "To fix this, I cloned the color from the left mirror into the right. The builder of the motorcycle had painted the bones their natural color," he continues. "For a stronger statement, I used color adjustment to create the redness on the bones as if the flesh had just been removed."

Otherworldly Visions

TOYOTA ALIEN—JOE POLEVOI

If you want to visit an otherworldly place, you need go no farther than Japan, home of high-tech toilets, birthplace of all the electronics fads that engulf the rest of the world a few months later, and source of cool automobiles including the baroque Toyota pictured by Joe Polevoi in the image on the opposite page. I read somewhere that the reason that Japanese cars are festooned with so many name badges, bits of chrome trim, and other doodads is that, in their crowded urban areas, being able to observe an entire vehicle at one glance may be rather rare. So their cars are given distinctive trim that makes it easy to divine which model you're looking at even if you can glimpse only a fender or tail light as it zips past.

Of course, someone may have been pulling my leg, as Joe Polevoi was eager to do with this image that he calls "Toyota Alien." He noticed that, from certain angles, a particular Toyota model had an otherworldly appearance. "I used mirror images of various parts of the car to create a kaleidoscope-like version that emphasized that alien look." Those of us in the Cleveland Photographic Society who have been subjected to Joe's strange visions in the past have started to wonder exactly what planet *he* came from.

From Sublime to Ridiculous

Very Serious Stop Sign—Joe Polevoi

Our next Polevoi-age takes us on a journey to the ridiculous, to a realm where road signs can be confusing, contradictory, or even preposterous. In other words, Cleveland, Ohio. I could tell you that this image was snapped with a Canon EOS 40D camera and Canon 17-85mm zoom lens, at f/16 and 1/250th second at ISO 400, but that wouldn't mean much. Although "Very Serious Stop Sign" looks like a straight shot, it was actually born in the mind of Joe Polevoi, who took relatively harmless signage at a construction site, and used an image editor to turn it into something more.

"With camera on my car seat, I stopped at an intersection at a construction site, stared at the stop sign, and suddenly visualized a much more potent message!" Polevoi says. "I took a snapshot of the sign, returned home and the fun began." By adding to the original restrictions of the stop sign using careful compositing techniques, the photographer created that type of impossible, no-reasonable-options situation that all of us encounter from time to time.

"This example of visual nonsense has stirred more comment than anything I've done previously," he says. "Stretch your imagination sometimes while glancing at very ordinary items in our lives. Something just might be waiting patiently to be discovered!"

Surreal Visions

LOOKING FOR MEMORIES—JOE POLEVOI

Some Photoshop magic is created by manipulating a single image. Other transformations result from compositing parts of several images together. But if you run out of photographs to process in creative ways, Photoshop also has a wealth of painting and rendering tools you can use to create new images from scratch, or using only the most basic true photographic elements. That's what Joe Polevoi did with "Looking for Memories," a surrealistic vision that might have come from the dream sequence of a film.

"I captured a photo of the subject's head in a parade in Tokyo," Polevoi notes. "He was wearing a costume of his ancient clan. The rest of the composition was created entirely in Photoshop." The photographer isolated the man's head from the original image, and rendered it in various sizes on several different layers. He used different amounts of opacity in the layers to create a fading look as the heads receded in to the distance.

The fronds of grass were created from scratch, using one of the brush-tip choices in the Brushes menu. (Choose the flyout menu at the top right of the Brushes palette, select a set of brushes, and choose Append to add them to the available tips in the palette. Everything from roses to rubber duckies are provided.) The sky was a simple medium-gray to light-gray gradient. "I used the gradient to imitate a normal overcast sky," Polevoi says. "My approach here was to portray a dream-like effect."

Celestial Mechanics

ECLIPSE—WILL SEBASTIAN

One thing anyone with a digital camera who has an interest in the night sky will do is try to take a picture of the moon. Such an image is likely to be one you've already attempted, or have included on your own personal Bucket List of photographs to take. While moon pictures aren't particularly difficult, beginners often make some mistakes and get poor results.

Will Sebastian avoided all the potential pitfalls—and surmounted a few new ones—when he captured what has to be one of the most difficult moon shots of all—a lunar eclipse. Armed with his Canon Digital Rebel XTi and a Canon

400mm f/5.6L lens, his photograph "Eclipse" is the result of braving 17-degree (Fahrenheit) temperatures in February to make seven exposures over a two-hour period. Follow Sebastian's example, and you, too, can grab some effective photos of the Earth's large satellite. Here are the keys:

▼ **Use a long lens.** The 400mm lens Sebastian used is virtually the minimum focal length you can use for a moon shot. Shorter lenses produce a small dot-like image that must be enlarged to see any detail at all.

▼ **Use the correct exposure.** You might have to bracket, especially during an eclipse, where the brightness of the moon varies during the event. But, with a full moon, start with roughly the same exposure you'd use in full daylight: 1/400th second at f/11 at ISO 200. A quarter moon is roughly 1/10th as bright. Beginners think they need a long exposure—but the moon is actually 33,000 times as luminous as the bright star Sirius.

▼ **Use a tripod and cable release.** Even with a fast shutter speed, that long lens will magnify any shaking. A tripod and remote release let you lock in your view and then trigger the camera without vibration.

IR Channel Swapping

MILL CREEK OVERLOOK—RICK WETTERAU

You got to view Rick Wetterau's infrared portrayal of nature in Chapter 3. "Mill Creek Overlook" is another example, taken on a brisk fall day with clouds illuminated by the mid-day sun. Shot with a Nikkor 12-24mm wide-angle lens at 12mm with Wetterau's Nikon D80 (converted to full time infrared use by LifePixel at www.lifepixel.com). The picture was taken handheld at ISO 100 with an exposure of 1/320th second and f/9. As with basic IR images, the resulting photograph was rendered in a combination of brick-copper and cyan tones, with the sky shown in various shades of the brick hues.

Channel swapping does nothing more than *exchange* the color values found in the red channel for those in the blue channel (leaving the green channel alone). For most landscape and nature-oriented infrared photos, exchanging the browns found in the sky, water, and similar elements for blue, while swapping the bluish/cyan tones of foliage for browns, produces a more "realistic" image, as shown on the facing page.

You can swap channels using Photoshop's Channel Mixer. Just follow these steps:

❶ Load the photograph you want to use with swapped channels.

❷ Choose Image > Adjustments > Channel Mixer.

❸ Select the Red channel from the drop-down list. Place the cursor in the box to the right of the Red slider. Type in the value 0. Place the cursor in the box to the right of the Blue slider and type in 100.

❹ Select the Blue channel from the drop-down list. Place the cursor in the box to the right of the Blue slider. Type in the value 0. Place the cursor in the box to the right of the Red slider and type in 100. Then click OK.

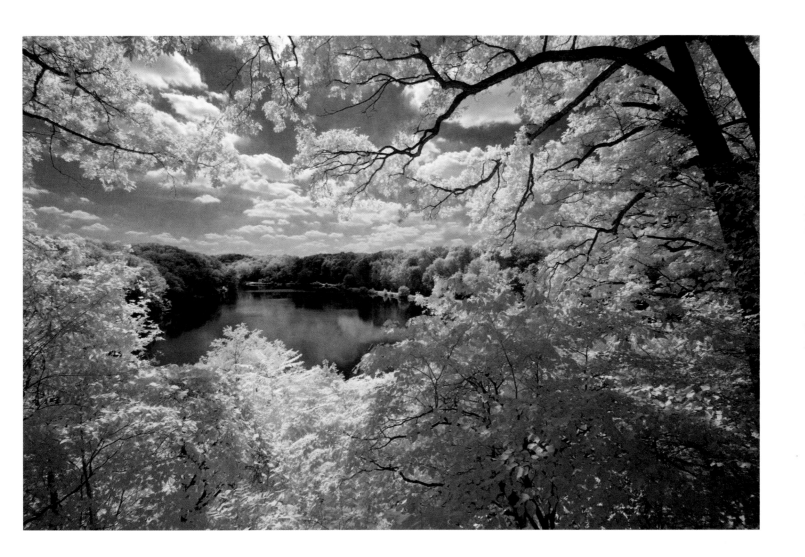

A Floral Abstract

SUNFLOWER UNWRAPS—JANET SIPL

Janet Sipl's original image of a sunflower, shown on this page, and taken with a tripod-mounted Olympus E-510 was a pretty good floral shot. Three cool light soft boxes illuminated the blossom, and a manual exposure of 1/4 second at f/22 with her Zuiko 50mm macro lens yielded a vivid image. But Sipl wanted something more.

"I had a vision of wanting to create a flower that was unfolding, trying to stretch and reach the sides of a frame to become its full size," Janet Sipl says. For "Sunflower Unwraps," she started with a sunflower picked at its peak, selected because of its intense single color and high contrast center.

Using Adobe Photoshop, she added the border to the original photo, and then selected only the original image area using the Rectangular Marquee tool. "Next, I selected the Warp tool in Edit>Transform. This selection put a moveable grid over the selected area leaving the black border untouched," she says. "By clicking and dragging lines and points, being careful not to distort the image too much from a natural flower form, I was able to manipulate the original Sunflower photo into the final form of the photo Sunflower Unwraps. What great fun! "

Painting with Light

IDEA MAN—VARINA PATEL

In addition to offering nature and landscape photography seminars with her husband, Jay, Varina Patel is a prolific stock photographer. One key to success in the field is to have a large number of creative images that can be readily applied to various product, packaging, and business applications. Patel spends a lot of time shooting photographs, not because they have an immediate application, but because they can potentially be useful for a broad range of messages.

"Idea Man" is a conceptual image that evokes a picture of "bright idea"—and a lot more. I particularly liked it because it shows what you can do with "painting with light" techniques—even if you're not actually using light to do the painting. In this shot, Patel has applied a new twist to an old idea.

The image consists of two separate photographs, combined with some digital manipulation. The light bulb was photographed with a Canon 20D, 50mm f/1.8 lens, at 1/8 second at f/4 and ISO 100. The moon was grabbed using a Sigma 75-300mm lens at 1/160th second at f/8 and ISO 100.

"Idea Man is a composite created using Adobe Photoshop and Illustrator," Patel says. "First, I photographed a single light bulb against a clean, white background. In Photoshop, I reversed the image—using a negative effect to produce an image of the light bulb against a black background. I made sure that the metal part of the bulb was not adjusted."

Then, she added a photograph of a full moon taken in Death Valley National Park. "I used Adobe Illustrator to draw a simple figure using my Wacom Intuos Graphic Tablet. I added the figure and several starry points of light to finish the image." The Illustrator shape simulates traditional painting with light techniques—often done in a dark room with a penlight pointed at the camera during a time exposure. By using the graphics tablet, instead, Patel was able to draw the image with much more precision.

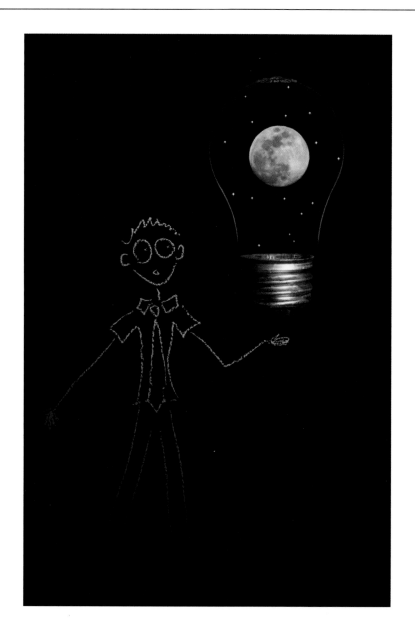

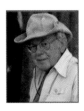

Photoshop Abstract

ROCK HALL ORIGAMI—ED RYNES

Cleveland's Rock Hall of Fame is interesting enough in its own right, with the strange shapes and cantilevered sections that jut out like a Jenga game gone awry. Ed Rynes captured the original photograph, shown on this page using a Nikon Coolpix 8800, with an exposure of 1/128 at f/4.5 at Cleveland's Rock Hall of Fame.

To create the image titled "Rock Hall Origami," Rynes' original shot was converted to black and white in Adobe Photoshop Elements. "I used black fill for sky area, then worked with a combination of layers and filters to affect a folded metallic appearance." The best way to show you what Rynes did is to present both photos.

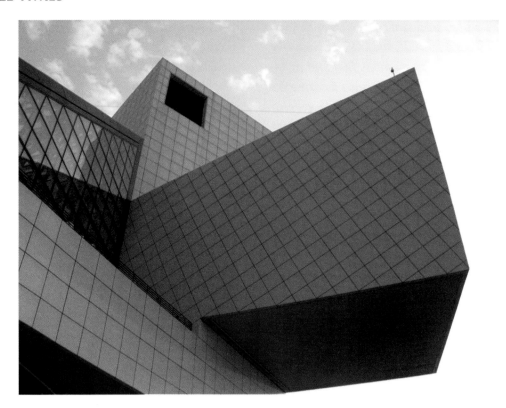

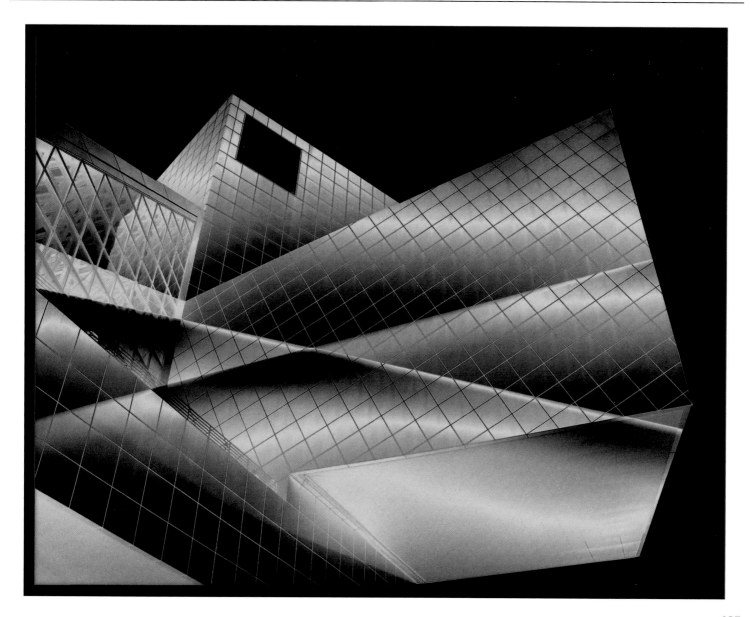

Abstract in Motion

Smoke—H. Arlan Heiser

Abstract images are fun to produce, and, like snowflake patterns, no two are alike. Photographing smoke is an easy way to create abstracts of a subject that's in constant motion. H. Arlan Heiser says that this type of photography, which resulted in "Smoke," makes an excellent rainy day project.

"In northern Ohio we can have some nasty weather that discourages going outside for photography," he explains. "On a very rainy day I wanted to do something with photography so I went to our basement and set up two incense sticks in front of a black backdrop. The incense was held in position with a McClamp unit (a flexible copper wire holding device with clamps at each end)."

He positioned two strobe units at 45-degree angles behind the sticks and aimed at the anticipated location of the smoke. After igniting the incense, Heiser learned that if he moved quickly the air was disturbed and the smoke would swirl away from the camera. "When I lightly touched the McClamp to bounce the incense sticks and moved very slowly back to the camera so the air was not disturbed, the rising smoke would make the series of interesting swirls shown in the photo." The original image was taken with a Nikon D300 camera using a 17-55mm f/2.8 lens, shot at 1/30 second at f/11 with ISO200.

"Just about every photo that I take gets some post processing." Heiser notes "I find Photoshop almost addictive but this shot did not get much enhancing." After cropping, the contrast was increased and the picture sharpened. Making the background a brilliant red to black gradient with the smoke a bright blue produced a striking picture. Heiser says, "Every smoke picture is different."

Moving Water

MASTER'S BRUSH—JEFF GRAY

Moving water, imaged using long exposures, can make for dreamy landscape photos, and are probably already on the list of techniques you'd like to use— if you don't already. Indeed, photos of waterfalls taken at exposures of a second or two have become such a standard (or cliché), that whenever I see tumbling water that isn't silky-smooth, I wonder what the photographer had in mind. Jeff Gray provides a new twist on the moving water theme with this gorgeous photo of a fast-flowing stream, in which the rivulets of the flow seem like brush strokes on a canvas. The shining water's texture inspired Gray's name for the image, "Master's Brush."

"I was walking near a stream on a cloudy day," Gray recalls. "Looking into the stream I saw moss on the rocks showing thru the ripples." The image, to him, seemed like magic. Gray set his Canon 5D to ISO 100 to allow a combination of both a relatively slow shutter speed and wide f/stop. Using a 400mm lens, he captured the image at 1/60th second and f/5.6. In post processing, Gray's only modifications were to increase the saturation a little. "God did the rest," he says.

Although moving water pictures are often taken with the camera mounted on a tripod or monopod, that's not always necessary. A fast-moving stream may have water flowing at such a velocity that a shutter speed of 1/60th second, or even faster, can produce the desired blur effect with the camera hand-held. For images captured at 1/30th second or slower, you'll probably want to use a steady camera support. Experiment with a variety of shutter speeds. You'll get quite different looks in the water movement at 1/15th or 1/8th second than you will at shutter speeds of a second or longer. The faster speeds allow the texture of the water to show; longer speeds produce a silky blur. To get sufficiently long exposure times under brighter lighting conditions, you may need a neutral density filter that blocks out 1, 2, or 3 stops worth of light.

A Appendix

Here you can meet the varied group who contributed the wonderful photos found in this book. At the end of this appendix, you can read about a makeup artist and two models, all favorites of club members, who participated in several of the images presented. Each participant was invited to supply a web page URL and e-mail address you can use to contact them, view more of their work, buy prints of their images, or hire them to work on projects you have in mind. Contact information was voluntary, so not everyone participated. I've left the bios pretty much as they were supplied to me; some are in first-person, others use the editorial third person.

Clara Aguilar

E-MAIL ADDRESS: CLARAGUILAR@YAHOO.COM

Clara is from Medellin, Colombia, South America. She received a degree in Journalism and started her career in Colombia freelancing for a couple newspapers and working full time in Marketing.

Photography has always been Clara's passion. She bought her first camera, a Nikon, when she was 17 years old and has been inseparable from a camera and photography ever since. She had a darkroom for black & white photographs while she was in college and used this technique for a while.

She moved to the USA in 1999, landed in Cleveland in 2000, and is currently working in Marketing. She's been a member of the Cleveland Photographic society since 2008. Moving from traditional film to digital took her a while to adjust. She is starting to explore and experiment with digital photography.

She is focused on capturing the reality of life through her images. She seeks out ideas that tell a story and create strong feelings and emotions. She enjoys travel and has visited many interesting and unique places. She enjoys taking photos of buildings, city landscapes, people, nature, or anything that keeps her memories and emotions alive and vibrant with the place and experience.

Her deep love and admiration for nature have inspired her photographs to capture the shape, texture, color, detail, beauty, and perfection of any and all elements in nature. "I have learned to respect, admire, and observe fine details in nature and be amazed. I will never stop being amazed. This beautiful planet nurtures my soul and spirit and I want to capture all of it through my lens."

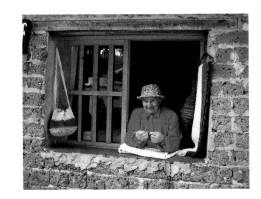

Nancy Balluck

WEB PAGE: WWW.NANCYBALLUCKPHOTOGRAPHY.COM

E-MAIL ADDRESS: NJBALLUCK@ROADRUNNER.COM

As a former art teacher, I've had the opportunity to pursue numerous artistic endeavors, none of which has brought me as much enjoyment as photography. Before going digital several years ago, I began my photographic adventure by taking numerous film based, black and white photography classes at our local community college. It wasn't long before I became a photographic junkie, especially when shooting natural light portraiture. There is nothing more exciting to me than looking through the viewfinder and making an instant connection with the person sitting on the other side of the lens.

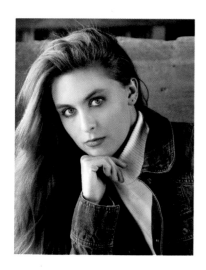

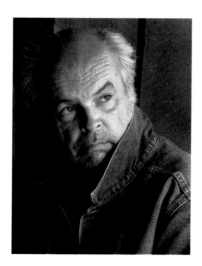

Tony Berling

WEB PAGE: WWW.TBERLING.PHOTOSTOCKPLUS.COM

E-MAIL ADDRESS: TONYBERLING@YAHOO.COM

I first picked up a camera around eighteen months ago as a stress-relieving hobby. Since then I have photographed a wide variety of animals including, wolves, tigers, grizzlies, snow leopards, lynxes, foxes, mountain lions, porcupines, bobcats, coyotes, and even a baby river otter to name a few. For the record, the only animal that has ever gnawed on me a little bit (in a playful and harmless way) was the baby river otter, as I underestimated this little creature, somewhat, after interacting with a grizzly. After starting with wildlife, my work has expanded to include landscapes and more recently people. My goal is to never stop learning with the camera and to be able to photograph anything and photograph it well.

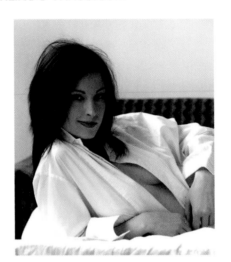

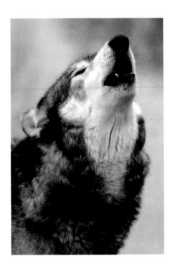

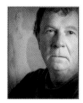

John Earl Brown

WEB PAGE: JOHNEARLBROWNPHOTOGRAPHY.COM

E-MAIL ADDRESS: JJEARLBROWN@ROADRUNNER.COM

John Earl received his B.A. from the Ohio State University in 1972 and became interested in photography while traveling through Europe, the British Isles, Scandinavia, Morocco, and Greece. Upon return, he studied photography for two years at Ohio University under Dr. Arnold Gassen. He then spent two years photographing in the Colorado, Utah, and Arizona area, while living in Boulder, Colorado. A long absence from photography ensued, but in 2004, this hiatus ended with the purchase of a digital camera. Since then, he has been actively photographing and exhibiting in various venues. His main emphasis with his images is to create secondary content that allows the viewer the opportunity for an interpretation unique to each individual. He enjoys photography that goes beyond the mere representation of a person, place, or thing. He feels creative photography should be able to communicate strong ideas, feelings, and concepts to the viewer. John Earl is currently a board member of the Cleveland Photographic Society.

Charles Burkett, Jr.

WEB PAGE: WWW.CHARLESBURKETT.COM

Charles Burkett has been taking pictures for more than 30 years. As a teenager, he initially learned about black and white film photography and processing during summer and after school programs at the Cleveland Board of Education's Supplementary Education Center. Over the years, he has taken photography-related courses at Hampshire College, Smith College, and Case Western Reserve University.

Photography gives Charles a chance to express himself creatively, as a counterpoint to his more analytical, quantitative pursuits as a professional in the economic development field where he has worked for over 20 years.

For the last four years, Charles Burkett has led the Digital Photography Special Interest Group for the Greater Cleveland PC User's Group. He is a part-time instructor in photography-related topics for the educational services division of Ideastream. He is a member of the Cleveland Photographic Society and the Digital Publishing Users Group. Several of his photographs were featured in the book *The Browns Fans' Tailgating Guide* published by Gray & Company.

Elisha Cerino

WEB PAGE: WWW.ELISHACERINOPHOTOGRAPHY.COM

I've had an interest in photography for many years and looked forward to pursuing it more when the time was right. Thankfully, my season has come. I'm blessed to have a great photography club close by, the Cleveland Photographic Society. Several years ago, I took their Fundamentals of Good Photography course and got involved in this wonderful club. I consider myself a life-long student. I attended Summer Intensive at Rocky Mountain School of Photography in 2008 and I look forward to many more photographic journeys. It's amazing how this world looks through the lens; I see God's hand in even the most ordinary subjects, and I strive to glorify Him in my life and in my photography.

Susan Sheaffer Curtis

E-MAIL ADDRESS:SSC728@YAHOO.COM

As an art major graduate from Morehead State University in Kentucky, I owe my 30 years as a professional designer with a roof over my head to photography. Taking photography classes led me to work in the university TV graphics department, summer internships in Marathon Oil Company's photography department, and my first full-time job in a Louisville pre-press plant. Eventually, I landed a career position as a graphic designer at Marathon in my hometown of Findlay, Ohio. During that time, a post-graduate photography course at Bowling Green State University generated a photo book I created portraying my 94-year old grandfather-in-law. Since then, I freelanced in Columbus, Ohio, for seven years, spent several years designing at SUNY Albany in New York, and now live in "rockin'" Cleveland, Ohio as a single mom of a teenage daughter and as senior designer with Deloitte.

Photography has enhanced my creative skills and documented my life-long love of travel. Transitioning from film and dark room work to digital and Photoshop has been exciting. Specializing in photo editing and restoration, I am inspired and challenged to make pictures that not only capture the moment but transcend time and spark the imagination!

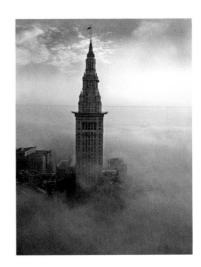

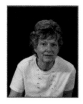

Jan DeBlaay

WEB PAGE: WWW.JANDEB.SMUGMUG.COM

E-MAIL ADDRESS: DDBJDB@AOL.COM

Photography enhances the beauty and wonder of life. Jan finds photographic moments on trips to Maui and Kauai, to the coasts of California and South Carolina or locally, on field trips with camera clubs and friends. She and her camera are constant companions to many social events and venues. Her popular focus encompasses portraits, artists in action such as gymnastics and dancers, landscapes, cityscapes, seascapes, night lights, and animals. She loves to visit places of interest: parks, gardens, events, and shows. Often, Jan will attend workshops, camps, and photographic shoots to practice current trends.

Jan's interest in photography peaked in the '90s with her first Canon SLR film camera. She completed several courses with Better Photo including a course on "Studio Lighting," which resulted in the purchase of three Alien Bees strobes, several backdrops, reflectors, and stands. She now has a home studio to photograph families' and children's portraits. A few years ago, Jan bought a Canon 5D and new lenses. She now has a website at Smug Mug where she posts her current shoots.

Over the past few years, Jan has attended workshops with professional photographers, Don Gale, Brenda Tharp, Bob Kulon, and Jack Graham. She will continue a quest for the "perfect" photo as her photographic life continues to evolve.

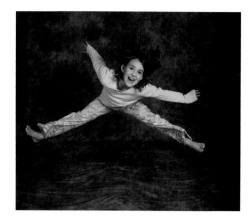

Cheryl Donovan

Hello, I'm Cheryl Donovan. I consider myself an enthusiastic amateur photographer who has always loved taking pictures of my family and friends to document their lives. It was easy to become more interested in photography when the digital era arrived, making it more affordable to shoot enough frames to actually get a better understanding of apertures, focal lengths, and shutter speeds.

In the fall of 2006, I enrolled in the Cleveland Photographic Society's fundamental photography class. I had such a great time at the school, I then joined their camera club. Being in an atmosphere with others who love to do their best work and enter it in competitions has helped me to become a better photographer.

Moving away from the crowded suburbs with my husband and daughter to Hinckley, Ohio has been one of the best things I have done. Looking out over our rolling pastures at our horses is an ever-changing picture that I never tire of looking at. I believe there is great inspiration in taking a picture of something ordinary and making it look extraordinary.

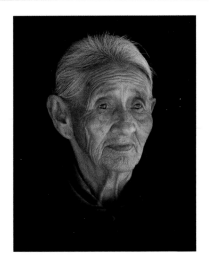

Sharon Doyle

WEB PAGE: WWW.DOYLEPHOTOS.COM

E-MAIL ADDRESS: SHARONDOYLE1@YAHOO.COM

Even as a young child, pictures were very important to Sharon. She enjoys observing the little details in pictures and can easily become mesmerized by captivating images. Pictures allow people to share moments, places, and feelings with others, as well as to create awareness. Sharon photographs everything, but she cherishes nature and wildlife most.

Sharon used the same 35 mm camera for almost 30 years and then finally bought a digital camera in 2007. Also in 2007, she joined the Cleveland Photographic Society and she is a proud winner in multiple competitions. Sharon has no formal training in photography. She is appreciative of all of the beautiful photographic opportunities presented by nature. Life is WONDERFUL!

Rob Erick

WEB PAGE: HTTP://WWW.FLICKR.COM/PHOTOS/CPS_ROB

E-MAIL ADDRESS: LIGHTINABOXPHOTOS@GMAIL.COM

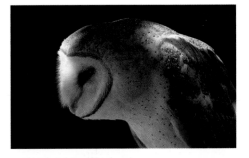

I always wanted to be an architect. So many times, we are forced to choose between primarily using either the left or the right side of the brain, but architecture blends the two seamlessly, challenging one to constantly balance art and science. But I never could draw anything that didn't involve straight lines, and math was never my strong suit.

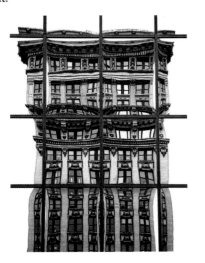

But later in life I found another way to explore that curious alchemy of precision and expression—and photography has been my passion ever since. The concentration necessary to compose an image pleasing to the eye while also effectively balancing light, movement, and depth allows for an immersion that permits a total, if temporary, escape from the ordinary.

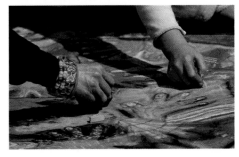

Photography allows one to see the world differently, to appreciate fine detail that others miss, and to delight in the play of light and pattern and shadow in everyday things. The talented group of people at CPS has encouraged and supported my growth as a photographer—and I am blessed to share with them the passionate pursuit of capturing light in a box.

Neil Evans

Web page: At www.flickr.com, search for user ncevans

E-mail address: nevans1524@aol.com

In terms of photography, I've been taking my hobby seriously for around five years now. I started out by photographing my roses and for the most part have concentrated on nature. I have my prints in several galleries and framing shops in the greater Cleveland area. I also have had several shows, probably the most noteworthy being in the library of the Cleveland Botanical Garden. I am the vice president of the Cleveland Rose Society and am now a member of the master's class of rose photographers of the American Rose Society. Several of my rose photographs have appeared in *American Rose* magazine. I have been a member of the Cleveland Photographic Society for a few years now.

As to my life: I was born in Cleveland and currently live in Brecksville. I am married, a retired high school English teacher, and my hobbies are growing roses and photography.

Jim Frazer

WEB PAGE: WWW.NEO-PHOTOGRAPHY.COM

E-MAIL ADDRESS: JIM@NEO-PHOTOGRAPHY.COM

My interest in photography started when I was a teenager in the late '50s. During my college years, I was in a cooperative program that had me working at Eastman Kodak for six months of the year. I was able to join their camera club and learned to appreciate photography even more. Life intervened for many years after that. My photos during those years were family and vacation shots. In 2007, I retired and shortly after that, I joined the Cleveland Photographic Society. Photography has now morphed from a hobby to a passion.

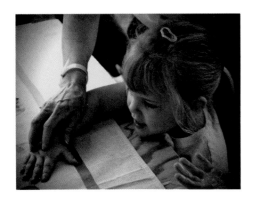

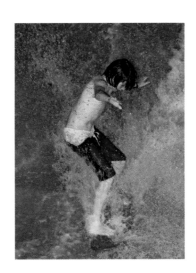

Diane Funk

E-MAIL ADDRESS: DIANEFUNK@HOTMAIL.COM

I love learning and then passing that information and/or skill on to others. I worked as a young peoples' art teacher in public schools; summers at Chautauqua Institution, New York; Saturdays at the Cleveland Institute of Art; and also for the young spirited adults in various programs and at the Cuyahoga Community College. After exploring various methods and media, I now love digital photography, working in my yard, and occasionally, traveling. Of course, the camera is in hand.

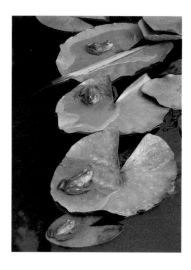

Dennis J. Goebelt

WEB PAGE: WWW.DENNISGOEBELTPHOTOGRAPHY.COM

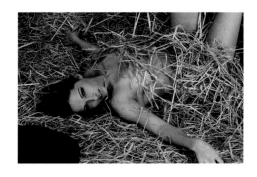

I have had an interest in photography all my life; but only became a serious photographer a few years ago when I retired from the fire service. My niche seems to be portrait and wedding photography. I love to work in black and white when possible. I am also a huge fan of film noir and photojournalistic style shooting.

In photography, I have found my life's new passion, and I will continue to strive to improve my skills as long as I have the strength to push the shutter release.

Jeff Gray

WEB PAGE: WWW.JEFFGRAYPHOTOSTUDIO.COM

E-MAIL ADDRESS: GRAY1411@SBCGLOBAL.NET

I have been a photographer for most of my life. I started out with a pinhole camera made from an oatmeal box. Luckily, times have change and so has the technology. I have embraced the new digital technology. I love taking pictures of the nature that surrounds me.

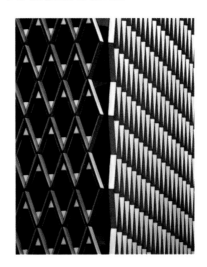

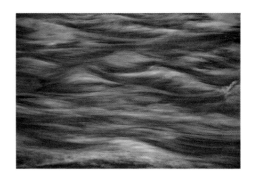

H. Arlan Heiser

E-MAIL ADDRESS: ARLANH@SBCGLOBAL.NET

Fifty-nine years ago while in high school I became interested in photography and had a dark room in our family basement. When the school paper or yearbook needed a photo, I would be excused from class to take the needed pictures. That beat being in Spanish class! Then there was a 20-year gap for college, marriage, and career before coming back to the hobby, this time using a Japanese SLR camera. Again, I put together a basement darkroom. Doing promotional photography of the products the company produced kept the darkroom busy, but after a few years increased career activity took precedence over photography and the darkroom collected dust. In 1993, I retired and shortly thereafter discovered digital photography and Photoshop with no darkroom required. We have a motor home that has taken my wife and me, plus lots of camera gear and computers, from Alaska to Florida to the north tip of Newfoundland. Shooting pictures during the day and processing them in the evenings adds a welcome and interesting dimension to our travels.

Don Keller

I played with photography while a teenager after receiving a developing kit as a gift. What a thrill it was to see the image come up in the developer! It wasn't important at the time to have only a box camera, the thrill was there.

While in the service I took record shots of places I visited fully expecting them to be photographic masterpieces. This attitude continued for many years but my shooting became limited to vacations when I became the photographic artist wanna-be only to have the slides returned and find that once again I had "missed it."

In 2002 my wife and I visited Grand Canyon; Bryce Canyon; Page, Arizona; and Zion National Park. I carried a Nikon 5700, my first digital camera and was hooked, in spite of the horrible images, and was motivated to learn more about this craft. Since then I have attended photo workshops, joined the Cleveland and Western Reserve Photographic Society, and subscribed

to several photo magazines all with the purpose of learning.

Today I greatly enjoy photographing the beauty of God's creation and do so as often as I can.

Dan Le Hoty

WEB PAGE: LEHOTYPHOTO.COM

E-MAIL ADDRESS: ELECTRODAN45@AOL.COM

Native to Cleveland, born in 1958, a union electrician by trade, I have one brother, two sisters, two daughters (both in college), and a son who shares my love for photography. My first interest in photography started early on at age 16 with black and white photography and darkroom processing. An avid enthusiast in nature, horses, Indian lore, jewelry (silversmithing), pencil drawing using various media, metal fabrication, and outdoor adventures.

As time progressed, my interest never left me from black and white but has expanded to include monochrome, infrared, black light, and color photography. I am currently specializing in macro of flowers, insects, and birds but still have a passion for landscape, places, and animals. Some of my photos and drawings have been sold and are proudly displayed in places of business, homes, and offices.

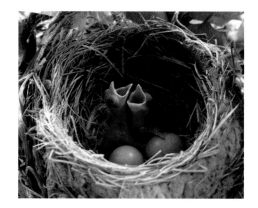

Todd Liebenauer

WEB PAGE: WWW.HOTRODSIGNS.NET

I have been an active photographer for about five years now. It all started when my wife wanted me to go on more nature hikes with her. She thought I would be more interested in going if we were taking pictures of the wildlife and landscapes we saw. I have to say she was right. At first, I mainly concentrated on nature photography. About three years ago I combined my passion for automobiles with my new hobby of photography and started my first business, Hotrod Signs. I create photographic signs of classic cars using Adobe Photoshop for people to display with their cars at car shows. When I was younger, I loved to draw and paint pictures. With photography, I have found a way to do this digitally.

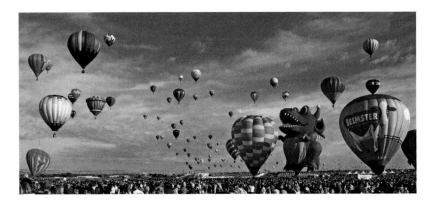

Michelle Leigh

WEB PAGE: HTTP://MLEIGH.PHOTOSTOCKPLUS.COM/

E-MAIL ADDRESS: M_LEIGH67@YAHOO.COM

I was surrounded by photography as a young child (thanks to my mom); however, I did not pick up my first "real" camera until a little over a year ago, when I was in my 40s. Now, I can hardly imagine life without a camera strapped around my neck as I race out the door, following and documenting my three beautiful daughters as they grow and change into beautiful young women.

What I love about photography is all the directions you can take it. It can be for documentation, for a record of life events, for fun, and, what I love most, it can be art.

Maria Isabel "Bel" Martins

WEB PAGE: WWW.BELGLOBEADVENTURE.COM, BELMARTINS.SMUGMUG.COM

E-MAIL ADDRESS: MARIAISABEL150@HOTMAIL.COM

Born in Brazil and now a resident of Parma, Ohio, Bel's interests in photography and travel started in her early years. Travel has been a constant in her life, but she just recently took photography seriously. She describes herself as a world photographer due to her large array of interests. Her main subjects are found in nature, followed by travel, nature close-up, still life, and fine art.

Even more recently, Bel has ventured into wedding photography and portraiture, which to her own surprise, she found very rewarding. She says, "I am just experimenting by taking photos of family and friends."

Bel writes articles on travel within Brazil and Brazilian culture for *Brazil Explore* magazine based in Los Angeles and contributes to *The Brazilian Pacific Times* newspaper in San Diego, California. She is currently planning photographic expeditions to the Amazon, Pantanal, national parks, and the coastal regions of her home country, Brazil.

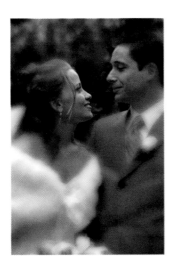

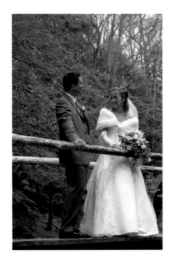

Peggy Miklus

E-MAIL ADDRESS: PEGGYMIKLUSPHOTOGRAPHY@YAHOO.COM

I always loved taking pictures of my daughters as they were growing up, trying to capture their unique poses and expressions that childhood brought, but I was limited with my little point and shoot camera. I remember picking up the old *Life* and *National Geographic* magazines staring at the black and white photography, and dreaming of creating some of those images myself one day. In 2006, I enrolled in a local community college to learn the technical aspects of photography by taking a Black and White Photography class. After purchasing my digital SLR camera, I joined the Cleveland Photographic Society in 2007 to attend the classes the club offered and also to interact with many different levels of photographers. Soon after I found my passion in taking close-up images of flowers and I had to have a macro lens. Flowers have a natural beauty and artistic quality all their own with their blend of colors, shapes, and curves; I find it a wonderful challenge to try to capture. Some of my framed images are on display at Nirvana Yoga Studio in Richfield, Ohio.

Kathleen Nelson

WEB PAGE: WWW.KATHLEENNELSON.COM

E-MAIL ADDRESS: KNELSON10@GMAIL.COM

Kathleen Nelson, having always had an interest in photography, took her first class in beginning photography at the Cleveland Photographic Society in 2001 using a basic film SLR camera. Since that time she has gone totally digital, with her current camera being the Canon 5D Mark II. She has taken many photography courses and workshops throughout the United States since her original class and will continue to do so, as photography is something one never stops learning. Her main subjects are her seven grandchildren, but she also loves photographing the beauty of nature, flowers, and landscapes (especially in her home state of Ohio and in Oregon, where her daughter and two of her grandchildren reside). Kathleen also sells stock photography through several agencies, including Alamy and Acclaim Images.

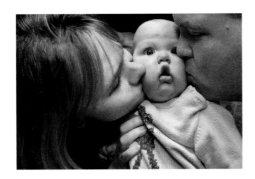

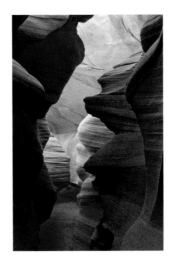

Varina Patel

WEB PAGE: WWW.PHOTOGRAPHYBYVARINA.COM

E-MAIL ADDRESS: VARINAC@MSN.COM

I shoot a wide variety of subjects, but there is nothing more remarkable to me than the power of nature. It is both cataclysmic and subtle. Slow and continuous erosion by water and wind can create landscapes every bit as astonishing as those shaped by catastrophic earthquakes or volcanic eruption. Nature is incredibly diverse—quiet streams and roaring waterfalls, burning desert sands and mossy riverbanks, silent snowfall and raging summer storms.

The physical demands of landscape photography are part of its appeal. It is not unusual to climb a steep trail and wait several hours for sunset—despite intense heat or numbing cold—only to climb back down in the dark without getting the shot because the light

wasn't right. I love hiking long trails through wilderness, crossing rivers on slippery stones, and climbing sand dunes by the light of the moon. I thrive on rising before the sun in order to capture those first rays of sun on the mountain. I don't mind wet feet, muddy clothes, or aching muscles— if in the end, the photograph makes an impression. I am irresistibly drawn to the challenge of finding the right light, in the right place, at the right time.

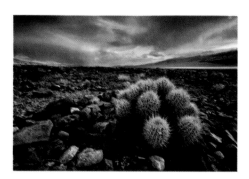

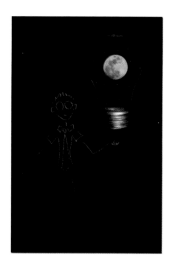

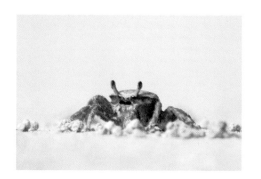

Barbara Pennington

Web page: BARBARAPENNINGTONPHOTOGRAPHY.COM

E-mail address: BARBSHALO@ROADRUNNER.COM

From the time I picked up my mother's box Kodak camera at age 10, I was drawn into the magic of the lens. Through the next 50 years the desire to explore photography was always there. So were life's responsibilities. Many long years later, Ed Coyle introduced me to the mysterious digital camera. From the time those first images appeared on my computer screen, I was hooked. Now, six years later, photography in some form, has become a part of my everyday life. My Nikon does not discriminate about age, gender, ethnicity, physical condition, or neighborhood. Photography opens the path to capture, record, surprise, friend, and gift. It pushes me, frustrates me, motivates me, soothes and comforts me. What an exciting adventure!

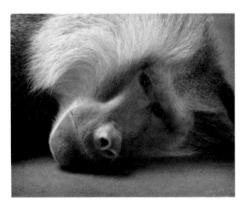

Joseph Polevoi

E-MAIL ADDRESS: JOEDRAWS@AMERITECH.NET

I'm currently having a ball combining my photos with Photoshop (and other filters) plus a little imagination. I refer to them as "Photoshop Phun." My career consisted of creating graphics and photography, mostly normal visual statements, performing as an art director before calling it quits in 1986.

I discovered computer graphics about 12 years ago and the creative fun began. I always look forward to sharing with my favorite photography crowd—the CPS folks. I may get serious every so often but don't fret: that does not usually last.

Shannon Rice

WEB PAGE: WWW.SRICEPHOTO.COM

E-MAIL ADDRESS: SHANNON@SRICEPHOTO.COM

I took my first photography class in 1997 and immediately fell in love with it, especially people photography. After briefly considering pursuing photography as a career, I decided against it because it was "not practical." I went off to college and studied the practical field of computer science, graduated and got a job in my field. Through all of this I remained a photographer, taking pictures everywhere I went.

As digital photography became popular, I knew it was the way I wanted to go. I love the idea of taking photos of everything without the added expense of processing film, then instantly reviewing the pictures to see what I can create. I strive for a great picture in the camera that can be turned into an extraordinary image in the computer.

In 2008 I discovered the Cleveland Photographic Society. I took some of the classes, attended field trips and meetings—and realized that "practical" isn't as important as doing what you love. In January 2009 we opened Shannon Rice Photography, LLC. We specialize in people photography of all kinds: studio and on-location, kids, families, high school senior portraits, and weddings.

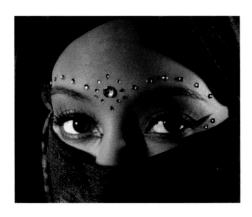

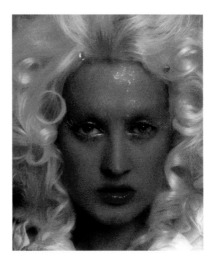

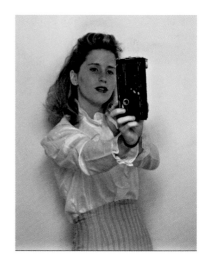

Kolman Rosenberg

WEB PAGE: WWW.KOLMANPHOTOS.COM

My interest in photography began as a college newspaper and yearbook photographer during the stormy 1960s and 1970s. I was influenced by many of the great photojournalists and documentary photographers such as W. Eugene Smith, Walker Evans, Dorothea Lange, Gordon Parks, Margaret Bourke-White, and other black and white photographers of *Life* magazine and the earlier Farm Security Administration. Though many of these photographers documented the horrors of war and the plight of poverty, they also showed me the dignity and adaptability of human beings in their desire to prevail.

The camera serves as a portal for me to view common sites in an uncommon way. It enables me to see, and point out to others, the beauty, irony, interest, humor, and sometimes the ugliness of the world we live in. I hope my images bring a realization to others that common things in life are often worth more than a glance; they are often worth a second glance.

My images will provide you with that second glance of the mundane, humorous, common-place, and sometimes ugly or painful aspects of our world with the intent of helping you also take the time to notice the dignity, beauty, and adaptability that is evident in each.

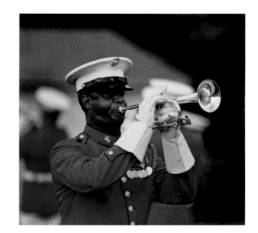

Ed Rynes

WEB PAGE: HTTP://WWW.CLEVELANDPHOTO.ORG/CPS MEMBER GALLERY/ED RYNES/INDEX.HTML
WWW.FLICKR.COM/PHOTOS/27000700@N05/

E-MAIL ADDRESS: EJRYNES@MINDSPRING.COM

Ed Rynes has been capturing photo images since obtaining a Contax 35mm camera as an 18-year-old G.I. in occupied Japan. He acquired some technical knowledge of photography at Ohio University and has attempted to build on this as photo technology has progressed. He now uses digital imaging almost exclusively. He currently enjoys stalking wildlife with his wife (Mary), stalking people (street photography), portraits and fashion, classic cars, assorted flora and fauna, and anything that can result in an interesting visual image. Every photo capture ends up in Photoshop where the fun begins.

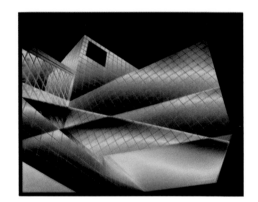

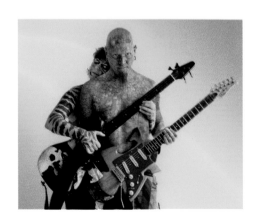

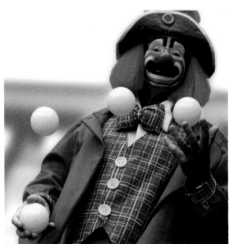

Mary Rynes

WEB PAGE: WWW.CLEVELANDPHOTO.ORG/CPS MEMBER GALLERY/MARY RYNES

Mary Rynes enjoys photography, but urges her camera to do most of the work. A fine digital camera (almost always on programmed setting) plus limited (hopefully improving) skill using Photoshop Elements encourages two kinds of overindulgence: spotting endless images out in the world, followed by spotting images in this or that or the other corner of the shot as taken. Benefiting from the company of a serious photographer (her husband, Ed),

Mary enjoys gathering, processing, and printing photographs. Birds are her favorite subjects, but she can't pass the Peter B. Lewis Building or a reflective surface or a visible fish without snapping away. Viewing the work of a community of excellent CPS photographers and studying the commentary of its thoughtful judges have provided a valuable introduction to what is becoming, for her, much more than a fascinating hobby.

Athena Salaba

E-MAIL ADDRESS: ASALABA1@YAHOO.COM

Many years ago I became interested in photography, purchased my first SLR camera and started shooting landscapes to capture trip memories. Busy times with school and work made it impossible to continue this hobby until a couple years ago when I purchased my new dSLR camera. As a life-long student, I enjoy learning new techniques and keep trying new things to improve my photography, many times inspired by the work of others and sometimes by experimenting on my own. Photography for me is the perfect means to express my love and amazement of nature without having to use a thousand words. It offers a different view of the world and makes you pay attention to wonderful details that would have been otherwise missed.

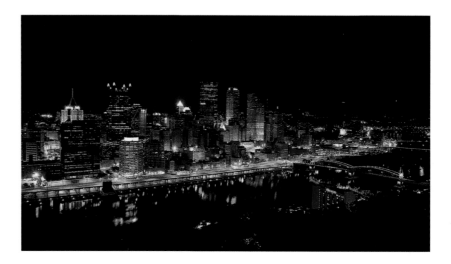

Carol Sahley

WEB PAGE: WWW.MAPLE.IMAGEKIND.COM (PRINTS AVAILABLE)

WWW.FLICKR.COM/MAPLECREST (PERSONAL WORK)

E-MAIL ADDRESS: CSAHLEY@GMAIL.COM

I became an avid amateur photographer after buying my first dSLR in the Fall of 2005. I live on a farm in Brecksville, Ohio, and enjoy taking pictures of our farm animals and pets. I strive to capture the unique personalities of our goats, cats, and horses, as well as the dramatic beauty of our dahlia gardens. My favorite subjects include my two Pygmy goats, Mimi and Jumper, and my playful Nigerian Dwarf goat, Casper (the friendly goat). We grow nearly 80 different varieties of dahlias, which provide endless photographic opportunities. I am also fascinated by macro photography, and am trying to master photographing water drops. My partner Brant is an excellent photographer's assistant!

David S. Saunders II

WEB PAGE: WWW.FLICKR.COM/PHOTOS/DSSTAO

E-MAIL ADDRESS: DAVE@DSAUNDERS.ORG

Beginning two years ago, David's discovery of photography follows an eclectic variety of other pursuits throughout his 31 years. As a young middle-school student, David became interested in computers, adding chess club and a black belt in Tae Kwon Do to his accomplishments as a teenager. After graduating, and until today, David started and operates three companies, has spent time living in China, picked up an affection for riding fast motorcycles, and continues to travel to other parts of the world including Japan and Brazil. Aside from photography and travel, his current passions include amateur investing, linguistics, psychology, entrepreneurship, and design of complex computer network infrastructure for his clients.

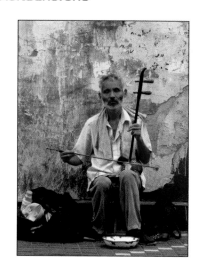

Will Sebastian

Web page: http://www.williamsebastianphoto.com

My interest in photography started when I bought my first digital camera back in 2002. I'd categorize myself as a serious amateur. Photography became a hobby of mine in 2006 when I really started to learn the art. My main focus is on nature photography and experiencing the outdoors. Just remember when you are out in nature; take only pictures and leave only footprints.

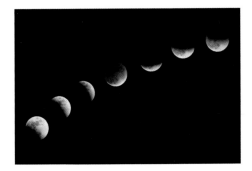

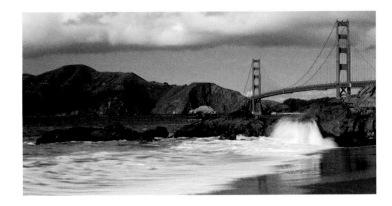

Dale/Jen Simmons

WEB PAGE: WWW.BLACKWATCHART.COM

E-MAIL ADDRESS: INFO@BLACKWATCHART.COM

Dale and Jen Simmons (aka BlackWatch) tell stories through their images—creating images that make you think, bring you to another time, or make you laugh. A talented artist in California once said of their work "a superb story teller. In my opinion this is how Hitchcock would have photographed people." Who wouldn't love being compared to Hitchcock!

Their inspiration comes from old movies and television, pop culture, painters (especially Jack Vettriano), a ridiculous sense of humor, and all of the little absurdities that surround us daily! A favorite quote of theirs is "If you are looking for a common theme in our work…think blatant disdain for reality!"

They are a husband and wife creative team—together they are tale spinner, creative director, makeup artist, wardrobe stylist, hair stylist, photographer, retoucher, and graphic artist. They like to think of themselves as artists that use a camera rather than photographers.

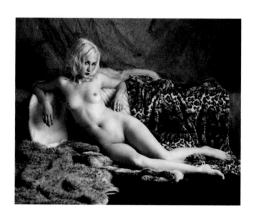

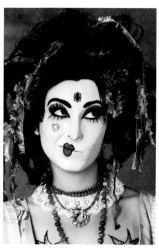

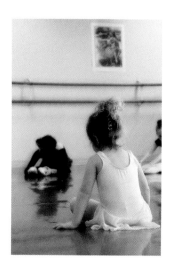

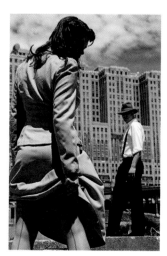

George A. Sipl

E-MAIL ADDRESS: IEQ@AOL.COM

I am an audio engineer/composer by trade. I find that using my eyes as opposed to my ears is very relaxing, hence photography is the perfect therapy. I was interested in photography in the mid '70s, taking mostly slides, but because I didn't have a darkroom, I was always frustrated by the results.

The advent of digital technology resurrected my camera addiction, allowing me to create and mold my compositions to my liking. I enjoy combining shots, then playing with the exposure, color, brightness, and all the other numerous toys software provides us.

Janet Sipl

WEB PAGE: WWW.FLICKR.COM/PHOTOS/23291684@N02/

E-MAIL ADDRESS: JSIPL@AOL.COM

I am a relative newbie to photography. I am soon to be a retired teacher and look forward to doing photography full time. I have only known the digital side of photography and I consider this to be an advantage. It is exciting to have such a variety of innovative digital tools and techniques available as resources. These tools along with a good creative eye can help create an end product that reflects a photographer's vision in a way never before thought attainable. I think of myself in terms of being an "Art-tographer." I find that as I try different things, new and amazing artistic doors open. I learn by doing, and my learning is an ongoing journey. I hope you enjoy some of the images that I have captured on this journey.

Nathalie Lovera Snyder

WEB PAGE: WWW.NATHALIEROSEPHOTOGRAPHY.COM

I don't know what to write. All I know is that I have loved photography as far back as I can remember. I got my first "real" camera when I was 12, and when I got my pictures back I was hooked. I love shooting people because I think there is something very magical in each individual and it's fun to try to bring that out. I also find the smile on a mother's face when she holds a beautiful picture of her baby very rewarding , or a photograph of a five-generations family, or one of a woman feeling beautiful. It's all about creating moments and memories for people that will be a part of them for the rest of their lives, even their kids' or grandchildrens' lives.

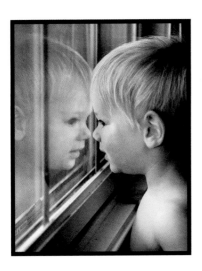

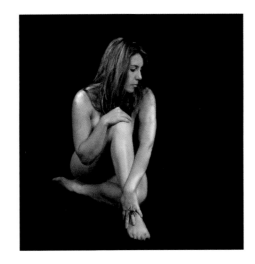

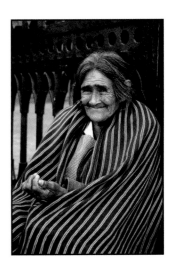

Jamie Ann Umlauf

E-MAIL ADDRESS: JAUMLAUF@COX.NET

My love for photography began with my parents. As far back as I can remember my mom and dad always had cameras in their hands. I can prove it with the stacks of scrapbooks hiding in the cabinet full of old photos, slides, and slide projectors. The photography "bug" really bit me my junior year in high school. I had taken an introduction to photography class. This is what began my love of black and white photos. Along with the basic rules and techniques of taking a good photograph, I learned the art of developing. My senior year I took Intro to Photography II and Advanced Color Photography. I loved every minute of it. One of my life goals was to spend eight years in college and become a veterinarian. After seeing a few of my photos, my aunt told me I was going into the wrong profession. Today I am a recent college graduate with a degree in wildlife biology and a minor in nature interpretation. Did I make the right choice? I'm not really sure, but one thing is definite. I'm confident in the photographs I take, and photography is a true passion I will have for the rest of my life.

Vincent Vartorella

Web page: www.vartorella.net

E-mail address: vartorella@vartorella.net

I enjoy photography as a hobby and as a profession. I love nature and macro photography, but have made a career of photographing automobiles for dealers.

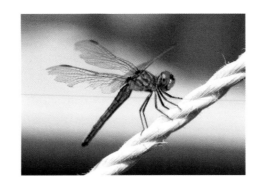

Ron Wilson

WEB PAGE: HTTP://WWW.RONWILSONPHOTOGRAPHY.COM/

Ron has been an avid photographer his entire life. "Capturing the essence of a scene, a moment, or a feeling is what motivates me." He is attracted to many diverse subjects for his photography—people, Amish life, dancers, cowboys, family, nature, flowers, animals, travel, scenery, landscapes, seascapes, cityscapes, architecture, and photojournalism. "If I have a weakness, it is that I try to cover too many areas and am spread too thin. But, I would get bored doing the same thing all the time." He is always looking for new subjects and trying new techniques.

About 20 years ago he began to share his knowledge and experience by teaching photography. His classes have been at the Cleveland Photographic Society, Mayfield Schools, Parma Schools, and Cuyahoga Community College. He continues to help others with the basic fundamentals of photography and the digital process of improving photos in the computer. "I get great personal satisfaction from helping others."

Ron has been "digital" for the last seven years. "I love digital! The instant feedback changes everything. Aside from instant gratification, it allows the photographer to learn more quickly, frees one from the economic restraints of film, encourages experimentation, and stimulates creativity."

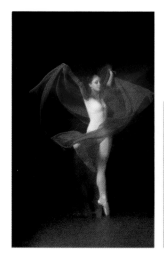

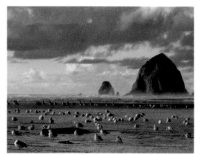

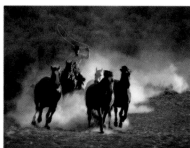

Rick A. Wetterau

WEB PAGE: RWETTERAUINFRARED.COM

E-MAIL ADDRESS: RICK@RWETTERAUINFRARED.COM

I became interested in photography just a few years ago. Took a couple courses at Cleveland Photography Society and became convinced this is where I could express myself through still images. I met David Busch at our club. I read his book on infrared photography, and have been completely overwhelmed with it since. I enjoy HDRs; florals with vibrant colors, and anything completely off the path. I'm still trying to find myself in this photography thing. Perhaps the search has no expiration. I'm at peace with that though; the journey supersedes the quest, doesn't it?

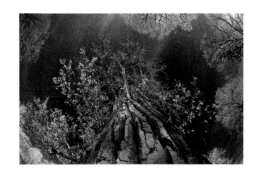

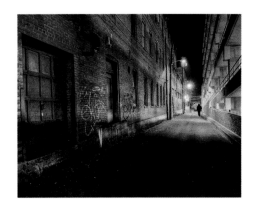

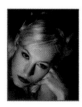

Tina Grimm (Model)

WEB PAGE: WWW.TINAGRIMM.COM

Tina was born February 19th in Cleveland, Ohio, which is not a warm place at all in February. Perhaps that is what makes her so resilient! She has a twin brother who is exactly one month older than she is. Tina knew she wanted to be in the entertainment industry at a very young age, organizing neighborhood fashion shows and performing her own one-act plays to an audience of stuffed toys. As she grew older, her passion for the arts expanded and she explored her creativity in illustration and painting as well as attending the Columbus College of Art and Design majoring in media studies (film and animation).

Tina is an independent film actress as well as a model. She is extremely dedicated to what she does and is always up for a challenge. Those who work with her become absolutely charmed by her pleasant nature and amazing attitude.

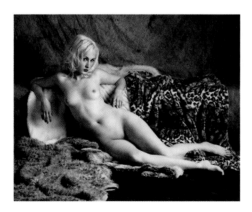

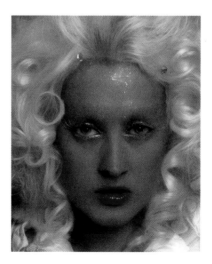

Rae Gentry (Model)

WEB PAGE: WWW.RAEGMODEL.COM

Rae Gentry (RaeG) has been modeling off and on for more than 10 years. She has an extensive background in theatre, dance, and currently spends most of her time performing with a group called Infusion. Rae is a versatile model who can bounce from alternative, pinup, and glamour to commercial.

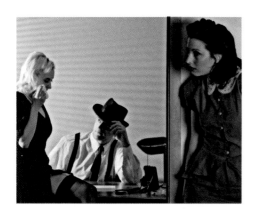

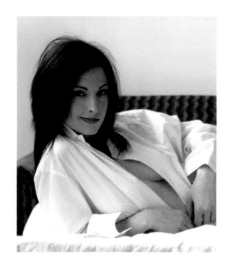

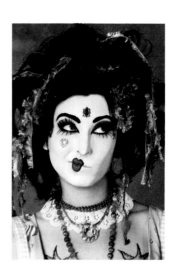

Denise Pace (In Memoriam)

DENISE PACE 1962-2009

"I must say that I LOVE what I do. There is no greater gift than to see the look of amazement on the model's face after she sees what I've done."- Denise.

Denise Pace was an accomplished and creative makeup artist with experience in all aspects of media makeup: fashion, video, and print. She worked with many creative teams especially around Ohio (including Dale & Jen Simmons, a.k.a. BlackWatch, featured in this book).

Denise's diverse background and experience created a unique style accredited only to her and her artistic talent. She had the innate ability to bring out the natural beauty of her subject, no matter the gender, ethnicity, or character portrayal. Her eye for detail was outstanding, and her glean for perfection showed in her work.

Whether her responsibilities took her on location to a video session or to a photographic makeup shoot for a catalog, Denise displayed her mastery for creating the right look—a "flawless on film" look, by using artistry techniques, beautiful skin tones, breathtaking shading, or coordinating exquisite colors always with the needs, goals, and objective of the project foremost in her presentation.

She was always thinking ahead at the shoot, working to make the model feel comfortable, and making sure that every detail was perfect. Denise is greatly missed by the photographers and artists whose work she contributed to and with whom she quickly became friends.

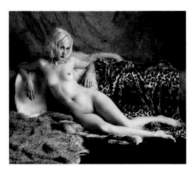
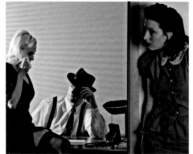

Index

We've got your shot covered.

Selections from Bestselling Camera Guide Author David Busch

David Busch's Pentax K200D
Guide to Digital SLR Photography
1-59863-802-5 • $29.99

David Busch's Nikon D300 Guide
to Digital SLR Photography
1-59863-534-4 • $29.99

David Busch's Nikon D60 Guide
to Digital SLR Photography
1-59863-577-8 • $29.99

David Busch's Canon EOS 50D
Guide to Digital SLR Photography
1-59863-904-8 • $29.99

David Busch's Canon EOS Rebel
XS/1000D Guide to Digital SLR
Photography
1-59863-903-X • $29.99

Canon EOS 40D Guide to
Digital SLR Photography
1-59863-510-7 • $29.99

David Busch's Canon EOS Rebel
XSi/450D Guide to Digital SLR
Photography
1-59863-578-6 • $29.99

David Busch's Sony α DSLR-
A350/A300/A200 Guide to
Digital SLR Photography
1-59863-801-7 • $29.99

The 50 Greatest Photo Opportunities

The 50 Greatest Photo
Opportunities in New York City
1-59863-799-1 • $29.99

The 50 Greatest Photo
Opportunities in San Francisco
1-59863-800-9 • $29.99

David Busch's Quick Snap
Guide to Lighting
1-59863-548-4 • $29.99

David Busch's Quick Snap Guide
to Using Digital SLR Lenses
1-59863-455-0 • $29.99

Other Great Titles

Picture Yourself Getting the Most
Out of Your Digital SLR Camera
1-59863-529-8 • $24.99

The Official Photodex
Guide to ProShow
1-59863-408-9 • $34.99

301 Inkjet Tips
and Techniques
1-59863-204-3 • $49.99

More Than One Way
to Skin a Cat
1-59863-472-0 • $34.99

Mastering
Digital Black and White
1-59863-375-9 • $39.99

The Digital Photographer's
Software Guide
1-59863-543-3 • $29.99

www.courseptr.com or call 1.800.354.9706